MASTERPIECES
of
GREEK ART

Third Edition, revised

Text & photography by
Raymond V. Schoder, S.J.

ARES PUBLISHERS INC., CHICAGO

The author and the publishers are most grateful to the museums and other institutions whose permission has been granted to reproduce in this book the works of art from their collections listed below by their plate numbers.

ATHENS
Acropolis, Plates 46 and 47
Acropolis Museum, Plate 20
Ceramicus Cemetery, Plate 56
Stoa of Attalos Museum, Plates 6 and 96
National Museum, Plates 1, 2, 22, 29, 58, 59, 60

BOLOGNA
Museo Civico, Plates 15, 32, 41

BOSTON
Museum of Fine Arts, Plates 5, 9, 13, 34, 37, 38, 49, 51a, 61a, 85

CAMBRIDGE, ENGLAND
Fitzwilliam Museum, Plate 84b

CAMBRIDGE, MASSACHUSETTS
Fogg Museum of Harvard University, Plate 18

CHATILLON-SUR-SEINE
Museum, Plate 26

COPENHAGEN
Ny Carlsberg Glyptotek, Plates 84a and 94

CORINTH
Archaeological Museum, Plate 10

CYRENE
Museum of Antiquities, Plate 23

DELOS
Plates 74 and 75

DELPHI
Plate 48
Museum, Plates 27 and 28

ELEUSIS
Archaeological Museum, Plates 8 and 73

FRANKFURT
Liebighaus, Plate 93

ISTANBUL
Museum of Archaeology, Plate 54

LAMBESE, ALGERIA
Museum, Plate 79

LEIDEN
National Museum of Antiquities, Plate 51b
LONDON
British Museum, Plates 4, 7, 11, 16, 24, 31, 35, 4 43, 50b, 55, 62, 83, and frontispiece
NAPLES
National Museum, Plates 64, 70, 71, 76, 77, 78, 8 87, 88b, 90
NAUPLIA
Archaeological Museum, Plate 3
NEW YORK
Metropolitan Museum of Art, Plates 33, 36, 86, 92
MUNICH
Glyptothek, Plate 25
Museum Antiker Kleinkunst, Plates 14 and 81
OLYMPIA
Museum, Plates 40 and 57
PAESTUM
Plate 45
Museum, Plates 21 and 53
PARIS
Louvre, Plates 19, 30, 44, 66, 68, 80
POMPEII
Villa of Mysteries, Plate 91
PRINCETON
University Museum, Plate 69
ROME
Capitoline Museum, Plate 67
National Museum (Terme), Plates 39, 72, 88a, 89, 9
Sale dei Conservatori, Plate 63
ST. LOUIS
City Art Museum, Plate 52
SYRACUSE, SICILY
National Museum, Plate 61b
TARANTO, ITALY
Archaeological Museum, Plate 50a
VENICE
San Marco Cathedral façade, Plate 65
WORCESTER, MASSACHUSETTS
Museum of Art, Plate 17
WÜRZBURG
Martin van Wagner Museum, Plate 12

© 1975
ARES PUBLISHERS, INC.
150 E. Huron Street
Chicago, Illinois 60611
ISBN 0-89005-071-6

No part of this book, including any of the illustrations, may be reproduced without the written permission of Ares Publishers Inc., to whom all applications to do so should be addressed.

Library of Congress Catalog Card Number 75-4410
Printed in Milan, Italy, by Amilcare Pizzi S.p.A.
First edition, 1960
Third edition, revised, 1975

MASTERPIECES
of GREEK ART

THIS BOOK IS, in a sense, a private art gallery, with talking guide. It seeks both to delight and to instruct. It assembles in one place 109 representative objects from every period and all branches of ancient Greek art, for the reader's enjoyment and analysis. The objects can speak for themselves, from their exact images in the color plates. To help toward a fuller appreciation of their merits, and toward seeing them in their cultural context, the commentaries discuss the objects' artistic qualities and supply useful background information. Each commentary is a unit, to be read on its own and not necessarily in the book's sequence—for this is a book to browse in as well as to study. I have sought to avoid merely subjective interpretations, preferring to approach the objects as they are in themselves and to seek out their intrinsic meaning—to evaluate and enjoy what is in them by their makers' intention and skill. The hope is to bring the reader into direct personal experience of the vitality and beauty of Greek art, and to an understanding of its history.

As an aid to seeing the objects in their relationships to one another and to the civilization in which they were produced, the introductory essay surveys the development of the arts in Greece, with attention to the intellectual and social milieu at each period which largely accounts for the variation in mood and emphasis discernible in different epochs of the long story. These inter-relations are presented schematically on the chronological chart which is provided.

In selecting the material for inclusion in this book, I have been guided both by the objects' intrinsic merit as art and by their suitability to show the special features of Greek art at different periods and in its many branches. Many other pieces equally deserve attention; perhaps they may receive their due in a later volume.

The color plates have all been made from my original 35mm slides, taken directly from the objects in their present location, sometimes under very difficult conditions. Every effort has been made to reproduce color tones as close to those of the original objects as possible, by use of six color-separation plates and carefully controlled inking. Total success in this is not yet technically possible, but we have done our best to show the various items as they really look, for their properly objective appreciation.

I am grateful to the publishers for undertaking the very large financial outlay necessary to the book's production, and for the fine cooperation of their editor, Mr. Burton Cumming, in all details of its preparation. Several friends have read the manuscript and made help-

ABOUT THIS BOOK

ful suggestions, for which I here thank them. I am especially grateful to Miss Anne McCabe, of Princeton, N.J., for her acute critique of the text on stylistic matters, which has often improved its readability. With characteristic generosity and friendliness, Dr. George Mylonas and Dr. Homer A. Thompson have read the proofs with an eye to the accuracy of my statements and interpretations. I greatly appreciate their courtesy and help. I wish also to thank the officials of the many museums here represented, for their permission to photograph these objects (and many others) and to reproduce the slides in this book. I hope that many readers will be inspired to visit the museums and see the objects at first hand.

The book could not have been planned, or the text written as it is, if I had not had the advantage of extensive special study and travel in connection with my teaching and lecturing in Classical literature and art. I am most grateful to my Jesuit superiors for providing me that opportunity and background. And to the many books and teachers from whom I have learned, and on whose wisdom and insights much of the book's substance is built:

ἕτερος ἐξ ἑτέρου σοφὸς

τό τε πάλαι τό τε νῦν·

οὐδὲ γὰρ ῥᾷστον

ἀρρήτων ἐπέων πύλας ἐξευρεῖν.

NOTE TO THIRD EDITION: The two previous editions of this book having sold 40,000 copies in eight languages, it is now re-issued with some corrections and revisions. All illustrations, and the text itself, remain as before, but the *Bibliography* has been extensively reworked and brought up to date. The book is being made available also in a less expensive format, primarily to serve the needs of college courses in ancient art. It is hoped that the new edition will thus have increased usefulness and authority for its growing audience of students and teachers as well as for the educated public which has already given the book such an encouragingly extensive welcome both in America and abroad. This new edition at moderate price has been made possible by a generous grant from the John and Helen Condon Trust.

GREEK ART:
ITS ANCIENT STORY
AND MODERN
RELEVANCE

We are all Greeks. Our laws, our literature, our arts have their root in Greece. But for Greece, Rome—the conqueror, the instructor, or the metropolis of our ancestors—would have spread no illumination with her arms, and we might still have been savages and idolaters... The human form and the human mind attained to a perfection in Greece which has impressed its image on those faultless productions whose very fragments are the despair of modern art, and has propagated impulses which cannot cease—through a thousand channels of manifest or imperceptible operation—to ennoble and delight mankind until the extinction of the race.

(Shelley, in introduction to his *Hellas*)

The phenomenon of Greece still startles the world. Great civilizations had preceded it elsewhere, and others were to follow. But there was a special brilliance and lasting validity about ancient Greek culture which has given it unique importance and universal appeal. In many ways, it was the Greeks who taught us to live as free men with intellectual interests. Not only they, of course; but they pre-eminently. The stimulus of their contribution to civilized living is still active among us, and many of our most treasured viewpoints, values, and works of art and literature are a direct inheritance from Greece. The purpose of this book is to make clear the scope and range of Greek artistic achievement, and provide representative examples for analysis and enjoyment. It will help to both ends if we survey briefly the remarkable history of Greek art from its origins to its decline, to make more understandable the stylistic periods into which it falls and their distinctive moods.

The Historic Role of Greece

The ancient Greeks were an Indo-European people who in the second millennium before Christ settled in the southern extremity of the Balkan peninsula and adjacent islands, and later along the coast of Asia Minor, Sicily, and southern Italy. Within their part of the Mediterranean world, the Greeks were long dominant in culture and commerce and in political control or influence. Only after Alexander the Great, toward the end of their long history, did the Greeks fuse with other nations into a mixed culture. Until then, they were largely a world to themselves in language, way of life, literature, and art. Within that small world marvels appeared with amazing frequency and variety—philosophers, scientific pioneers, poets, dramatists and every type of literary genius, artists of superb power and originality, great military leaders, champions of civic freedom, creative thinkers in every line of human endeavor. The impact of all this produced a unified culture of extraordinary quality, and injected into the life-stream of Western civilization elements which nourished its healthy growth and still contribute much of its vigor and momentum. Next to the supremely formative influence of Judaeo-Christian truths and ideals, it is due mostly to the Greeks that our civilization in its better aspects is what it is. Their historic importance to the West is that basic! We can therefore understand our culture in its vital principles only if we know—and understand—the fertile Greek element in it. That is the challenge to which the plates and related thoughts in this book are

1

directed. They can provide only a partial understanding, but even that is important, and can easily lead to more.

There is a special quality about the Greek mind which largely explains the remarkable Hellenic achievements and their enduring significance. Though the 'Greek mind' is naturally best seen in its highest representatives—Sophocles, Plato, Pericles, and others—there is evidence that its main features were characteristic of the common man also, though to a less remarkable degree. For Greek attitudes were basic national traits, and the people of Greece were imbued by the distinctive outlook constantly conveyed by their leaders in policy, art, and literature. The great geniuses differed much among themselves in personal interests, emphases, and formulations of ideas; but they had even more in common, and were all distinctly Greek, in many ways different from the best minds of other races. What, then, are the characteristic traits of the Greek mind which, in their total combination, mark it as something special and go far to explain its phenomenal achievements in speculative thought, literature, and art?

The Greeks enjoyed thinking. They loved to understand things in their causes, to explore their inherent purpose and their relationships to other things—both the objective relations rooted in the orderly plan of Nature and subjectively created ones produced by imaginative links of metaphor, mythology, and artistic interpretation. They honored reason, and sought to control the forces of human life and the external world by intelligence rather than by technology. With a few exceptions such as Archimedes and the legendary Daedalus, Greeks had little interest in practical applications of scientific knowledge to mechanical conveniences or implements. They showed in general a surprising lack of concern for materialistic comforts and luxury, though much given to the satisfaction of the senses. Politics absorbed their interest much more than money-making, and they did not live for success in business at the cost of personal values. It was primarily things of the mind and the world of beauty which they most admired, and the national ideal was eminence in human worth—in a life truly worthy of man's higher powers and personal dignity and the joys of freedom within a framework of civic responsibility and fairness for all. This led to their great pioneering in democratic liberties and their refusal—except at Sparta and in late Hellenistic times—to subordinate themselves to totalitarian Statism or to individual despots immune to popular controls.

The Greeks cherished freedom of the mind as well as of the person. They wanted no irrational restrictions on their inquiry into reality and life-values. But they were ready to accept the limitations imposed by reality itself, and always thought that there is an intelligible pattern in each thing and in the universe as a whole, which they sought to perceive and understand; and they were willing to fit their thinking and practical conduct to the realities and laws thus discovered—to live in accord with the facts, not obtusely ignore them or futilely defy them. They welcomed truth when found, and sought to arrive at sound conclusions and a coherent system of understanding, not just indulge in ceaseless search for its own sake. They trusted the mind and its ability to master situations and attain to permanently valid truths. Homer's Odysseus, the infinitely resourceful and quick-witted man, was as much the Greek ideal as Achilles with his heroic sense of honor and fearless courage. Sophocles' great ode to man in the *Antigone* (332–375), or Pericles' famed praise of Athenian values in life (Thucydides 2.35–46), would find ready acceptance by the majority of Greeks, while Aristotle's *Ethics* presents an analysis of human dignity in a rationally ordered scheme of life that is a triumph of Greek insight into man's nature and worth. There was a robust confidence in the importance and essential decency of man that colored all Greek attitudes toward life. Hellenic emphasis on man as more exciting than Nature or science, and on the priority of man's mind and spiritual ideals over brutish materialistic preoccupations, constitutes the core of that Greek *humanism* which is a unique and precious contribution to Western culture. It needs important correction and supplementing by Christian truths and ideals, but is susceptible of that easily—which shows its essential validity and worth.

The Greek mind loved clarity. It sought precision and lasting substance in its interpretations of things, and was impatient with vagueness or mere approximation. It liked to be certain, and to know *why* things are and function as they do. It sought to find the natural laws and inner essences of everything, and to see all reality in a unified system that gave it meaning, direction, value. Greeks instinctively shunned subjectivism, the esoteric, mysticism which repudiated reason, and all exaggerated symbolism which lost sight of the objective meaning of things. Yet they had phenomenal powers of imagination, and created a body of myth and poetry which is unmatched in the world. They were not deluded by these fancies, however, and usually knew better than to take them too seriously in their surface sense. They ranged freely in metaphor, but always within a firm framework of sober convictions and objectivity. Experimentation

in every field of thought and art and literature brought constant progress at an amazing pace, but sound values of established forms were not abandoned, though often restated in new terms. The Greeks accepted inherent limits in reality, and found there the key to the meaning and intended purpose of things. For they thought that pattern, essence, intrinsic form was the intelligible element in things and they delighted in its discovery and contemplation. This agreed with the special Greek sense of moderation and restraint, prudent limits, *sophrosyne*, as they called it. They hated excess of any kind, particularly where it involved arrogance or empty show. They were repelled by lushness, emotionalism, exaggeration in any form. It was balance, clarity of form, that aroused their admiration and satisfied their peculiarly vivid sensibility to beauty. Always it was beauty which they most prized and searched for, and even moral worth of persons was primarily considered as beauty of the soul. They approached any revelation of beauty with awe and delight, as the thing man is most meant for: truth in its splendor and radiance.

Working together, these instincts for beauty and for order produced the classic quality of *integration* which characterizes Greek literature and art. This is the element of perfection in it, the full exploitation of every aspect of rational worth in the object or experience, but never to the point of excess or imbalance of any kind. The Greeks saw supreme beauty in a peculiar effulgence of intelligibility, a burst of inherent glory in an ordered richness of reality that nourishes and delights the contemplating mind. This was connected with their esteem for wisdom—seeing things not merely on the surface or in isolation but to their depths and in perceived relation to the rest of reality. There could be found the truest meaning and importance of the object, as part of the great symphonic harmony of the universe. Against that coherent background, each thing took on perspective and a glow of reflected richness. Its beauty was both heightened and set off in its individuality, like a marble temple seen against the rich blue of the Greek sky. This stability of essential beauty, no mere surface diffraction or subjectively stressed partial facet of the object, constituted the permanent universal quality which the Greeks esteemed above all else. They looked on art objects as 'possessions for ever', as sources of timeless significance and joy. They approached them reverently, as manifestations of man's genius and as perfect objects—permanently achieved and enduring expressions in a material medium of a meaningful vision of beauty. Hence the Greek preference for calm and serenity and uni-versal representativeness in the object, rather than exciting novelty or startling individuality. It is this which has made the best Greek literature and art *classic*—in the double sense of 'first-rank' and 'permanent, universal model and norm.'

A final facet to the richly endowed Greek spirit: its delight in challenge and competition. The Greeks did not flee the world. They loved life, and enjoyed a vigorous struggle for mastery. They had confidence in their ability to control most things, if only they kept control of themselves. They did not often succeed at that, and factional strife and interminable war among Hellenic cities is the great disgrace of Greek history. But the reaction to challenge on other levels was constructive, and led to constant alertness to new ideas and stimulated rapid progress in every line of human endeavor. Echoing this, a love of sport is a very prominent feature of the Greek spirit. There was nothing like it in other ancient civilizations, except in Minoan Crete. It is an injection into the life of the West from which we still benefit, though we produce no Pindars to see in sport a deep ethical meaning and moral beauty. In this general trait of the Greek character is also to be found the explanation of the extraordinary vitality and freshness of Greek poetry and art, never stagnantly traditional, always bursting with vigorous life and with new forms for expressing it.

These being the main qualities of the Greek approach to life, the art which issued from that milieu is naturally distinctive. Greek art is like no other, in its total character. It resembles all great art of every culture in essentials, as it is an expression of human interests and faculties that are basically the same in all men. But in the complex of its emphasis on humanism, symmetry, clarity of form, perfection of refinement, fidelity to nature but vital creativity in interpreting it, and in direct intelligibility, Greek art is unique. Yet within this horizon of uniformly Greek character, the art shows remarkable variety and progress, a constant dynamic growth over a period of 1500 years. To appreciate this fascinating mystery of the Many and the One, we may turn now to a rapid survey of the major epochs of Greek art, and watch the living development and change down the centuries of that remarkable story.

The Mycenaean Age

Greece was widely inhabited in prehistoric times. Recent excavations at Lerna and elsewhere show that by the third millennium B.C. a number of settlements were of substantial size and well built. Into this world came the Greeks.

3

apparently from somewhere in Asia Minor, by way of the chain of Aegean islands and perhaps also by land around the northern coast of the Aegean. Others think they came from the north, through the Balkans. They were related to the people who settled at Troy. They reached northern Greece in the latter part of the third millennium B.C., and had largely taken over control of central and southern Greece in the period following 1900 B.C., when perhaps a further large group of them arrived. They were later called Achaioi and Danaoi, and there are references to them in Egyptian and Hittite records of the time. (The name 'Greek' comes from Latin *Graeci*—extended to the whole race from a group of colonists at Cumae in Italy). The chief center of their military and cultural strength was at Mycenae in the Peloponnesus, and the term 'Mycenaean' is commonly used today for the whole civilization and era after 1600 B.C. It was strongly influenced by the culture of Minoan Crete.

The Mycenaeans were true Greeks, direct ancestors (along with the later-arriving Dorians) of the Greeks of the Classic Age. Their social organization was essentially feudal, with much dependence on the sea for commerce and coastal raiding as a source of wealth and slaves. They developed a brilliant civilization, which Homer tried to reflect in those first 'historical novels' the *Iliad* and *Odyssey,* written much later but drawing on materials, traditions, and techniques inherited from the Heroic Age when the Achaeans were at the peak of their power. These original Greeks ranged over the whole Mediterranean world, and eventually controlled Knossos, the mighty capital of Crete, and conquered the citadel of Troy. Not long thereafter, in the early twelfth century B.C., another large band of Greeks, the more organized and disciplined Dorians, with superior weapons of iron, swept over Greece and conquered and destroyed all the great Mycenaean centers except Athens, which twice repulsed them. Thus ended the splendid first era of Greek history.

During this 'Mycenaean Age', as indeed for most of the second millennium B.C., the culture of the Aegean world was basically uniform, a blend from many areas which circulated among all of them in return. Attitudes, ideas, art had much in common in Crete, Egypt, Syria, Greece. Artists travelled widely, and art objects were imported from many regions so that mutual influences in content and style were very strong. Asiatic lions and griffins, Egyptian papyrus-flowers, lotus-designs, and cats appear in Mycenaean Greek contexts. Foreign ideas and symbolism can be traced, though often given new Greek meanings. An extant document from Nestor's palace at Pylos, in 'Linear B' script (adapted to Greek from the 'Linear A' form of writing in Crete) specifically records among items listed in an inventory: 'Two tripods: goat motif: of Cretan workmanship'. The splendid gold-inlaid daggers found at Mycenae (Plate 1) are in a technique first developed in Syria, but their themes contain elements from Asia Minor and Egypt. Their spirit, however, is more Mycenaean than Cretan, and they were owned by a Greek king in whose tomb they were found. This cultural intermingling is further illustrated by many other objects of the period.

Mycenaean palaces were grandiose affairs, elaborately laid out and richly ornamented with bright frescoes and fine furniture. The Pylos inventory, a generation after the Trojan War, mentions stone tables with inlaid designs in ivory, tin, gold, ebony—in wave-patterns, spirals, palmettes, and figures of men, stags, and horses. Skillfully carved ivory plaques have been found in these palaces and adjacent tombs, along with a vessel of crystal in graceful bird shape, beautifully incised intaglio gems, jewelry of amber, faience, and gold, and much else of high merit—especially the magnificent gold relief cups from Vapheio (Plate 2). Sculpture was little practised at this time, apart from small statuettes and some relief figures on architectural friezes. Pottery was often very attractive, both in finely proportioned shapes and in imaginative decoration in brown, orange-red, or black on the buff clay. Often the designs are floral or symbolic (Plate 3), sometimes lively scenes of bird and animal life (Plate 4), occasionally of men. Frescoes and carvings also represented religious processions, ritual dances, hunt scenes, sports in honor of the gods, battle actions, and ceremonial honor to the king. Often the themes are traditional and Cretan, but the dress and armor are brought up to date and the situation re-interpreted for Greek tastes.

In general, Mycenaean art takes its themes from nature, with flowing shapes which are their own source of interest. Cretan qualities predominate in the earlier stages, but after the middle of the fifteenth century B.C. the native Greek spirit begins to come to the fore—manifesting itself in more formal balance and rhythm of design, a greater restraint and clarity, and a narrative technique which hints at action beyond that directly shown. There is progress toward more abstract and stylized themes with an intellectual rather than visual interest. But the emphasis on human figures and man's primary importance, so characteristic of Classical Greek art, has not yet developed.

Greek art, in so far as we know it from extant examples, thus begins on a level of brilliant achievement equal to any

it ever attained later. Just so, somewhat later, Greek literature bursts upon us in full splendor with Homer. It is clear that both the epic and the art had antecedents, on whose long development and varied sources the surviving masterpieces drew. Whatever we may have lost from the earlier stages, at least the magnificent objects which we do possess from the Mycenaean era prove the high competence of the Greeks in artistic appreciation, and prepare us for the great developments in their art during the following thousand years.

The Geometric Interlude

By the end of the twelfth century B.C. the brilliant civilization of Achaean Greece had largely collapsed. The Mycenaeans had over-reached themselves in the attacks on Crete and Troy, and the independent fortified citadels of central and southern Greece developed tensions and rivalries among themselves (e.g., the expedition of the seven chiefs against Thebes) which undermined their united strength. A massive incursion of warlike Dorian Greeks succeeded within the century in conquering many parts of Greece. They destroyed by burning and pillage all Mycenaean centers, except Athens on its great acropolis, and killed many inhabitants. Some of the Achaeans fled abroad to Ionia, where they established important settlements such as Miletus, Colophon, and Smyrna which were later to be dynamic centers of reborn Greek culture. Perhaps it was also at this time that occurred the cataclysmic explosion of Thera, a volcanic island at the southern edge of the Cyclades, of which memories survived into Classical times. That explosion—vastly greater than any hydrogen bomb—left lingering terror and may have contributed to the disruption of commerce and to the economic upheaval and decline which followed the confusion caused by the Dorian invasion.

Life in the Geometric era seems much poorer and duller than in Mycenaean days. People ate mostly bread and porridge, little meat. There was a constant weary struggle to survive, hard toil on the land, not much travel or commerce, and no heroic adventuring. The art of writing was lost; no great palaces or cyclopean walls were built, and there is no evidence of any more frescoes or gold and ivory work, at least until the end of the period in the eighth century. Houses were simple structures, mostly mere huts. No temples are known, but only unroofed altar precincts, and cult statues were rough wooden cylinders with rudimentary figures. The only important art was in pottery and small bronzes.

'Sub-Mycenaean' vases during the early eleventh century are unpretentious and crude, thick in structure and less gracefully proportioned than formerly. Their decoration is usually in broad bands around the main girth, with narrow border bands (often three of them) above and below. Used mostly as grave offerings, their ornamentation is usually naturalistic. Household pottery was basically practical, with little effort at artistic merit. The times were too unsettled for art to prosper.

In the later eleventh century B.C. a new style develops, known today as 'Protogeometric', which continues through the tenth century. There are no figures of men and animals; decoration consists of concentric circles or semi-circles, diamonds, or vertical zigzag in one or more horizontal bands. The vase neck becomes taller, the body more oval with lower center of gravity. Contours are crisp and neat, the clay being formed by hand on a rapid wheel. Large vases usually have a light background; small ones are wholly covered with black glaze except for the decorative panels. The new Dorian mood of orderliness and practicality is beginning to manifest itself. Even in Attica the effect is seen.

From the early ninth century through most of the eighth, 'Geometric' pottery predominates. It is frequently burial urns or storage vessels, but some ornamented household ware is also found. Handles are strong, the body slimmer, with high narrow neck most common. The whole surface is decorated, in the fully developed period, with abstract geometric designs in a series of horizontal bands, some of them divided vertically into square frames like metopes in a later temple frieze. Birds sometimes occur in orderly single-file. All is dominated by rhythmic repetition and elaborately inter-related patterns of parallels and contrasts. The over-all effect can be most pleasing (Plate 5). There is a clear sense of order and coherence, of power and compactness, of balance, intelligible unity, and sober restraint.

There was a vigorous rebirth of intellectual, cultural and political activity in Greek Ionia at the middle of the eighth century B.C. The Pan-Ionian League of Greek cities along the central western coast of Asia Minor gained strength from unity and stimulus from competition. Once again the Greeks felt confident of their ability to master their surroundings and to express their distinctive view of life. Contact with great cultures to the east, and broadened travel by sea, quickened the new life and set in motion the phenomenal subsequent growth of Greek civilization. On the mainland of old Greece, this came much later and more

slowly, but was destined to take the lead away from Ionia in the sixth century and thereafter. The first major Greek colony abroad was established at this time, around 750 B.C., at Cumae in Italy. The alphabet had been borrowed from the Phoenicians a generation or less before that, and had great impact on the growing momentum of Greek progress in every phase.

It is now, apparently, that Homer appears and with supreme poetic genius creates from antecedent bardic materials and old traditions the first great epics, the *Iliad* and *Odyssey*. These present a fascinating reminiscence of the Heroic Age of Mycenaean Greece and a vivid sense of national spirit and ideals, along with profoundly civilizing insights into human values. All Greeks were ever after primarily influenced in outlook by the Homeric vision. Modern scholars point out the striking resemblances in general stylistic principles common to Homeric epic and contemporary Geometric vases—a paratactic arrangement of scenes each interesting in itself, yet having its place in the over-all unity; the grand scale of design, and wealth of enjoyed details; the sense of rhythmic balance and intelligible structure; and the growing human interest, which in the later Geometric pottery comes to the fore while abstract forms recede into decorative context for human or other living centers of attention (Plate 6). Men in action, often as groups, dominate the later Geometric vases, and sculpture becomes more common—the small bronze primitive figures of men and animals popular in the eighth century. The Geometric Age now quickly fades away into the dawn of fully characteristic Greek art.

The Archaic Period

In the seventh and sixth centuries Greek culture found itself and rapidly developed into its distinctive form. It was a time of burgeoning progress on every plane. The Greek city-states grew powerful, and vividly conscious of their individuality and of their capabilities. They established an amazing number of colonies all over the accessible world—along the coasts of the Aegean, the Propontis and Euxine Sea, in Sicily, Italy, France, Spain, Africa. Powerful personalities dominated political life: Polycrates in Samos, Pisistratus at Athens, Periander at Corinth, and similar 'tyrants' elsewhere. The common people had as yet few civic liberties, and were burdened by economic subjugation to the landed nobility. But a vigorous mercantile and industrial class now began to develop, which by its wits and energy and the new

invention of coinage (a form of wealth independent of land and animal stock) rapidly became able to challenge the vested aristocracy. Class tensions grew, and much civic unrest. At Athens, already growing pre-eminent on the mainland, laws of justice and property were codified by Draco, and major reforms were made a generation later by Solon, who sought a peaceful balance of power between the social classes, with a strong government as mediator. To the East, Egypt had conquered Assyria in 672 B.C. and invited Ionian settlers along the Nile. Nearby Lydia grew strong under Croesus, but fell to the organized imperialism of Persia, which in the later sixth century extended its fairly lenient control over Ionia also and the Greek cities there. The whole Greek world was in a ferment of change and rebirth and new challenge. This is naturally reflected in its art and literature.

Poetry becomes strongly personal and takes for theme the inner emotions of the writer. Archilochus' robust individuality and biting satire are something wholly different from Homer and totally distinct in mood from Hesiod and his harsh, glum world. The beauties of nature and sensitive personal feelings find exquisite expression in the new lyric movement of Alcman, Alcaeus, Sappho, Stesichorus. Science and philosophy begin their brilliant career in Greece as Thales, Pythagoras, Xenophanes, and others seek to discover the basic laws of nature and of thought. In art, too, striking innovations appear and trends begin which were to continue in dynamic development for centuries. The Archaic stage is similar in many ways to the Romanesque period in later European art. It is characterized by an honest, authentic feeling, without artificial pretense or heavy sense of duty to convention. There is a direct, open approach to problems and a lusty strength of self-expression, seeking to produce objects which will hold the interest of lively minds. Techniques are still rough and tentative, but the progress in their refinement is rapid. And always the special Greek quality, the clarity and humanism and sound objectivity, comes more to the fore and breaks free of alien traditions.

In pottery, the period begins with the 'Orientalizing' movement. Under the influence of new contacts with Egyptian painting and Assyrian textiles and metal ware, Greek vases become more ornate and naturalistic, less orderly and less purely geometric in decoration. Palmettes, lotus flowers, floral motifs are common, and rays of color on the base. Stylized lions, panthers, sphinxes, plant forms become prominent (Plate 9). Human figures are no longer mere silhouettes or unreal triangular-chested symbols as on late Geo-

metric vases, but are given some outline and basic realism, and are larger elements of the design. Pottery shapes become imaginative (Plate 7). 'Proto-Attic' work of the period is often on a grand scale and likes vigorous action for theme (Plate 8). Corinth developed a style of its own (Plate 10) which for a century was very popular and widely exported. Laconian ware at Sparta has a striking elegance (Plate 11), while the special Chalcidian style at Greek colonies in Italy (Plate 12), and other distinctive styles elsewhere, show the fertile diversity of Greek genius and taste. In the seventh century, Athens developed its famous 'black-figure' pottery which rapidly swept the field and practically eliminated all competition (Plates 13–18). Human action is the center of interest and the background is cleared of irrelevant ornamentation, though beautiful floral or geometric bands often grace the neck and base (Plates 16, 17). Men and gods are somewhat stiff and formal, and shown in side-view only; but they are increasingly real, and often drawn with great skill (Plates 16–18). Execias, the finest of the black-figure artists, produced vases of undying charm (Plate 14); and so did many others.

Archaic sculpture has much in common with contemporary vase painting in general style. Anatomy is stiffly conventional at the start but grows continually more flexible and true. At the middle of the seventh century, when full-size statues in stone first appear in Greece (earlier sculpture had been in wood, or small bronzes), Egyptian traditions are very obvious in the monumental aloofness of bolt-upright figures facing directly forward, with arms close to the sides, hands clenched or flat against the flanks, narrow waist, broad shoulders, left foot slightly forward, and details of muscles only generalized. The head is oval, with stylized mouth, eyes, ears in flat planes. The hair is elaborately systematized, often like a woven mat falling over the shoulders. Standing youths are the commonest subject, or standing young women with simple dress, which is sometimes patterned in rhythmic folds. Seated male and female statues also occur, stiffly frontal, with hands on knees, as in Egyptian and Assyrian models. But within a century and a half, these formal conventions, which had prevailed for thousands of years in Egypt and the Near East, were left behind as Greek sculpture became ever more purely Greek and expressive of anatomical realities as well as of humanistic idealization. Throughout the archaic period, a fresh buoyant vitality is evident, and a fascination with the challenge of representing human dignity and feeling. By the middle of the sixth century, technique had progressed very notably, and the fully characteristic Archaic style had been attained. Its special charm can be appreciated in Plates 19 and 20.

Architecture too became an art in the Archaic epoch. Earlier temples had been of wood, mud-brick, and tile, simple 'houses of the gods' something like a Mycenaean megaron —a central hall with porch and walled rooms. In the early sixth century, these began to be replaced by large rectangular structures of stone, the first examples of the 'Doric' style (at Olympia and Syracuse) and the original 'Ionic' temple at Ephesus. Many fine temples soon followed elsewhere, and the architectural orders rapidly developed their characteristic styles, reaching perfection in the fifth century. Similarly, the beginnings of painting are in the Archaic period. There are ancient references to polychrome panels at Corinth and in Ionia, and two wooden plaques survive from Sicyon, painted very much like a black-figure vase of the time. Etruscan tomb paintings in Italy in the sixth century clearly imitated Greek models. In ivory carving, wood inlay, gold work, incised gems, and decorative glass, other facets of the reawakened Greek artistic spirit are given expression.

The Age of Transition

The two generations from about 530 B.C. to around 470 saw dramatic developments in Greece and its arts. This period of sixty years was an age of varied transition, when older styles perceptibly changed into the full Classical manner. The political system moved away from democracy—that great Greek innovation. This was especially so at Athens, where Cleisthenes' reform undercut old factional tendencies rooted in group loyalties and brought cooperation of all citizens for the common good and distributed civic responsibilities among all classes. The tremendous challenge of the Persian Wars forced new unity on Greece, and the triumphant heroism at Marathon, Thermopylae, and Salamis galvanized all Greeks with a surge of pride and enthusiasm whose momentum created the subsequent Classical era of supreme cultural achievement in every line. At the same time, the Greeks in Sicily hurled back the serious threats from Etruscan and Carthaginian foes, and further intensified Hellenic national spirit. The greatest epoch of Greek spirit and attainment was now well under way.

Literary geniuses like Simonides and Pindar gave lyric

poetry new forms and heightened repute. Tragedy was developed by Aeschylus, on the basis of earlier dramatic experiments of Thespis, and comedy also emerged, both at Athens and Syracuse. In Ionia, Hecataeus started historical writing toward its true dawn a generation later with Herodotus.

Around 530 B.C., vase painting was radically transformed by the introduction of the 'red-figure' technique—the direct opposite of earlier procedure. (See commentaries on Plates 13 and 31). This allowed much more freedom of position of the figures and more subtle detail, and opened the way for a diversity of individual styles (Plates 31–33). Mural and panel painting progressed also, broke away from silhouettes, developed depth and perspective, gave new refinement to figures and drapery, and undertook large action scenes. Coins often became splendid works of art (Plate 61a), and fine gems were carved.

In sculpture, the transition is clear and rapid. Everything is more natural—stance, motion, anatomical details, drapery, facial expression (Plates 21–26), culminating in the magnificent Charioteer at Delphi, unmistakably and splendidly Greek (Plates 27–28). Impressive new temples were built: the Ionic Heraeum at Samos, and Doric temples at Paestum, Aegina, Athens, and in Sicily. The often observed Archaic smile (Plates 19, 20) well typifies the contemporary general satisfaction with a full life strongly unified and motivated by deep religious and patriotic feeling.

The Classical Plateau

From the second quarter of the fifth century B.C. till the last quarter of the fourth, Greece was at its cultural peak. An amazing number of brilliant minds in every branch of thought and art peopled that small land in its days of glory. Most of them were attracted to Athens, which emerged from the Persian Wars powerful, wealthy, and ambitious beyond any other Greek city, though Syracuse, Sparta, and Corinth were close behind. Pericles' policy of glorifying Athens brought splendid artistic developments, but resulted in a disastrous war with the Peloponnesian alliance which ended Athens' military predominance, wrecked her commerce, and broke much of her spirit and her democratic traditions. Sparta was supreme for the generation after 404 B.C., Thebes for the next, until Philip of Macedon's strategy and astuteness brought him control of Greece and changed the country's whole political situation and outlook.

In these centuries, ancient drama reached its summit in the *Agamemnon* of Aeschylus (458 B.C.), the classic tragedies of Sophocles and Euripides, and the brilliant comedies of Aristophanes. Herodotus made historical writing an art, and Thucydides gave it scientific precision. Xenophon became the first accomplished war correspondent with his account of the great adventure of ten thousand Greek troops struggling back from Asia. Public oratory flourished, with Lysias, Isocrates, and Demosthenes most prominent. Philosophical thought turned from preoccupation with cosmological and scientific problems to the analysis of being (Parmenides, Zeno, Heraclitus) and of ethical and human issues (Gorgias, Protagoras, Socrates), culminating in the fourth century in the profound systematic metaphysics of Plato and Aristotle. There was a new emphasis on the individual and his rights and civic responsibilities, a confidence in the importance and sound sense of the common man, educated to freedom—though this suffered disillusion by the end of the period. Craftsmen's guilds were established to promote personal creative integrity. Industry prospered in household furnishings, artifacts, books, and armor. Banking and credit systems developed, and there was organized public relief and social benefactions (the 'liturgies'). Women, however, had no vote or property rights and a very restricted life beyond the home. Male citizens had a most direct and constant participation in civic and international affairs. Slaves, however, were considered sub-human.

The art of the time reflects this new awareness of personality and of ultimate issues in life. It expresses the importance of the human person and of community action. Dignity, serenity are stressed, and always the universal and timeless aspect, the intellectual meaning, is underlined. All is idealized, without losing reality. Simplicity, restraint, and clarity are the stamp of Classical art, along with total perfection of technique. Art works are balanced, harmonious wholes, fully integrated units with an inner center of conscious purpose and control. The old restrictive conventions growing out of collective thinking are now broken through, and Classical statues or vases stand forth as individual objects to be admired on their own merits, though always fitting readily into the stable, clear framework of general life-views in the Classical Age. Always, man is the chief theme.

Grateful to the gods who had saved her from alien Persian rule, Greece set about rebuilding her destroyed sanctuaries and erecting new ones. The Doric order reached its perfection in noble temples at Olympia and Paestum (Plate 45) and in the Parthenon at Athens, among many others springing up on the mainland and abroad (Plate 48). The finest of

Ionic buildings were now created: the Mausoleum at Halicarnassus, the new Artemis temple at Ephesus, and at Athens the little Athena Nike shrine and the elegant Erechtheum (Plates 46–47).

In sculpture, the style is somewhat severe and grave at first (Plates 29–30), but soon reaches full flowering of humane fluency and grace. With the magnificent Discus-Thrower of Myron (Plate 39) and the Athena Lemnia of Phidias (Plate 41), classic purity and perfection is in bright bloom. The majestic pedimental groups at Olympia (Plate 40) and ideal human figures by Polyclitus revealed the grandeur and inherent beauty of man—in whose image the Greeks imagined their gods—and the famous Zeus at Olympia by Phidias was said to have added to religious understanding and awe, so adequate to the divine nature was its dignity (Quintilian, 12.10.9). Animals were represented with consummate sympathy and skill (Plates 42–43, 49a), and are often full of vitality, while the features of men are uniformly given a serene repose above the struggles of life and even of their represented action (Plates 54, 44). In the fourth century, humanism is at its peak, with wonderful naturalness and grace and ultimate technical refinement (Plates 58–60). The figures have warmth and calm beauty, to raise our esteem of man (Plates 55–56). An element of softness and sensuous appeal was introduced by Praxiteles (Plate 57), while Scopas emphasized realism and strong emotions, and at the close of the period Lysippus' lithe athletic types found beauty in refined naturalism rather than in abstract ideals. In fifth and fourth century sculpture, the principles of foreshortening and depth relationships are fully mastered. Anatomy is accurate and graceful, without excessive detail. Drapery is often magnificent, showing the texture of the represented cloth and the living body beneath. A variety of stance and motion is at the artists' command, and weight is properly distributed. Interest in the individual, rather than ideal types, increases steadily.

Painting of the fifth and fourth centuries has not survived, but ancient accounts make clear that it attained high merit. Polygnotus was considered the greatest Classical painter, famous for effective character depiction and the noble idealism of his human figures. Apollodorus introduced more realism by shading, chiaroscuro technique, and subtle tonalities of color. Zeuxis specialized in emotional pathos and mellow humanism and was a master of shadow effects and natural lighting. Delicate detail was Parrhasius' forte, and facial revelation of character. Pausias developed the 'encaustic' procedure of binding pigments by warm wax, which produced effects rather similar to those of oil painting—a late medieval invention. Three-dimensional quality and good foreshortening and perspective were mastered by the fourth century. The supreme painter of that era was Apelles, who worked for the court of Philip and Alexander in Macedon, doing portraits and other pictures highly praised for their humane charm and superb technical skill. Other artists are mentioned, and some elaborate mural compositions at Delphi, Athens, and elsewhere.

Vase painting in the Classical Age was mostly in the red-figure manner, which acquired very distinctively different styles in the hands of individual artists and their schools. The finest fifth century examples have a beautiful clarity and restrained elegance (Plate 34). The more complicated white ground type of vase (Plate 36), which had occasionally been produced earlier (Plates 18, 35), enjoyed considerable vogue. Sotades made many unusually shaped drinking rhytons (Plate 37), and other artists developed pictorial styles of their own. There was much progress in perspective, motion, natural positions and anatomical accuracy, and a general humanism of conception and treatment. It is known that vase painters were much influenced by the greater contemporary artists of panels and murals. Towards the fourth century, vase decoration became more ornate and careless and used a variety of colors and sometimes gold—e.g., the Meidias painter and the Kertch style. The art rapidly declined in Attica, but carried on in the Greek cities of Italy, where a variety of new styles developed: Paestan, Campanian, Apulian, Tarentine, Gnathian, and others, which made much use of white and yellow and brown, often with gold overlay, in rather crowded and undistinguished drawings whose favorite themes were literary episodes. In Greece proper, pottery became objects of practical use rather than for artistic decoration; moulded relief generally replaced painted designs; and metal vessels became more common. Some of these were finely made, in the tradition of earlier bronze vases like that in Plate 38.

Throughout the Classical period, other arts also flourished. Gold jewelry and ornamentation were exquisitely refined (Plates 50a, 51a). Gem carving reached its perfection with Dexamenus (Plate 49), and many coins were masterpieces of engraving and design (Plates 61b, 62). Household glass ware was often delicate and colorful (Plate 80). The Greeks of the Classical era dwelt constantly amid great beauty of nature, literature, and art, all of which were active in their continuous education which produced that cultural plateau that all the world admires.

The Hellenistic Revolution

The phenomenal career of Alexander the Great radically changed Greek civilization. His rapid conquest of most of the known world not only brought Greek language and culture into international prominence, but exposed both of these to strong alien influences which inevitably wrought profound modifications. The Koine or 'universal' dialect now developed, replacing the many local dialects. Oriental and other attitudes in religion, life-values, art, and political structure infiltrated the Greek outlook and deeply affected its subsequent quality. The Hellenic world is dissolving, the Hellenistic Age begins.

After Alexander, the Greek world was under the political domination of powerful monarchies dividing it into rival kingdoms: Macedonia, Asia Minor, and Egypt. Democracy largely vanished and the ideal of local independence was lost. Rather there was loose union within a larger international kingdom, a blend of many racial groups and diverse traditions into a basically common outlook which was necessarily complex. Tendencies quite at variance with one another struggled for expression. It was an age of turmoil and uncertainty. The old unifying forces of religion and the State, which in the close-knit world of earlier Greeks had direct appeal to each man's loyalties, were now diffuse and ineffective. There was no sense of national unity, only a vague spirit of world fellowship. Religion was not a vital motive in personal life and the old myths were considered mere sportive fiction. There was no dominant, clear ideal in life, no conviction of purpose. Man's worth was consequently questioned and most men lived only from day to day, by expedience or make-shift. The spirit of the times became jaded, blasé, and old enthusiasms no longer held appeal. A crass and cynical attitude toward moral values led to widespread materialistic emphasis and weary hedonism. There was much open graft and political selfishness, and men's minds were restlessly curious for new ideas and amusements to mitigate the spiritual hunger of the times. In many aspects there is a striking parallel between the mood and problems of the Hellenistic Age and our own turbulent era since the First World War. This gives it a special fascination.

There were aspects of strength and progress also, and Hellenistic literature and art have much that is new and worthwhile, and of a more cosmopolitan quality. For the first time in Greek art children receive understanding and skillful depiction, and the special attributes of old age are given explicit attention. Non-Greek 'barbarian' types appear and are treated with new interest and respect. The unsettled and syncretistic mood of the age, weary of old traditions, fostered experimentalism and led the best artists and writers to original approaches and unconventional themes. Individualism prompted the artists to more open self-expression, and art was mostly looked on now as a means of personal display of wealth and taste by the private collector, rather than of communal expression at temples and public buildings. It served the contemporary love of riches and splendor in the newly luxurious homes. Art therefore emphasized the emotional and sentimental aspects of its themes, and often chose subjects for such effect. Classical restraint and serenity were often replaced by deliberate striving to startle or shock, or when not that sensational, art was at least often consciously vehement and dramatic. Realism was popular, and sometimes exaggerated. This included bringing art and literature down to every-day, prosaic themes and to studies of the common people, with no pretense at grandeur or elevation or philosophical universalities. Yet at the same time a sturdy current of traditionally serene and dignified beauty flowed through the Hellenistic Age, little affected by these eddies of turbulent change. Thus the Classical style survived in both literature and art, though on a somewhat less exalted plane.

Hellenistic literature mirrors all these varied movements. The conventional forms were widely imitated, and Apollonius of Rhodes wrote his epic on the Argonauts in Homeric dialect and meter. But mostly the patterns and taste have changed. The comedy of manners has replaced satire on civic figures, and Menander and Diphilus are very different in spirit from Aristophanes, Eupolis, and Cratinus. Tragedy has given way to romantic verse and fancy. Poetry is self-conscious and learned in Callimachus' hands, while Theocritus' pastoral idylls introduce a new literary genre. Scholarship and organized learning become prominent and promote the growth of erudition, allegory, symbolism in literature. Textual criticism is born. Great scientists and mathematicians (Aristarchus, Archimedes, Eratosthenes) write specialized treatises on astronomy, mechanics, geography, while Euclid gives geometry its classic synthesis.

In art, both the continuity and the changes characteristic of the age are best seen in sculpture. Attica is no longer the dominant center of production; the chief schools are at Alexandria, Pergamum, Ephesus, Rhodes. Artists travelled widely on commissions, hence styles are not confined to localities. The continuing Classical tradition is represented

by the splendid Winged Victory of Samothrace (Plate 66) and the Venus de Milo (Plate 68), and the magnificent bronze horses in Venice (Plate 65) seem to belong to this period. The realistic movement may be seen in vivid portraits such as those in Plates 63 and 64, and the special Pergamene vigor and emotional intensity in the Dying Gaul (Plate 67). Humor and the seeking of themes in common life account for the delightful bronze comic actor statuette of Plate 69. The third century is the great age of terracottas from Tanagra (Plate 84). Gold and ivory work continues on a high level (Plates 51b, 52, 53) and cameo carving is brilliantly developed (Plate 82). Coins carried fine portraits of ruling princes and were more commonly in gold. Hellenistic painting has not survived, but is known to have developed great technical skill in perspective, action, and color tones. Still-life themes were popular, and Aetion specialized in interiors. Philoxenus and Sosus are among the other great artists of the period. Realism and unpretentious scenes from daily life prevailed in painting, as in sculpture. A special Hellenistic art form is the beautifully painted funeral vase (Plate 86). Few new temples were built, but the great altar at Pergamum was a marvel. Altogether, it was an age of great vitality in art, and though inspiration was not on the Classical level, technique was better developed.

Greece Captures Rome

The final age of Greek art is the era of Roman domination. During the Hellenistic period, Rome's power had grown mightily and she emerged from the mortal struggle with Carthage the supreme power of the world. In 146 B.C., Rome gained control over Greece and thirteen years later over the Hellenistic kingdoms of western Asia Minor. For the next six hundred years, it was Rome that shaped the civilization of the Western world—and of much of the East—but under profound influence from Greece on all cultural levels. Educated Romans were widely familiar with Greek literature and art, which remained the models and norm of their own. Vast amounts of Greek sculpture and painting were transported to Rome, where most of it perished in Nero's fire and other destructions. (Some was shipwrecked enroute, and has since been recovered—e.g., the statues in Plates 29, 30, 58, 60). Greek artists worked in Italy or for Roman purchasers, and native Italian craftsmen were trained in the Greek traditions. Most Romans were not very discriminating in art appreciation, and quality suffered widely under their undemanding tastes and the

mass-production and merely imitative work which grew up under the circumstances. In general, the art is a direct continuation of Hellenistic forms, with growing emphasis on portraiture and historical reliefs.

The great literature of the age was written mostly by Romans—Catullus, Lucretius, Cicero, Vergil, Horace, Tacitus—but in conscious relation to Greek models. Some life was left in the Greek language too, which produced its last harvest: the Alexandrian poets, the essays and satires of Lucian, Plutarch's lives and moral essays, some major scientific and historical works, Pausanias' guide to Greek sites and their art, philosophical treatises by Philo and Plotinus, the brilliant literary criticism of 'Longinus', and the Greek novelists. Already Greek was in the service of Christian writers, who soon became its chief heirs.

In this intellectual context, the art of the period finds ready place. The favorite architectural style was everywhere the Corinthian, whose major monument was the great Olympieion at Athens. Roman temples imitated the Greek orders, but with important differences and less refinement of design. Sculpture was produced in great quantity but generally without originality or high inspiration. Some exceptional pieces deserve attention, however—the dramatic Laocoon group and monumental 'Farnese Bull' (both made in Rhodes), a powerfully realistic bronze portrait of an old man (Plate 71) and the battered Boxer of the Terme (Plate 72), the Resting Mercury from Herculaneum, and the delightful Dancing Faun from Pompeii (Plate 70). A striking horse head at Eleusis (Plate 73) shows unusual imagination. The wonderfully vivid portraits of the Roman Age were often made by Greek artists, though some others are evidently of Roman workmanship. They preserve for us very reliable likenesses of great men of the times (Plates 94, 85), and sometimes of children, like the charming girl in Plate 95. Splendid mosaics at Delos, Pompeii, and elsewhere reveal consummate skill in an art undeveloped in the Classical era (Plates 74-79). Decorative glassware is often of the highest order (Plates 81, 83). Terracotta statuettes from Myrina and south Italy do not rival those of Tanagra for delicate grace, but are of varied interest nevertheless. Hundreds of paintings survive from Pompeii, Herculaneum, Stabiae, Rome, mostly from the first century before Christ and the century following. A few are of real merit, as close copies of Greek originals (Plates 87-88) or new works by late Greek artists (Plates 90-91). Others at least draw on techniques developed by Hellenistic painters (Plate 89). A special branch of painting are the mummy-case

portraits from Graeco-Roman settlements in Egypt (Plates 92–93).

If the last epoch of Greek art, with all this to its credit, is thought of as its final decline, it is only because the stages that had preceded were so phenomenally fertile in works of genius. When the fire went out, at the end of the fourth century after Christ, it had well deserved its rest!

The After-Glow

The creative capacity of the Greeks reached exhaustion only after nearly two thousand years of immense productivity. The vast majority of its creations have long since perished from a variety of destructive forces both natural and human. What survives is often not the best or the most representative. But among these survivals are many true masterpieces, and enough evidence of vanished glory to fill us with wonder. This rapid survey of the Greek achievement in art, and the illustrations which follow, can only sketch the main outlines of the remarkable story. We must remember that besides its own ancient fecundity, the Greek artistic spirit has also been a stimulus and guide to later cultural achievements. The radiant multitude of Byzantine mosaics and paintings is a direct offspring of its Greek parent, whose ancient traditions and skills were given new life and sublimity by the Christian vision. Renaissance art is also largely a product of a parentage half Greek, half Italian. It could never have occurred if the Greek heritage had not preceded and to some extent survived. Actually, Renaissance literature and art are mostly Roman in inspiration and derivation. Authentic Greek art was not yet available to any extent, still awaiting excavation. But Roman art itself was essentially derivative from Greek, so that the great products of the Renaissance are at least the grandchildren of Hellenic genius. The Renaissance saw Greek art and literature through Roman filters, and did not see it clearly. The cold lack of color in neo-Classical sculpture is a misunderstanding and a loss. The idea of static perfection to be imitated but not reconceived is a Renaissance travesty of the true Classical spirit, which was always vitally progressive, freshly alive, honestly original in inspiration. The imitations in seventeenth through nineteenth century art (Thorvaldsen, Ingres, etc.) are similarly false and weak in comparison to authentic Greek art; yet the considerable merits they have are largely due to their Classical principles of proportion and idealized objectivity.

Greek art today is much better understood. Archaeology has restored to us not only a great wealth of ancient objects, but also the context and perspective for their proper analysis and appreciation. Our museums display Greek art with reverence and pride—though few of them with suitable aesthetic freedom from distraction, and hardly any against the background of the blue Greek sky for which they were made. Modern photography has made available to all whatever of importance has survived in Greek art, though the present book is the first to display the whole range of the subject so extensively in full color. The material is therefore now readily at hand for an intelligent personal appreciation of Greek art in its many branches and periods. *That* is the reader's own responsibility.

Greek Art and Ourselves

Throughout its long history and successive developments, Greek art retained an essential unity of character that kept it Greek. To a different degree and with varying emphasis in each period, Greek art was consistently marked by a special combination of qualities: directness and objectivity; a naturalness which makes it easy for all men of any era and culture to understand and enjoy it; an unexaggerated realism which shuns the esoteric and restrains the elements of allegory and symbolism that occasionally tempt it; a sure instinct for beauty, which is found in rational comprehension of intrinsic pattern, proportion, symmetry, the intelligible form radiant in its clarity and meaningfulness; an honest delight in the beauty found, which is esteemed for itself and as an inspiration to noble use of the mind; a love of clarity, simplicity, relevance, and an insistence on seeing the relationships of parts to the whole and of the art object to reality in the large; a search for universal significance in things, their unchanging essence and nature beyond the limits and inadequacies of the particular—things as they should be, not just as they are; a sane idealism, emphasizing what is most admirable, most true, most humanly uplifting in things, rather than their defective, sordid, or merely ordinary aspects; a pervasive humanism of outlook which finds man and his nobler qualities the chief element of interest, with Nature and the animal world significant mainly in their relationship to man and his needs; a spontaneous, unforced motivation in producing art objects which are an authentic expression of the feelings and the vision personally experienced by the artist, and therefore without posing or sham; and a remarkable agility of mind, alert to all human experiences and their significance, quick to learn, progressive,

imaginative, always driving to perfection of technique, abhorring carelessness and stagnant conventionalism, always vital, energetic, creative, alive. The result is an art which is eminently sane and constructive, of lasting human value, by nature 'classic' and of universal worth.

Such an art surely has claims on our attention today. As an historical fact, Greek art has been a major formative element of Western culture, and is still a vitalizing force within our intellectual life. It has to be known—extensively and accurately—if we are to understand ourselves as heirs of Western civilization. It is a major instrument of liberal education, which our technological age especially needs to cultivate if we are to keep our balance and our human pre-eminence over the machine. But more than all this, Greek art is a continuing potential source of refined esthetic delight. Its great masterpieces (some of which are presented in this book) can still bring us valuable pleasure, insight, and inspiration. We have only to give them a chance!

Five hundred and fifty years after the Periclean Age, Plutarch, in his life of Pericles (12–13), perceptively wrote of the great Classical buildings on the Acropolis that 'they brought delight and adornment to Athens, and the greatest amazement to the rest of mankind... They arose no less towering in their grandeur than inimitable in their grace of form, for the workmen eagerly strove to surpass one another in the beauty of their craftsmanship... These works were created in a short time for all time. Each one of them was from the start already ancient in its beauty; yet in the freshness of its vigor each of them is, even to this day, recent and newly wrought. There is a perpetual newness which blooms upon them untouched by time and preserving their charm— as if they held within them some everlasting breath of life and an ageless spirit intermingled in their composition.'

In our day, too, Greek art is still meaningful, for the same reasons. For as Keats said,

'A thing of beauty is a joy forever.'

Chart of Comparative Chronology in the Development

Dates, B.C.	History	Literature	Architecture
20–13 cent.	First Greeks settle in central and southern Greece, c. 1900– 'Mycenaean Age': c. 1600–1150 Greeks control Knossos: c. 1450–c. 1200 The Seven against Thebes: 13 c. Trojan War: c. 1240–1230, or c. 1210–1200	Itinerant bards 'Linear B' records early hymns, saga	Shaft Graves, Mycenae: 17/16 c. Tholos tombs: 15–12 c. Palaces: Mycenae, Pylos, etc. houses around megaron earliest temples fortified citadels
12–8 cent.	Dorians invade Greece: c. 1200– Pylos, Mycenae, etc. sacked Athens attacked: 12, 11 c. Tribal Kingdoms in Greece Migration to Ionia: 11–9 c. First Olympiad: 776 First colony: Cumae, c. 750	pre-Homeric bards Alphabet in Greece: c. 850–750 Homer: c. 750–700 early epic cycle Hesiod: c. 725	unroofed altar precincts simple houses, huts
7 cent.	growth of City-States era of 'tyrants' colonization abroad Draco's laws: 621	Archilochus Alcman Callinus Tyrtaeus	primitive temples of wood, mud-brick, tile
600–550	Solon's reform: 593 Pisistratus: 560–527 Phalaris rules Acragas Croesus king of Lydia	Alcaeus, Sappho Stesichorus, Anacreon Theognis Thales, Pythagoras	early temples in stone: Hera at Olympia Apollo at Syracuse Artemis at Ephesus (old)
550–520	Persian Empire grows Cyrus conquers Ionia Polycrates rules Samos Darius king of Persia: 521	Aesop Hipponax, Phocylides Xenophanes, Anaximander Thespis – first dramatist	Selinus: C, D Corinth: Apollo Pisistratid temple on Acropolis Paestum: 'Basilica' (Hera) Samos: Heraeum (largest, Ionic)
520–490	Harmodius and Aristogeiton assassinate Hipparchus: 514 Cleisthenes' reform: 507 Ionian Revolt vs. Persia: 499 Marathon: 490	Simonides Hecataeus: early history Epicharmus, Phrynichus Heraclitus	Acragas: Zeus Olympius Paestum: 'Ceres' (Athena) Delphi: Treasury of Athens
490–470	Persian Wars Thermopylae, Salamis: 480 Carthaginians and Etruscans vs. Greek Sicily Delian Confederacy: 478–	Pindar Aeschylus Bacchylides Cratinus	Aegina: Aphaia Athens: pre-Persian Parthenon Himera: Nike Syracuse: Athena

Sculpture	Vases	Painting	Other Arts
relief work on stone slabs (palaces, graves) Lion Gate at Mycenae (13 cent.)	'Middle Helladic' pottery (hand-made, coarse) Minyan Ware (grey, yellow· wheel-made) 'Late Helladic' (Mycenaean) pottery (glossy monochrome designs on buff clay; wheel-made)	frescoes in palaces (Mycenae, Pylos, Tiryns)	gold-inlay daggers gold cups (Vapheio) ivory carving carved crystal vessels gold face-masks amber, faience, jewelry intaglio gems
Geometric bronze statuettes primitive cult statues in wood (xoana) or stone	'Sub-Mycenaean' early 11 c. Protogeometric: later 11 c. through 10 c. Geometric: 9–8 c. Attic Dipylon early Proto-Corinthian & Orientalizing		Geometric gems early ivory statuettes
bronze griffins earliest Kouroi Prinias frieze Delos: Naxian lions Auxerre lady Samos wood statue Cleobis & Biton	Orientalizing styles Proto-Attic Proto-Corinthian early Corinthian Rhodian, East-Greek early Attic blackfigure	Ionian panels Corinthian monumental polychrome terracotta metopes at Thermon	ivory and wood inlay (Cypselus' cask) terracotta figurines Rhodian gold plaques
Corfu pediment 'Hecatompedon' Triton Rampin archaic knight Calf-Bearer small wood statues	Laconian middle & late Corinthian François vase Fikellura Clazomenian	Clazomenian sarcophagi Philocles of Naucratis Cleanthes of Corinth Telephanes of Sicyon Corinth terracotta plaques	archaic gems early coins ivory reliefs (Samos) archaic jewelry
Selinus C metopes Siphnian Treasury, Delphi Acropolis maidens bronze crater, Vix pre-Parthenon pediment	Lydus Amasis painter Execias Chalcidian Andocides painter early red-figure	early Etruscan Frescoes (Greek influence) polychrome wood plaques from Sicyon, Corinth Clazomenae sarcophagi	sand-core glass ivory small figures
later Acropolis maidens Aristion stele Strangford kouros 'Harpy Tomb' dog and marten fight Sele metopes	Nicosthenes painter Euphronius Phintias Euthymides Berlin painter	Gordion murals Cimon of Cleonae – faces at ¾ angle, drapery refinements	Epimenes: gems blue-glaze glass
Critius' Harmodius and Aristogeiton Critius' kouros Delphi Charioteer bronze horse (in N.Y.)	Brygus painter Macron Douris Foundry painter Pan painter	Agatharchus – scenery for Aeschylus, perspective Micon – battles in Theseum, Stoa Poikile best Etruscan frescoes (imitate Greek)	Demareteion silver coin, Syracuse

Chart of Comparative Chronology in the Developmen

Dates, B.C.	History	Literature	Architecture
470–450	Ephialtes' reform: 462 Athens at war with Peloponnesians: 459–446 Athenian disaster in Egypt: 454	Sophocles Euripides Parmenides, Zeno (Elea) Herodotus Gorgias, Protagoras	Olympia: Zeus Paestum: 'Poseidon' (Hera) Selinus: Hera
450–430	*Periclean Age* Peloponnesian War: 431– plague at Athens: 430	Eupolis Thucydides Antiphon Hippias	Bassae: Apollo Athens: Hephesteum Athens: Parthenon Athens: Propylaea Sounium: Poseidon
430–400	Sicilian Expedition: 415–413 Revolt of Athens' allies Arginusae naval battle: 406 Athens surrenders: 404 Thirty Tyrants rule Athens	Aristophanes Lysias Democritus Hippocrates Socrates	Rhamnous: Nemesis Acragas: Concord Athens: Athena Nike (Ionic) Delos: Apollo Segesta Athens: Erechtheum (Ionic)
400–323	Spartan supremacy in Greece: 404–371 Sparta wars vs. Persia Corinthian War: 395–386 Theban supremacy: 371–338 Philip of Macedon wins control of Greece Alexander Great rules: 336–323	Plato Aristotle Theophrastus Philemon Isocrates Demosthenes Aeschines Xenophon Theopompus	Delphi: Apollo (new), Tholos Mausoleum at Halicarnassus Ephesus: Artemis (new) Theater at Epidaurus Sardis: Artemis/Cybele Nemea: Zeus Priene: Athena Polias Lysicrates' Monument Stratos: Zeus
323–146	*Hellenistic Age* Seleucid, Antigonid, Ptolemaic kingdoms Carthage attacks Sicily Rise of Rome's power; Punic Wars: 264–146 Greek influence on Roman culture grows Mummius conquers Greece: 146	Menander Diphilus Callimachus Apollonius Rhodius Theocritus Euclid Polybius earliest Roman literature Eratosthenes Archimedes	Didyma: Apollo Magnesia: Artemis Leucophryene Athens: Olympieum construction renewed by Cossutius Pergamum: Great Altar: c. 18c Stoa of Attalus (Athens) houses on Delos
146– A.D. 330	*Roman Age* Greece and Asia Minor parts of Roman Empire Roman Republic ends at Philippi, Actium (42, 31 BC) Augustus rules: 27–AD 14 Imperial era Constantinople founded 324–330 A.D	Moschus Alexandrian scholars Bion, Meleager Strabo, Ptolemy Plutarch Dionysius of Halicarnassus Philo, Josephus Pausanias Lucian novelists Plotinus Longinus	Athens: Olympieum finished b Hadrian 132 AD Eleusis: Propylaea of sanctuary Corinthian style dominant Roman adaptation of Greek orders

Sculpture	Vases	Painting	Other Arts
'Ludovisi Throne' Selinus E metopes bronze Zeus/Poseidon Calamis' Sosandra Myron: Discobolus Olympia pediments	Penthesilea painter Niobid painter Sotades Villa Giulia painter Chicago painter	Polygnotus – character expression, idealism, nobility	terracotta plaques from Locri, Melos Naxos coins Aetna coins
Phidias: Athena Lemnia, Zeus Polyclitus: Doryphorus Parthenon sculptures Cresilas: Amazon Portrait of Pericles	Polygnotus Achilles painter Codrus painter Cabiric caricatures	development of foreshortening and color tones Agatharchus, decorated Alcibiades' home	gold jewelry
Paeonius: Nike Alcamenes: Hermes bust Agoracritus: Nemesis Nike temple balustrade Nereid Monument Hegeso stele	Cleophon painter Aeson Midias painter	Apollodorus – chiaroscuro shading, mixed colors, realism Zeuxis – light and shade, humanism, pathos Eupompus	Dexamenus: gems fine coins by Euaenetus, Cimon Sicyon mosaics
Sidon Sarcophagi Cephisodotus: Eirene Demeter of Cnidus Praxiteles: Hermes, Aphrodite Scopas: Mausoleum frieze Timotheus: Epidaurus ped. Leochares: Ganymede Portraits Sophocles, Euripides Lysippus: Agias, Alexander	ornate red-figure style Kerch style Italic styles Asteas	Parrhasius – subtle lines, facial character Apelles – charm, technical skill, portraits Protogenes – detail Pausias – encaustic Nicias – 3 dimensional by light and shadow	gold Nike ear-ring Olynthus mosaics classic gold jewelry
Alexander sarcophagus Demosthenes portrait by Polyeuctus Boethus' Boy and Goose Dying Gaul Victory of Samothrace Pergamum altar frieze Venus de Milo Laocoon	West Slope style (painted) relief vases Megarian bowls Centuripe (painted in tempera)	painted stelae at Volo Aetion – interiors Philoxenus – Alexander at Issus	Pella mosaics Tanagra terracottas 'Farnese Plate' cameo portrait coins Sosus: mosaics on still-life themes
bronze 'Hellenistic Prince' 'Farnese Bull' Apotheosis of Homer relief Roman portraits by Greek artists bronze Boxer		Timomachus – Medea 'Aldobrandini Wedding' Odyssey landscapes Villa of Mysteries series Pompeii, Herculaneum, Stabiae, etc.: copies of Greek paintings Prima Porta garden Fayum portraits	'millefiori glass' Delos mosaics Myrina terracottas portrait gems Alexander at Issus mosaic Dioscorides mosaics mosaics at Pompeii, Rome Praeneste Portland vase Aspasius mosaic

BIBLIOGRAPHY *SOME NON-TECHNICAL BOOKS IN ENGLISH*

SOURCES

K. JEX-BLAKE and E. SELLERS, The Elder Pliny's Chapters on the History of Art (London, 1896; re-issue with updated bibliography and introduction by R.V. Schoder: Chicago, Ares, 1975)

H. STUART JONES, Select Passages from Ancient Writers Illustrative of the History of Greek Sculpture (London, 1895; re-issue, Chicago, Argonaut, 1966)

J. J. POLLITT, The Art of Greece: Sources and Documents (N.J., Prentice-Hall, 1965)

GENERAL ASPECTS

G. BECATTI, The Art of Ancient Greece and Rome (London, Thames & Hudson, 1968)

J. BOARDMAN, Greek Art (London, Thames & Hudson, 1964)

J. BOARDMAN, J. DORIG, W. FUCHS, The Art and Architecture of Ancient Greece (London, Thames & Hudson, 1967)

RHYS CARPENTER, The Aesthetic Basis of Greek Art (2nd edition, Indiana University Press, 1960)

—, Greek Art: A Study of the Formal Evolution of Style (Philadelphia, University of Pennsylvania, 1962)

F. CHAMOUX, Greek Art (New York Graphic Society, 1966)

J. CHARBONNEAUX, R. MARTIN, F. VILLARD, Archaic Greek Art; Classical Greek Art; Hellenistic Art (London, Thames & Hudson, 1971, 1973, 1974)

R. M. COOK, Greek Art (London, Weidenfeld & Nicholson, 1972)

ARTHUR FAIRBANKS, Greek Art: The Basis of European Art (New York, Longmans, 1933)

H. N. FOWLER and J. R. WHEELER, A Handbook of Greek Archaeology (New York, American Book Co., 1909)

E. A. GARDNER, The Art of Greece (London, Studio, 1925)

P. GARDNER, The Principles of Greek Art (London, Macmillan, 1914)

E. HOMANN-WEDEKING, Archaic Greece (London, Methuen, 1966)

S. MARINATOS and M. HIRMER, Crete and Mycenae (Abrams, 1960)

FRIEDRICH MATZ, Crete and Early Greece (New York, Crown, 1962)

J. J. POLLITT, Art and Experience in Classical Greece (Cambridge University Press, 1972)

—, The Ancient View of Greek Art: Criticism, History, Terminology (Yale University Press, 1974)

G.M.A. RICHTER, A Handbook of Greek Art (London, Phaidon, 1959)

M. ROBERTSON, A History of Greek Art (Cambridge, 1975)

BENJAMIN ROWLAND, The Classical Tradition in Western Art (Harvard University Press, 1963)

K. SCHEFOLD, The Art of Classical Greece (London, Methuen, 1966)

W. H. SCHUCHHARDT, Greek Art (London, Weidenfeld & Nicholson, 1972)

B. SCHWEITZER, Greek Geometric Art (London, Phaidon, 1970)

C. SELTMAN, Approach to Greek Art (London, Studio, 1948; Dutton, 1960)

LUCIE SIMPSON, The Greek Spirit in Renaissance Art (New York, Philosophical Library, 1953)

F. B. TARBELL, A History of Greek Art (New York, Macmillan, 1930)

A.A.M. VAN DER HEYDEN and H. H. SCULLARD, Atlas of the Classical World (Nelson, 1959)

H. B. WALTERS, The Art of the Greeks (London, Methuen, 1934)

T.B.L. WEBSTER, Art and Literature in Fourth Century Athens (University of London Press, 1956)

—, From Mycenae to Homer (London, Methuen, 1958) chapters 2 and 7, on Mycenaean and Geometric art.

—, Greek Art and Literature, 700-530 B.C. (London, Methuen, 1959)

—, Greek Art and Literature, 530-400 B.C. (Oxford University Press, 1939)

—, The Art of Greece: The Age of Hellenism (London, Methuen, 1967)

MAX WEGNER, Greek Masterpieces of Art (New York, Braziller, 1960)

ARCHITECTURE

B. ALLSOPP, A History of Classical Architecture (London, Pitman, 1965)

ELIZABETH AYRTON, The Doric Temple (London, Thames & Hudson, 1961)

E. BELL, Hellenistic Architecture: Its Genesis and Growth (London, Bell, 1920)

H. BERVE, G. GRUBEN, M. HIRMER, Greek Temples, Theaters, and Shrines (London, Thames & Hudson, 1963)

M. BIEBER, A History of the Greek and Roman Theater (Princeton University Press, 1961)

A. BURFORD, The Greek Temple Builders at Epidauros (University of Toronto Press, 1969)

W. B. DINSMOOR, The Architecture of Ancient Greece (London, Batsford, 1950)

T. FYFE, Hellenistic Architecture (Cambridge University Press, 1936)

I. H. GRINNELL, Greek Temples, (New York, Metropolitan Museum, 1943)

A. W. LAWRENCE, Greek Architecture (London, Penguin, 1957)

R. D. MARTIENSSEN, The Idea of Space in Greek Architecture (University of Johannesburg, 1956)

E. MELAS, Temples and Sanctuaries of Greece (London, Thames & Hudson, 1970)

M. H. MORGAN, Vitruvius: The Ten Books on Architecture (Harvard University Press, 1914; New York, Dover, 1960)

H. PLOMMER, Ancient and Classical Architecture (London, Longmans, 1956)

D. S. ROBERTSON, A Handbook of Greek and Roman Architecture (Cambridge University Press, 1945)

R. L. SCRANTON, Greek Architecture (New York, Braziller, 1962)

VINCENT SCULLY, The Earth, the Temple, and the Gods: Greek Sacred Architecture (Yale University Press, 1961)

G. P. STEVENS, Restorations of Classical Buildings (American School of Classical Studies in Athens, 1958)

R. E. WYCHERLEY, How the Greeks Built Cities (London, Macmillan, 1949)

GEMS AND JEWELRY

C. ALEXANDER, The Art of the Goldsmith in Classical Times (New York, Metropolitan Museum, 1928)

—, Greek and Etruscan Jewelry (New York, Metropolitan Museum, 1940)

J. D. BEAZLEY, The Lewes House Collection of Ancient Gems (Oxford University Press, 1920)

J. BOARDMAN, Island Gems (London, Society for Promotion of Hellenic Studies, 1963)

—, Greek Gems and Finger Rings: Early Bronze Age to Late Classical (London, Thames & Hudson, 1971)

—, Archaic Greek Gems (London, Thames & Hudson, 1968)

—, Engraved Gems: The Ionides Collection (London, Thames & Hudson, 1968)

C. CARDUCCI, Gold and Silver Treasures of Ancient Italy (Greenwich, New York Graphic Society, 1964)

F. COARELLI, Greek and Roman Jewellery (Middlesex, Hamlyn, 1970)

P. CONNELL, Greek Ornament (London, Batsford, 1968)

R. A. HIGGINS, Greek and Roman Jewelry (London, Methuen, 1961)

H. HOFFMANN and P. DAVIDSON, Greek Gold: Jewelry From the Age of Alexander (Boston, Museum of Fine Arts, 1965)

K.R.M. HYSLOP, Western Asiatic Jewellery, Ca. 3000 to 617 B.C. (London, Methuen, 1971)

F. H. MARSHALL, Catalogue of the Finger Rings, Greek, Roman and Etruscan in the Dep't of Antiquities, British Museum (Oxford, British Museum, 1907, reprint 1968)

—, Catalogue of the Jewellry, Greek, Roman and Etruscan in the Dep't of Antiquities, British Museum (Oxford, British Museum, 1911, reprint 1969)

D. OSBORNE, Engraved Gems: Ancient and Modern (New York, Holt, 1912)

G.M.A. RICHTER, Ancient Gems from the Evans and Beatty Collections (New York, Metropolitan Musuem, 1952)

—, Engraved Gems of the Greeks and Etruscans (London, Phaidon, 1968)

—, Catalog of Engraved Gems in the Metropolitan Museum (Rome, Bretschneider, 1956)

. SEGALL, Museum Benaki, Katalog der Goldschmuckarbeiten Athens, Benaki Museum, 1938)

. B. WALTERS, Catalog of Engraved Gems and Cameos in the British Museum (London, British Museum, 1926)

FURNITURE

. S. BAKER, Furniture in the Ancient World (New York, Macmillan, 1966)

.M.A. RICHTER, The Furniture of the Greeks, Etruscans, and Romans (London, Phaidon, 1966)

. H. ROBSJOHN-GIBBINGS and C. W. PULLIN, Furniture of Classical Greece (New York, Knopf, 1963)

. SAVAGE, Glass (New York, Putnam, 1965)

COINS

. DAVIS, Greek Coins and Cities (London, Spink, 1967)

. DAVIS and C. KRAAY, The Hellenistic Kingdoms: Portrait Coins and History (London, Thames & Hudson, 1973)

. L. DONALDSON, Architectura Numismatica: Ancient Architecture on Greek and Roman Coins and Medals (London, 1859; re-issued Chicago, Argonaut, 1965)

. GARDNER, History of Ancient Coinage (Oxford, 1918; Chicago, Ares, 1974 reprint)

. V. HEAD, A Guide to the Principal Coins of the Greeks (London, British Museum, 1959)

—, Historia Numorum: A Manual of Greek Numismatics (London, 1911)

. F. HILL, Historical Greek Coins (London, British Museum, 1906)

—, Select Greek Coins (Paris, 1927; Chicago, Ares, 1974 reprint)

. IMHOOF-BLUMER and P. GARDNER, Ancient Coins Illustrating Lost Masterpieces of Greek Art, new edition by Al. N. Oikonomides (Chicago, Argonaut, 1964)

. KRAAY and M. HIRMER, Greek Coins (London, Thames & Hudson, 1966)

. KRAAY, Greek Coins and History (London, Methuen, 1969)

. MACKAY, Greek and Roman Coins (London, Barker, 1971)

. G. MILNE, Greek and Roman Coins (London, Methuen, 1939)

. T. NEWELL, Royal Greek Portrait Coins (New York, Wayte Raymond, 1937)

. SELTMAN, Greek Coins (London, Methuen, 1955)

—, Athens, Its History and Coinage Before the Persian Invasian (Cambridge, 1924; Chicago, Ares, 1974 reprint)

—, Masterpieces of Greek Coinage (Oxford, Casirer, 1949)

.H.V. SUTHERLAND, Art in Coinage (London, Batsford, 1955)

TERRACOTTAS

. A. HIGGINS, Greek Terracottas. (London, Methuen, 1967)

.B.L. WEBSTER, Greek Terracottas (London, Penguin, 1950)

MOSAICS

. B. HETHERINGTON, Mosaics (London, Hamlyn, 1967)

. ROBERTSON, "Greek Mosaics," in Journal of Hellenic Studies, 1965, pp. 72-89.

VASES AND PAINTING

. E. ARIAS and M. HIRMER, A History of Greek Vase Painting (London, Thames & Hudson, 1962)

. BEAZLEY, Attic White Lekythoi (Oxford University Press, 1938)

—, The Development of Attic Black Figure (University of California Press, 1952)

. BOARDMAN, Athenian Black Figure Vases: A Handbook (London, Thames & Hudson, 1974)

. BUSCHOR, Greek Vase Painting (London, Chatto, 1922)

. N. COLDSTREAM, Greek Geometric Pottery (London, Methuen, 1968)

. M. COOK, Greek Painted Pottery (London, Methuen, 1960)

. R. DESBOROUGH, Protogeometric Pottery (Oxford University Press, 1952)

. DEVAMBEZ, Greek Painting (New York, Viking, 1962)

R. S. FOLSOM, A Handbook of Greek Pottery (New York Graphic Society, 1967)

M.A.B. HERFORD, A Handbook of Greek Vase Painting (Manchester University Press, 1919)

A. D. LACY, Greek Pottery in the Bronze Age (London, Methuen, 1967)

A. LANE, Greek Pottery (London, Faber & Faber, 1963)

A. P. LAURIE, Greek and Roman Methods of Painting (London, 1910)

A. MAIURI, Roman Painting (Geneva, Skira, 1953) for Pompeii, etc.

E. PFUHL, Masterpieces of Greek Drawing and Painting (London, Chatto, 1955)

E. POTTIER, Douris and the Painters of Greek Vases (New York, Dutton, 1909)

G.M.A. RICHTER, Attic Red Figured Vases (Yale University Press, 1946)

—, The Craft of Athenian Pottery (Yale University Press, 1923)

—, Greek Painting: The Development of Pictorial Representation from Archaic to Greco-Roman Times (New York, Metropolitan Museum, 1952)

—, Perspective in Greek and Roman Art (London, Phaidon, 1970)

M. ROBERTSON, Greek Painting (Geneva, Skira, 1959)

C. T. SELTMAN, Attic Vase Painting (Harvard University Press, 1933)

M. SWINDLER, Ancient Painting (Yale University Press, 1929)

I. WEIR, The Greek Painter's Art (New York, Ginn, 1905)

J. WHITE, Perspective in Ancient Drawing and Painting (London, Hellenic Society, 1956)

SCULPTURE

S. ADAM, The Technique of Greek Sculpture in the Archaic and Classical Periods (London, Thames & Hudson, 1966)

W. H. AGARD, The Greek Tradition in Sculpture (Oxford, Ohio, American Classical League, 1930)

B. ASHMOLE, The Classical Ideal in Greek Sculpture (University of Cincinnati, 1964)

J. BARRON, Greek Sculpture (London, Studio, 1965)

J. BEAZLEY and B. ASHMOLE, Greek Sculpture and Painting (Cambridge University Press, 1932)

M. BIEBER, The Sculpture of the Hellenistic Age (New York, Columbia University Press, 1961)

C. BLUEMEL, Greek Sculptors at Work (London, Phaidon, 1955)

J. D. BRECKENRIDGE, Likeness: A Conceptual History of Ancient Portraiture (Northwestern University Press, 1968)

B. R. BROWN, Anticlassicism in Greek Sculpture of the Fourth Century B.C. (New York University Press, 1972)

RHYS CARPENTER, Greek Sculpture (University of Chicago Press, 1960)

S. CASSON, The Technique of Early Greek Sculpture (Oxford University Press, 1933)

J. CHARBONNEAUX, Greek Bronzes (New York, Viking, 1962)

P. E. CORBETT, The Sculpture of the Parthenon (London, Penguin, 1959)

PIERRE DEVAMBEZ, Greek Sculpture (New York, Tudor, 1961)

A. FURTWAENGLER, Masterpieces of Greek Sculpture (London, Heinemann, 1895; reprint 1964, Chicago, Argonaut)

E. A. GARDNER, A Handbook of Greek Sculpture (London, Macmillan, 1929)

G. M. HANFMANN, Classical Sculpture (New York Graphic Society, 1967)

D. HAYNES, The Parthenon Frieze (London, Batchworth, 1959)

G. KARO, Greek Personality in Archaic Sculpture (Harvard University Press, 1948)

W. LAMB, Greek and Roman Bronzes (London, Methuen, 1929)

A. W. LAWRENCE, Greek and Roman Sculpture London, Cape, 1972)

—, Later Greek Sculpture (London, Cape, 1927)

R. LULLIES and M. HIRMER, Greek Sculpture (London, Thames & Hudson, 1957)

G.M.A. RICHTER, Archaic Greek Art (Oxford University Press, 1949)

—, Portraits of the Greeks, 3 vols. (New York Graphic Society, 1966)

—, The Sculpture and Sculptors of the Greeks (Yale University Press, 4th ed., 1970)

—Three Critical Periods in Greek Sculpture (Oxford University Press, 1951)

N. YALOURIS, Classical Greece: The Elgin Marbles (Greenwich, New York Graphic Society, 1960)

RESEARCH BIBLIOGRAPHY

Some Detailed Analyses
of Particular Objects Featured in this Book

1. **Inlaid Dagger:** G. Karo, *Die Schachtgräber von Mykenai* (München, 1933), pp. 137, 313; F. Matz, *Crete and Early Greece* (London, 1962), pp. 166-169.

2. **Vapheio Cups:** Matz (cp. #1), pp. 129-136; S. Marinatos, *Crete and Mycenae* (London, 1960), pp. 104, 169; Ellen Davis, in *American Journal of Archaeology* 74 (1970), p. 191.

3. **Spout Vase:** A.J.B. Wace, *Chamber Tombs at Mycenae* (Oxford, 1932), pp. 81-82 #31, Plate 4; Lacy, *Greek Pottery in the Bronze Age* (London, 1967), p. 183.

4. **Cup with Bull and Bird:** *Corpus Vasorum Antiquorum: British Museum* 1, Plate 10 #7 and description p. 8; A. Lane, *Greek Pottery*² (London, 1963), p. 22 and plate 2B; Lacy (cp. #3), p. 210.

5. **Geometric Pitcher:** A. Fairbanks, *Catalog of Greek and Etruscan Vases* (Boston, Museum of Fine Arts, 1925), #266; J. Coldstream, *Greek Geometric Pottery* (London, 1968), p. 71.

6. **Geometric Scyphus:** H. A. Thompson, in *Hesperia* 19 (1950), pp. 330-331 and plate 104b; E. T. Brann, *The Athenian Agora*, Vol. 8: *Late Geometric and Proto-Attic Pottery* (Princeton, 1962), p. 67 #319.

7. **Cycladic Oenochoe:** E. Buschor, *Griechische Vasenmalerei* (München, 1914), p. 71; Lane (cp. #4), pp. 26-28 and plate 15.

8. **Proto-Attic Amphora from Eleusis:** G. Mylonas, *Protoattikos Amphoreus tis Eleusinos* (Athenai, 1957), with English summary at end; Mylonas, *Eleusis* (Princeton, 1961), pp. 74-75; P. Arias, *History of Greek Vase Painting* (London, 1962), p. 274.

9. **Rhodian Oenochoe:** Fairbanks (cp. #5), #290; Lane (cp. #4), pp. 29-31 and plate 18.

10. **Corinthian Alabastrum:** S. Weinberg, in *Hesperia* 17 (1948), pp. 218-219 #D15; for style cp. R.M. Cook, *Greek Painted Pottery* (London, 1960), pp. 53-54.

11. **Laconian Hydria:** Lane (cp. #4), p. 36 and plate 29; Lane in *Annual of British School in Athens* 34 (1936), pp. 146, 187, and plates 43-44.

12. **Chalcidian Crater:** A. Rumpf, *Chalkidische Vasen* (Leipzig, 1927), pp. 13-14, #14 and pp. 122-125, and plate 33; G. Vallet, *Rhegion et Zancle* (Paris, 1958), pp. 211-215; P. Arias, (cp. #8), pp. 310-311; E. Langlotz, in *Griechische Vasen in Würzburg* (München, 1932), p. 22 #160.

13. **Tyrrhenian Amphora:** D. von Bothmer, *Amazons in Greek Art* (Oxford, 1957), p. 7-- he ascribes this example to the Timiades Painter; cp. his article on Tyrrhenian vase-painters in *American Journal of Archaeology* 48 (1944), pp. 161-170.

14. **Cylix by Execias:** W. Technau, *Exekias* (Liepzig, 1936, plates 6 and comments, p. 10; J.D. Beazley, *Development of Attic Black-Figure* (Univ. California, 1952), pp. 67-68; Arias (cp. #8), pp. 300-302.

15. **Amphora by Nicosthenes:** G. Pellegrini, *Catalogo dei Vasi Antichi Dipinti nel Museo Civico* (Bologna, 1900), pp. 28-? #197.

16. **Olive-Pickers Amphora:** J. D. Beazley, in *Journal of Hellenic Studies* 47 (1927), pp. 65-67, 70-72; Beazley, *Attic Black Figure Vase Painters* (Oxford, 1956), p. 273 #116; Beazley, *Development* (cp. #14), pp. 80-81.

17. **Amphora by Rycroft Painter:** M.H. Swindler, 'The Worcester Vase by the Rycroft Painter and its Boston Companion', *Worcester Art Museum Annual* 6 (1958), pp. 1-7; Beazley, *ABFVP* (cp. #16), p. 335 #5 bis.

18. **White-Ground Pitcher:** *Corpus Vasorum Antiquorum: Fogg Museum*, plate 21 #8, and p. 39.

19. **Rampin Knight:** H. Payne and G.M. Young, *Archaic Marble Sculpture from the Acropolis* (London, 1936), pp. 6-9 and plates 11, 133; K. Schefold, *Die Grossen Bildhauer des Archaischen Athen* (Basel, 1949), pp. 41-44; J. Charbonneaux, *La Sculpture Grecque Archaique* (Paris, 1938), p. 15; G.M.A. Richter, *Archaic Greek Art* (New York 1949), p. 65.

20. **Maiden from Chios:** H. Schrader, E. Langlotz, W.H. Schuchardt, *Die Archaischen Marmorbildwerke der Akropolis* (Frankfurt, 1939), pp. 91-93; R. Lullies, *Greek Sculpture* (London, 1960), pp. 66-67.

21. **Dancers from Sele:** P. Zancani Montuoro and U. Zanotti-Bianco, *Il Heraion Alle Foce del Sele* (Rome, 1951), Vol. 1, pp. 123-126; Richter (cp. #19), p. 188.

22. **Aristion Stele:** H. Schrader, 'Aristokles,' in *Die Antike* 18 (1942), pp. 95-101; Rhys Carpenter, *Greek Sculpture* (Chicago, 1960), pp. 63-65; G.M.A. Richter, *The Archaic Gravestones of Attica* (London, 1961), p. 47.

23. **Maiden from Cyrene:** E. Paribeni, *Catalogo delle Sculture di Cirene: Statue e Rilievi di Carattere Religioso* (Rome, 1959), #9; E. Pfuhl, in *Archäologische Mitteilungen* 48 (1923), pp. 137-147.

24. **Harpy Tomb:** F.J. Tritsch, in *Journal of Hellenic Studies* 62 (1942), pp. 39-50; O.S. Tonks, in *American Journal of Archaeology* 11 (1907), pp. 321-338; Richter (cp. #19), pp. 176-177; Charles Picard, *Manuel d'Archéologie Grecque: La Sculpture* (Paris, 1935), Vol. 1, pp. 552-555.

25. **Aegina Hercules:** A. Furtwaengler, *Aegina* (Munich, 1906), pp. 250-252; H. Lechat, *Sculptures Grecques Antiques* (Paris, 1925), p. 36.

26. **Vix Crater:** R. Joffroy, *Le Trésor de Vix* (Paris, 1955); J. Charbonneaux, *Les Bronzes Grecques* (Paris, 1958), pp. 41-45.

27-28. **Charioteer of Delphi:** F. Chamoux, *L'Aurige* (Paris, 1955)— Vol. 14 #5 of *Fouilles de Delphes excavation report;* Picard (cp. #24) vol. 2. pp. 133-140; Rhys Carpenter, *Greek Art* (Philadelphia, 1962), pp. 146, 149.

29. **Poseidon/Zeus:** G.E. Mylonas, 'The Bronze Statue from Artemision', in *American Journal of Archaeology* 48 (1944), pp. 143-160; H.G. Beyen, *La Statue d'Artemision* (Leiden, 1938); Carpenter (cp. #22), pp. 165-166; Picard (cp. #24), vol. 2, pp. 62-66.

30. **Apollo from Piombino:** E. Buschor, *Frühgriechische Jünglinge* (Munich, 1950), pp. 154-157; Picard (cp. #24), vol. 1, pp. 489-490; G.M.A. Richter, *Kouroi²* (London, 1960), pp. 144-145.

31. **Berlin Painter:** J.D. Beazley in *Journal of Hellenic Studies* 31 (1911), p. 283 and plate 14; Beazley, *Attic Red-Figure Vase Painters²*, p. 206 #132 and p. 1633; Beazley, *Der Berliner Maler* (Berlin, 1930), plates 29-31 and commentary pp. 13-14.

32. **Crater of Theseus and Aethra:** Beazley, *ARFVP* (cp. #31), p. 633 #6 and p. 1663; G.M.A. Richter, *Attic Red-Figured Vases²* (Yale, 1958), p. 106; Pellegrini (cp. #15), p. 46 #285.

33. **Douris Cylix:** Beazley, *ARFVP* (cp. #31), p. 437 #114 and p. 1653; Richter in *Bulletin of Metropolitan Museum of Art*, Nov. 1952, pp. 100-101; Richter (cp. #32), pp. 83-84.

34. **Chicago Painter Stamnus:** Beazley, *ARFVP* (cp. #31), p. 629 #8 and p. 1662; L.D. Caskey and J.D. Beazley, *Attic Vase Paintings in the Museum of Fine Arts, Boston* (London, 1931), vol. 1, plate 16 and commentary.

35. **Alabastrum by Pasiades:** Beazley, *ARFVP* (cp. #31), p. 98 #1 and p. 1626; R. Pfuhl, *Masterpieces of Greek Drawing and Painting* (London, 1955), pp. 36-37; Lane (cp. #4), p. 53 and plate 89c.

36. **White-Ground Pyxis:** G.M.A. Richter and L.F. Hall, *Red-Figured Athenian Vases in the Metropolitan Museum of Art* (Yale, 1936), vol. 2, plate 77, and commentary in vol. 1, pp. 101-102; Beazley, *ARFVP* (cp. #31), p. 890 #173 and p. 1673; Richter (cp. #32), p. 98.

37. **Rhyton by Sotades:** Beazley, *ARFVP* (cp. #31), p. 772 bottom, and p. 1669; Bothmer (cp. #13), p. 222 #81, and plate 90; D. Dunham, *The Egyptian Dept. and its Excavations* (Boston, 1958), p. 126; *Bulletin of Boston Museum of Fine Arts* 21 (1923), pp. 11, 25; *Boston Museum of Fine Arts: Guide to the Greek, Etruscan, Roman Art²* (Boston, 1963), pp. 93-94.

38. **Bronze Oenochoe:** D.M. Robinson, 'New Greek Bronze Vases', in *American Journal of Archaeology* 46 (1942), pp. 185-186.

39. **Discus-Thrower:** Carpenter (cp. #22), pp. 82-85, 105-106; G.M.A. Richter, *The Sculpture and Sculptures of the Greeks³* (Yale, 1950), pp. 207-210; B. Schroeder, *Zum Diskobol des Myron* (Strassburg, 1913); Picard (cp. #24), vol. 2, pp. 225-232.

40. **Olympia Pediment:** Carpenter (cp. #22), pp. 117-121, 128-132; Picard (cp. #24), vol. 2, pp. 203-207; E. Kunze and U. Jantzen, *Zu den Skulpturen des Zeustempels: Olympia Bericht IV* (Berlin, 1944), pp. 143-150; G. Becatti, *Il Maestro d'Olimpia* (Firenze, 1943), passim.

41. **Athena Lemnia:** A. Furtwaengler, *Masterpieces of Greek Sculpture* (London, 1895), pp. 4-25; Richter (cp. #39), pp. 227-228; Picard (cp. #24), vol. 2, pp. 330-334; Lechat (cp. #25), pp. 84-86.

42. **Parthenon Heifer:** A. H. Smith, *The Sculptures of the Parthenon* (London, 1910), pp. 61-65; M. Collingnon, *Le Parthenon* (Paris, 1914), pp. 86-87.

43. **Parthenon Horse:** Smith (cp. #42), pp. 10-16; S.D. Markman, *The Horse in Greek Art* (Baltimore, 1943), pp. 78, 181-182; F. Chamoux in *Man Through His Art*, Vol. III (New York Graphic Society, 1965), pp. 25-26.

44. **Bronze Athlete's Head:** J. Charbonneaux, *Les Bronzes Grecs* (Paris, 1958), pp. 111-112; Picard (cp. #24), vol. 2, p. 702; G. Lippold, *Griechische Plastik* (Munich, 1950), p. 165.

45. **Paestum Temple:** W.B. Dinsmoor, *The Architecture of Ancient Greece³* (London, 1950), pp. 110-111; A.W. Lawrence, *Greek Architecture* (London, 1957), pp. 148-149; Dinsmoor, *The Greek Temples at Paestum* (Vol. 20, 1950, of *Memoirs of American Academy in Rome*).

46-47. **Erechtheum:** J.M. Paton and G.P. Stevens, *The Erechtheum* (Cambridge, Mass., 1927), pp. 232, 110-119; Dinsmoor (cp. #45), p. 193; I.T. Hill, *The Ancient City of Athens* (London, 1953), pp. 173-175; A.H. Smith, *Catalog of Greek Sculpture in the British Museum* (London, 1892), vol. 1 #407; Richter (cp. #39), p. 179.

48. **Tholos at Delphi:** J. Charbonneaux, 'La Tholos,' pp. 1-32 of *Fouilles de Delphes*, Vol. 2 part 2 (Paris, 1925); Dinsmoor (cp. #45), pp. 234-235; Lawrence (cp. #45), pp. 183-185.

49. **Gems by Dexamenus:** J.D. Beazley, *The Lewes House Collection of Ancient Gems* (London, 1920), #50, 67; D. Osborne, *Engraved Gems* (New York, 1912), pp. 59-60; A. Furtwaengler, *Antike Gemmen* (Leipzig, 1900), vol. 2, p. 45 #31 and p. 66 #3.

50. **Gold Crown, Necklace:** R. Bartoccini in *Japigia* 6 (1935), pp. 248-254; E. Coche de la Ferté, *Les Bijoux Antiques* (Paris, 1956), pp. 65, 67, plate 25; R.A. Higgins, *Greek and Roman Jewellery* (London, 1961), pp. 120-122, 127-128; C. Carducci, *Gold and Silver Treasures of Ancient Italy* (Greenwich, Conn., 1964), p. 42.

51. **Gold Ear-Rings:** B. Segall, in *Bulletin of Museum of Fine Arts, Boston*, 40 (1942), pp. 50-54; R. Jacobsthal, *Greek Pins* (Oxford, 1956), p. 70; *Boston MFA Guide* (cp. #37), p. 145; on the lion-griffin type cp. Higgins (cp. #50), p. 162.

52. **Gold Medallion:** D.M. Robinson, 'Unpublished Greek Gold Jewelry and Gems,' in *American Journal of Archaeology* 57 (1953), pp. 5-12; T.P. Hoopes, a detailed study of the medallion in *Bulletin of the City Art Museum, St. Louis,* 41 (1956), pp. 46-55; P. Amandry, *Collection Helene Stathatos: Les Bijoux Antiques* (Strasbourg, 1953), p. 105; for the type, cp. Coche de la Ferté (cp. #50), p. 69; for hair-net interpretation and parallels cp. H. Hoffmann and P. Davidson, 'Greek Gold: Jewelry from the Age of Alexander' (*Museum Exhibit Catalog*, 1966), p. 223, pp. 226-270 and figures 90 and 124.

53. **Ivory Athena:** P.C. Sestieri, 'Statuine Eburnee di Posidonia,' in *Bolletino d'Arte* 38 (1953), pp. 9-13, figures 1-7.

54. **Lycian Sarcophagus:** O. Hamdi Bey and Th. Reinach, *Une Necropole Royale à Sidon* (Paris, 1892), pp. 209-212; *Illustrated Guide to the Greek and Roman Collections of the Archaeological Museum of Istanbul* (Istanbul, 1956), pp. 22-25, 29.

55. **Ephesus Drum:** M. Bieber, *The Sculpture of the Hellenistic Age*[2] (New York, 1961), p. 28; Richter (cp. #39), p. 273; Picard (cp. #24), vol. 4, pp. 119-124; Lullies (cp. #20), p. 93.

56. **Funeral Monument of Pamphile:** Lippold (cp. #44), p. 245; Picard (cp. #24), vol. 4, p. 1321.

57. **Hermes by Praxiteles:** G.E. Rizzo, *Prassitele* (Milano, 1932), pp. 66-70, 116; a symposium of divergent views in *American Journal of Archaeology* 35 (1931), pp. 249-297, and 58 (1954), pp. 1-12; Bieber (cp. #55), pp. 16-17.

58. **Bronze Youth from Anticythera:** Bieber (cp. #55), p. 12; Lullies (cp. #20), pp. 92-93.

59. **'Hygieia':** C. Dugas, J. Berchmans, M. Clemmensen, *Le Sanctuaire d'Aléa Athéna à Tegée* (Paris, 1924), pp. 117-120 and plates 113-115; G. Mendel, in *Bulletin de Correspondance Hellénique* 25 (1901), pp. 260-261; Bieber (cp. #55), p. 24; Lullies (cp. #20), p. 88.

60. **Marathon Boy:** F. Studniczka, *Der Bronze-Knabe von Marathon* (Liepzig, 1927); Charbonneaux (cp. #44), p. 22; Lullies (cp. #20), p. 93.

61. **Silver Coins:** B.C. Head, *A Guide to the Principal Coins of the Greeks*[3] (London, 1959), p. 29 #54, and p. 30 #67; C. Seltman, *Greek Coins*[2] (London, 1955), pp. 102-104, 127; A. Gallatin, *Syracusan Dekadrachms of the Euainetos Type* (Harvard, 1930), pp. 12-13.

62. **Gold and Electrum Coins:** Head (cp. #61), p. 3 #19, and p. 38 #16; Seltman (cp. #61), pp. 30, 200-201.

63. **'Brutus' Portrait:** G.M.A. Richter, *Greek Portraits*, 1 (Bruxelles, 1955), pp. 43-44; Richter, *Ancient Italy* (Ann Arbor, 1955), pp. 32-33; B. Schweitzer, *Die Bildnis-Kunst der Römischen Republik* (Weimar, 1948), pp. 55-56; Bieber, (cp. #55), p. 169; G.M.A. Hanfmann, *Roman Art* (Greenwich, Conn., 1964), p. 88 #61.

64. **'Lysimachus' Portrait:** P. Arndt and G. Lippold, *Griechische und Römische Porträts* (München, 1891), pp. 91-92; H. Bloesch, *Antike Kunst in der Schweiz* (Zurich, 1943), #35; A.J.B. Wace in *Journal of Hellenic Studies* 25 (1905), p. 89; O. Brendel in *Die Antike* 4 (1928), pp. 314-324.

65. **Bronze Horses:** Markman (cp. #43), pp. 130-131; G.M.A. Richter, *Animals in Greek Art* (New York, 1930), p. 17.

66. **Victory from Samothrace:** H. Thiersch, 'Die Nike von Samothrake,' in *Nachrichten der Göttingen Gesellschaft* 1931, pp. 338-341; Bieber (cp. #55), pp. 125-126; Lullies (cp. #20), pp. 102-103; Carpenter (cp. #22), pp. 201-204.

67. **Dying Gaul:** A.W. Lawrence, *Later Greek Sculpture* (London, 1927), p. 20; Bieber (cp. #55), p. 102; Lippold (cp. #44), p. 342; Lechat (cp. #25), p. 196.

68. **Aphrodite from Melos:** J. Charbonneaux, *Le Vénus de Milo* (Bremen, 1959); Furtwaengler (cp. #41), pp. 367-401; Bieber (cp. #55), pp. 159-160; Carpenter (cp. #22), pp. 211-212; Lullies (cp. #20), p. 105; E. Suhr, *Venus de Milo: The Spinner* (New York, 1958).

69. **Bronze Actor:** M. Bieber, 'A Bronze Statuette of a Comic Actor,' in *Record of the Art Museum, Princeton University,* 9 (1950), pp. 5-12; F.F. Jones, in *Archaeology* 7 (1954), p. 237.

70. **Dancing Faun:** A. Mau, *Pompeii in Life and Art* (London, 1904), p. 442; H. Bulle, *Der schöne Mensch im Altertum* (München, 1912), p. 194; Bieber (cp. #55), p. 39.

71. **Bronze Old Man:** L. Laurenzi, *Ritratti Greci* (Firenze, 1941), p. 138; K. Schefold, *Die Bildnisse der Antiken Dichter, Redner, und Denker* (Basel, 1943), pp. 134-138, 212; Richter, *Greek Portraits* (cp. #63), vol. 1, pp. 31-32; Bieber (cp. #55), p. 143.

72. **Bronze Boxer:** P.L. Williams, in *American Journal of Archaeology* 49 (1945), pp. 330-347; Bieber (cp. #55), p. 180; Lullies (cp. #20), pp. 106-107.

73. **Horse Head:** Charles Picard, 'Dioscure à la Protomé Chevaline,' in *Bulletin de Correspondance Hellénique* 82 (1958), 435-465.

Dolphins Mosaic: M. Bulard, *Peintures Murales et Mosaïques de Délos* (Paris, 1908), p. 197 and plate 13; J. Chamonard, *Exploration Archéologique de Délos: Le Quartier du Théatre* (Paris, 1922), p. 139.

Dionysus on Panther Mosaic: J. Chamonard, *Exploration Archéologique de Délos: Les Mosaiques de la Maison des Masques* (Paris, 1933), pp. 11-26.

Mendicant Musicians Mosaic: H. Bulle in *Abhandlungen der Bayerischen Akademie der Wissenschaften, Philosophische Klasse,* 33 (1928), pp. 282-283; M. Bieber and G. Rodenwaldt, in *Jahrbuch des Deutschen Archaeologischen Instituts* 26 (1911), pp. 1-22; M.H. Swindler, *Ancient Painting* (Yale, 1929), pp. 276, 315; Pfuhl (cp. #35), pp. 129-131; A. Maiuri, *Roman Painting* (Geneva, 1953), pp. 94-97.

Alexander Mosaic: F. Winter, *Das Alexandermosaik aus Pompeii* (Strassburg, 1909); Pfuhl (cp. #35), pp. 7-8, 92-99; A. Fuhrmann, *Philoxenos von Eretria* (Gottingen, 1931), passim; Maiuri (cp. #76), pp. 69-70; Swindler (cp. #76), pp. 280-283; M. Bieber, 'The Portraits of Alexander,' in *Proceedings of American Philosophical Society* 93 (1949), p. 387.

Mosaic Portrait: P. Gusman, 'Les Portraits à Pompeii,' in *Revue de l'Art Ancien et Moderne* 10 (1897), pp. 343-350; E. Pernice, *Die Hellenistische Kunst in Pompeji: Band VI, Pavimente und Figurliche Mosaiken* (Berlin, 1938), pp. 178-179; Maiuri (cp. #76), p. 99.

Nereids Mosaic: F. de Pachtère, *Inventaire des Mosaïques de la Gaule et de l'Afrique, Vol. 3: Algérie* (Paris, 1911), #190; A. Blanchet, *La Mosaïque* (Paris, 1928), p. 56; J.M.C. Toynbee, *Some Notes on Artists in the Roman World* (Bruxelles, 1951), p. 45.

Glass Types: F. Schuler, 'Ancient Glass-Making Techniques,' in *Archaeology* 12 (1959), pp. 47-52, 116-122; and 15 (1962), pp. 32-37; F. Neuburg, *Ancient Glass* (London, 1962), pp. 26-27, 72-84.

'Millefiori' Glass: A. Kisa, *Das Glas im Altertum* (Leipzig, 1908), p. 518; Neuburg (cp. #80), pp. 21-22, 32, 76.

'Farnese Plate': Fürtwaengler (cp. #49), 2, pp. 253-256; I. Noshy, *The Arts in Ptolemaic Egypt* (London, 1937), p. 132; Bieber (cp. #55), p. 101: G. Lippold, *Gemmen und Kameen des Altertums* (Stuttgart, n.d.), p. 182 #XCIX.

Portland Vase: E. Simon, *Die Portlandvase* (Mainz, 1957); Neuburg (cp. #80), p. 80; W. Mankowicz, *The Portland Vase and the Wedgwood Copies* (London, 1952); Kisa (cp. #81), vol. 2, p. 582; D. Haynes, *The Portland Vase* (London, 1964); B.L. Brown, in *American Journal of Archaeology* 74 (1970), p. 189.

Terracotta Figurines: V. Poulsen, *Catalogue des Terres Cuites Grecques et Romaines* (Copenhagen, 1949), p. 28 #47; the Cambridge example has no separate publication.

85. **Terracotta Portrait:** G.H. Chase, *Greek and Roman Sculpture in American Collections* (Harvard, 1924), p. 173; *Boston Guide* (cp. #37), p. 218; on interpretation of Pliny's remarks on molds from the life see Carpenter (cp. #22), pp. 232-236; Roger Hinks, in *Man Through His Art,* Vol. VI (New York Graphic Society, 1968), pp. 23-25.

86. **Centuripe Vase:** G. Libertini, *Centuripe* (Catania, 1926), pp. 145-186 on the style and examples; also Richter in *Metropolitan Museum Studies* 2 (1930), pp. 187-205, and 4 (1932), pp. 45-54; Cook (cp. #10), p. 211; M. Robertson, *Greek Painting* (Geneva, 1959), pp. 172-175.

87. **Medea Painting:** A. Rumpf, *Malerei und Zeichnung* (München, 1953), pp. 167-168; Pfuhl (cp. #35), p. 116; M. Borda, *La Pittura Romana* (Milano, 1958), pp. 160-162; Swindler (cp. #76), pp. 311-312.

88. **Wall Paintings:** Swindler (cp. #76), p. 333; Borda (cp. #87), pp. 46-51; Maiuri (cp. #76), pp. 28-30; S. Aurigemma, *Guide to Museo Nazionale Romano*[3] (Rome, 1955), #359, 364.

89. **Mural from Primaporta:** Borda (cp. #87), pp. 67-68; Swindler (cp. #76), p. 341; Aurigemma (cp. #88), #358.

90. **Painting on Marble:** Robertson (cp. #86), p. 161; Borda (cp. #87), pp. 189-190; Maiuri (cp. #76), p. 105; O. Elia, *Pitture Murali e Mosaici nel Museo Nazionale di Napoli* (Rome, 1932), p. 41.

91. **Villa of Mysteries Mural:** P.B.M. Cooke, 'The Paintings of the Villa Item at Pompeii,' in *Journal of Roman Studies* 3 (1913), pp. 157-174; Swindler (cp. #76), pp. 330-332; Maiuri (cp. #76), pp. 50-63; Borda (cp. #87), pp. 191-194; Pfuhl (cp. #35), pp. 119-121; Hanfmann (cp. #63), comments on Plates XL and XVI.

92-93. **Fayum Portraits:** on the method see O. Rossbach, 'Enkaustik,' in *Pauly-Wissowa* RE, vol. 5, cols. 2570-2578; and D. von Bothmer in *Bulletin of Metropolitan Museum* 9 (1951), pp. 156-161; Pfuhl (cp. #35), pp. 123-127; Swindler (cp. #76), pp. 312-324; Hilde Zaloscher, in *Man Through His Art,* VI (cp. #85), pp. 26-28.

94. **Pompey Portrait:** F. Poulsen, 'Les Portraits de Pompeius Magnus,' in *Revue Archéologique* 7 (1936), pp. 16-25; W. Helbig, in *Römische Mitteilungen* 1 (1886), p. 37; R. West, *Römische Porträtplastik* (München, 1933), vol. I, p. 67; V. Poulsen, *Les Portraits Romains* (Copenhagen, 1962), vol. I, pp. 39-41.

95. **Portrait of Girl:** L. Polacco, *Sculture Greche e Romane de Cirene* (Padova, 1959), pp. 318-319; E. Strong, *Roman Sculpture* (London, 1907), plate 118; Aurigemma (cp. #88), #332.

96. **Smiling Faun:** T.L. Shear, in *Hesperia* 9 (1933), pp. 536-541.

LIST OF
COLOR PLATES
AND RELEVANT
DATA

All dates are B.C. *unless otherwise noted; most are approximate only*

Masterpieces of Greek Art

INLAID DAGGER FROM MYCENAE
(Details of both sides)

16th century B.C.
Athens,
National Museum

The excavations of Schliemann and Stamatakis at Mycenae in 1876-79, shortly after the epochal discovery of Troy, were world-wide sensations of the day and have remained landmarks of modern archaeology. A major reason for the interest and lasting importance of these excavations is the splendid art which they brought to light. Many notable objects were found which not only are of high merit in themselves, but have brought new understanding of early Greek culture.

Several daggers found in the Shaft Graves within the citadel walls of Mycenae, and dating to the end of the 16th century B.C., are outstanding on both scores. The bronze blades have superbly skillful inlay work of gold and electrum, in scenes of great vigor and excitement. Composition is vivid and imaginative, the action highly dramatic. With a sure touch and strong clear style, the ancient metalworker has captured moments of quick motion at their most dynamic stage, so that the tension implicit in the scenes still pulses and gives the illusion of continuing action, of life observed. The lions are wonderfully life-like, with lithe powerful bodies and fierce spirit. This is the more remarkable because lions did not exist in Crete or Greece at the time. The artist must be drawing on other representations, or on observation in Syria or Asia Minor. The men are taut with fear and courage, the fleeing gazelles a marvel of nervous fright and swift graceful motion as they bound off in terror.

In both scenes, death mingles with vibrant life to give added drama and emotional impact. Though starkly real, death is not gruesome here, and its mystery is dominant. These are not mere pictures of actual events; they are sharp studies in beauty of form and the significance of life's struggle. The surging emotions of all participants are vividly clear, and their mutual contrast in the struggle intensifies their magnetism on the beholder. That such masterpieces of reflected life should be buried with dead kings is further fascination.

The art of these inlaid daggers has much in common with Homeric epic in its directness, lucidity, brilliantly observed detail, vibrant life. The later poet knew of such craftsmanship from the heroic age he sought to re-create, and his description of the shield of Achilles with its many scenes from life in inlaid silver, gold, and tin should be read for comparison and as a guide to the spirit of these decorated daggers (*Iliad* 18.468-608).

There is no real evidence for the common assertion that these inlaid blades are of Cretan inspiration and workmanship. Metal inlay work has never been found in excavations in Crete, and there is no indication that the Minoans had the highly developed technology needed for this process in colored gold and niello. The vigor, vehemence, and realism of the scenes reflect the robust interest in life and in the thrill of combat that is distinctive of Mycenaean Greeks. Very likely, we have here the work of an early Greek genius—a portent of his people's dynamism and their brilliant artistic future.

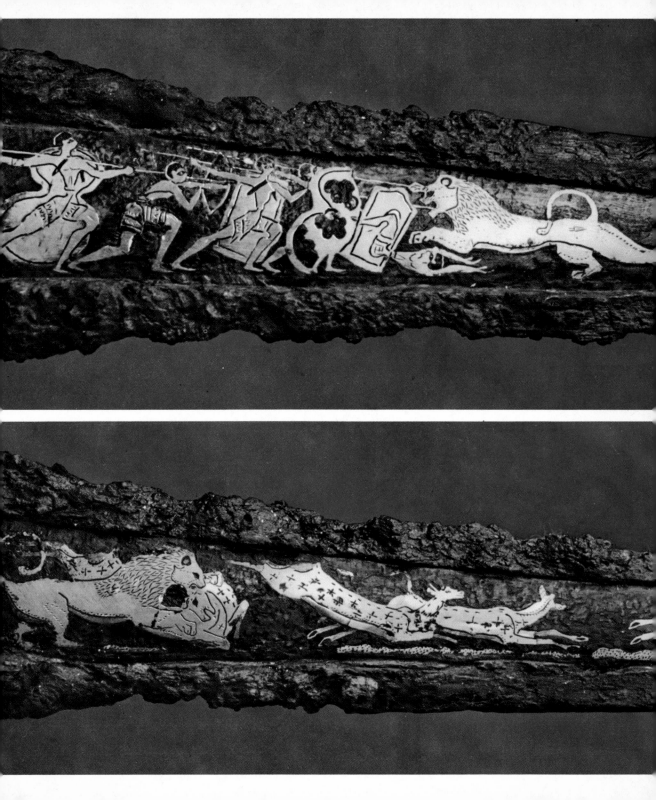

The Vapheio Cups rank among the most universally admired art objects that have come down from the ancient world. Found in 1889 in a Mycenaean tholos tomb near Sparta, they are striking examples of vitality and realism.

Differences in mood, conception, and technique give reason to ascribe these two cups to separate artists. The quiet scene (lower picture) has sharper details, finer surface working, and a flowing continuity reflecting traditions of Minoan Crete. The other is violent, dynamic, vividly organized, full of exciting action, echoing the fresh enthusiasm of the young Greek civilization then exuberantly adventuring throughout the Mediterranean world, and it is probably by a Mycenaean craftsman. In any case, it was a Greek prince who owned both cups and prized their magnificent expression of delight in nature and in man's conquest of forces far stronger than himself—an early proof of the Greeks' good sense in art.

Three and a half inches high, the cups are made of very pure gold. They are put together in two parts. An outer plate has been beaten onto a wooden mold into low relief, then details engraved on the surface. Inside is a smooth band making the container. The handle is fastened on with four rivets. The cups were no doubt used at banquets, not just as ornaments of the palace.

On one the theme is the capture of bulls. A powerful beast is shown thrashing wildly about in a net strung between trees. He is bellowing in rage and his contorted body dramatically emphasizes the mighty force which man's cunning has brought under control. The trees shake from his fury. To the right, another bull dashes off to freedom. At the left, a third is tossing one man and tumbling another—to stress the risks and daring involved for 'wily man who captures the race of savage beasts,' as Sophocles was later to say in admiration of man's courage (*Antigone* 332-352).

Contrasting with this vehement animation is the serenity of the other cup. There three quiet scenes show a bull grazing near a formalized tree (here illustrated), another standing next to a cow, a third being tied by the leg with a rope by a man standing behind. These seem to be aspects of successful domestication, though some would interpret the cup as showing the same bull alone, then next to the cow who serves as a decoy, and finally roped for his imprudence in falling into this 'tender trap'. In any case, man's cleverness has brought the animal's strength into his service.

The figures are formed with admirable realism. Small details are carefully worked in, and the three-dimensional effect is most natural, with a fine play of light and shadow. The stylized trees have a strikingly 'modern' quality.

Bulls played a large part in Cretan life, ritual, and sport. The artist has here presented them with fine sympathy and understanding. Some Mycenaean prince appreciated his superb skill, and bought these cups.

GOLD
CUPS
FROM
VAPHEIO

15th century B.C.
Athens,
National Museum

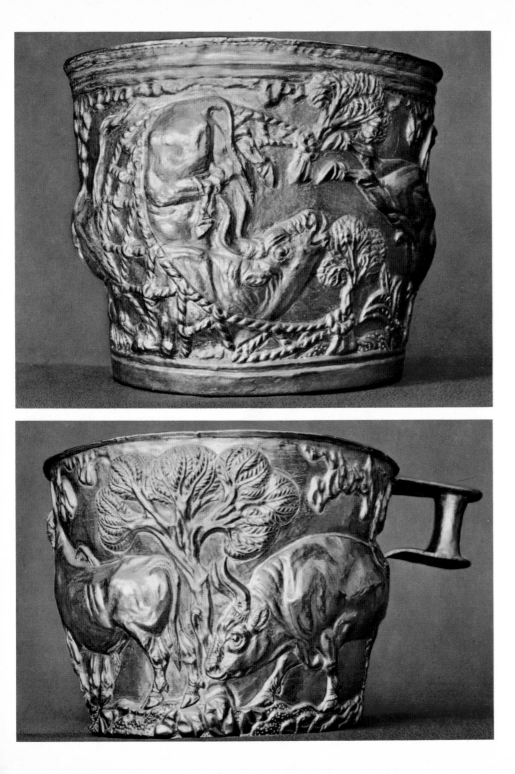

LATE HELLADIC SPOUT VASE

16/15 century B.C.
Nauplia,
Archaeological
Museum

In pre-Greek times in the Aegean area, pottery had reached a considerable level of development in technique and decoration. During the early centuries of the Achaean Greeks' presence in the region, art was under the dominating influence of Crete. There, in the Middle Minoan period (2200–1550 B.C.), an attractive type of vase had come into fashion which is known as Kamáres Ware. It was of thin-walled structure in interesting shapes, with a non-glossy black surface carrying imaginative designs in mat white and red. In the following centuries, termed Late Minoan in Crete and Late Helladic in Greece (1550–1100 B.C.), the style changed. Instead of polychrome decoration on a black ground, pottery now is usually painted in a single color—brown, black, or orange-red— of a glossy nature like later glaze, and on the natural background of buff clay. Traditional motifs were more persistent, but new themes also come into use. Many vases of this period have great merit and charm.

The spout vase here illustrated is a good example of early Greek practicality enhanced by tasteful decoration. The vase is for daily use, and for daily delight as well. The rows of dots function interestingly to give importance to the open spaces, and at the same time cleverly vary the circular theme emphasized by the solid bands above and below. On the neck the line of dots weaves up and down in rhythmic life, and the encircled spots modify the general pattern of the large designs below. These central designs are based on the Cretan labrys, a double-headed axe used in ceremonial ritual and symbolic decoration. But here they take on the quality of festoons, and even suggest a third level of meaning by their bird-like shape.

If it is too strong to call this design 'sophisticated' it at least shows remarkable sense of form and intellectual control of surface space.

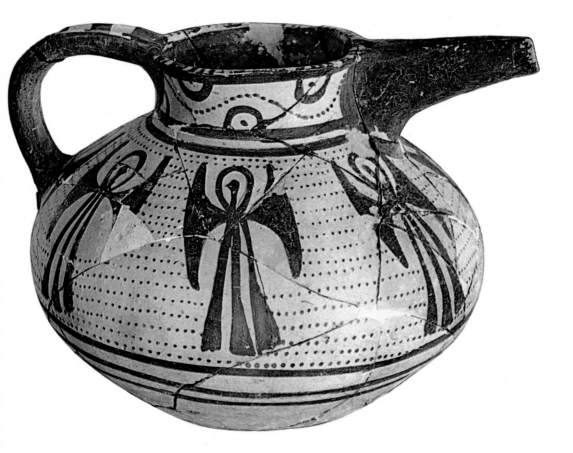

4

LATE HELLADIC CUP FROM ENKOMI, CYPRUS

14/13 century B.C.
London,
British Museum

A lively interest in animated nature and an untrammeled directness of drawing combine to give this cup from the Mycenaean age a special fascination. The shape of the vessel is neatly clean and simple and the decorative bands inside and out effectively serve to bring its surfaces into an intelligible pattern. Restraint and simplicity of detail and the lack of cluttering irrelevancies show that the artist has a firm vivid concept of his theme and a conviction that it is interesting in itself. The ancient owner must have prized this cup and showed it with eagerness to his guests, who would share with him the delighted interest in every aspect of real life which the Homeric poems ascribe to that era. Like Homer too, the artist concentrates on his vision with rapt clarity, while letting the creative glow of his imagination play over the scene freely. This explains the remarkable license in depicting the eyes, so fanciful anatomically yet artistically so effective. The bull's thin horns and scrawny legs are delightfully awkward, as is the bird's humorously inadequate tail. The bodies of both are boldly unreal, and their surface patterns sheer fancy. This is a creative work, not the well known real world but the artist's private new one. It is that which made it challenging, instructive, entertaining. And worth buying!

The scene is not uncommon in art of the period, though this portrayal of it is particularly intriguing. Bulls seem to have often had friendly birds who enjoyed a kind of private concession for hunting out their ticks and lice. As our sympathetic artist here represents the relationship, both partners are benefitted and well pleased. He shares their simple joy. And we may his.

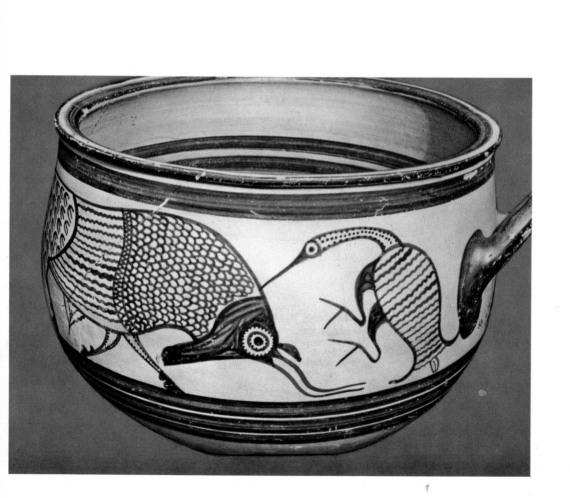

5

GEOMETRIC PITCHER

8th century B.C. (c. 730)
Boston,
Museum of
Fine Arts

After the collapse of the brilliant culture of the Mycenaean Age, under the impact of the Dorian Invasion and the changed ways of life in the Iron Age which then began, civilization in Greece and its islands underwent many vicissitudes. Times were hard and the struggle to survive absorbed most of the people's attention. Little art was produced, and that was mostly pottery—with the main purpose practicality rather than aesthetic interest. The style is 'geometric,' as in many primitive cultures throughout the world: the surface crowded with circles, ziz-zags, triangles, meanders, waves, dots, and sometimes birds or animals or thin-waisted, triangular-chested men. The shapes generally lack delicacy; they are primarily sturdy and utilitarian. Some vases, however, are much superior in quality, and prove that the Geometric style at its best can be very attractive.

An outstanding instance is the pitcher here illustrated. Its decoration is not over-crowded and reveals a developed sense of order and variety. The predominantly horizontal sweep of lines carries the eye in a series of motions to contemplate the intriguingly different decorative themes. At the middle, vertical elements resembling columns form square panels like metopes on a temple frieze. The alternation of the panels between birds and four-leafed designs further breaks any possible monotony. When the three rows of birds are examined more closely a new variation is observed by which the artist avoids a cloying uniformity: between the birds of the top band are angular lozenges, while the middle row uses dotted circles instead and the bottom panel nothing. It is this combination of diversity and rhythmic repetition which gives the best vases of this style their peculiar charm.

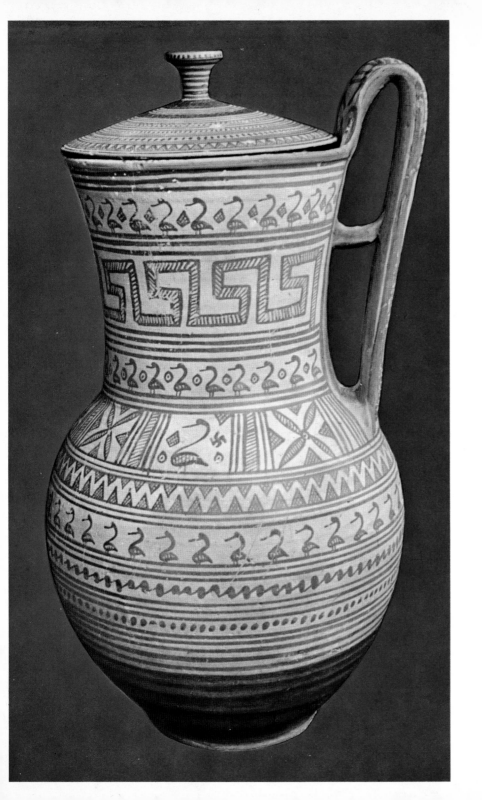

6

LATE GEOMETRIC SCYPHUS

c. 725 B.C.
Athens,
Stoa of
Attalos
Museum

As the Geometric style of ceramic decoration developed it became more free and imaginative and broke from some of the more stiffly regular patterns. Often this resulted in inferior designs, not well organized or always neatly drawn. Experimentation upset the earlier established balance. Some works of the later Geometric period, however, are very fine. Obviously artists were active who were both original and painstaking and many delightful decorations resulted. That here shown will bear comparison with any. It was found in the recent excavations in the Agora at Athens, and is dated toward the end of the eighth century, when new influences from the eastern fringe of the Greek world were beginning to be felt.

This is a drinking cup for table use, in the general shape of a high-rimmed bowl or 'scyphus'. In later Attic work, this form usually has its horizontal handles toward the top of the cup. Here they are sturdily fixed to the bulging base and have a pleasing upward inclination. Rhythmic traditions are evident in the careful parallelism of all elements: the two panels with their counter-balanced birds, the horizontal triple lines at each side, matching all the other three-lined dividers, the equal number of star-flowers and their coordinated positions, the flowing rows of dots, spikes, and angle-lines. All is carefully ordered, yet there is no monotony. Here is a fine example of the Greek sense of controlled variety.

The birds, as usual in this period, are far from accurately representational. They are not absurd or contorted, however, and in no way childish. Rather, their simplicity of outline and unzoological feather-pattern strike us as brightly suggestive both of reality and of a new way of looking on it.

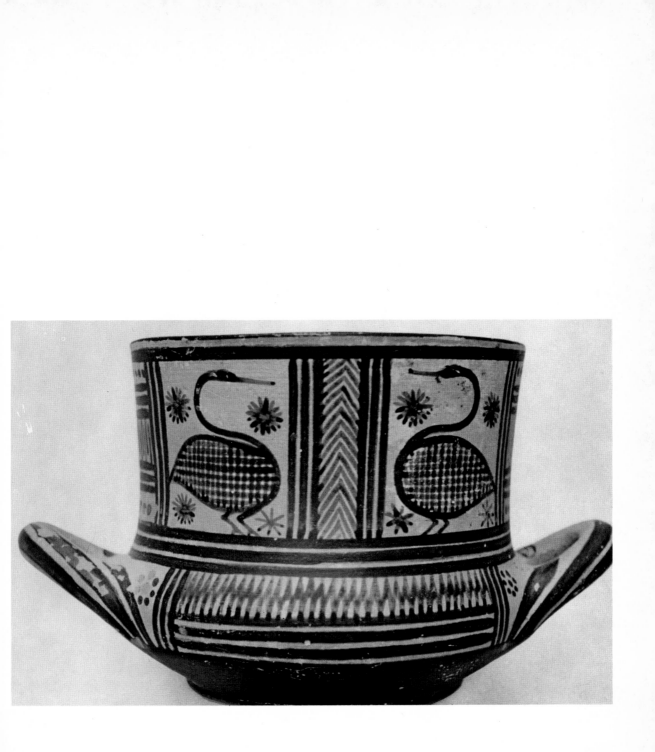

CYCLADIC OENOCHOE FROM AEGINA

700-650 B.C.
London,
British Museum

The Oriental influences which were strongly at work in the Greek world in the seventh century are manifest in this remarkable wine-jug found in Aegina, the island southwest of Athens. It was, however, most likely imported from farther east. Products of this general area of central Aegean islands are termed Cycladic, after the circle of islands known as Cyclades. There is a basically uniform spirit and style in art works of this region, differing in some ways from both the mainland manner and that of Ionia, and combining qualities characteristic of each.

The shape of the jug here shown is strikingly imaginative. Griffins' heads were common decorations of metal cauldrons and tripods at this period, seemingly a middle-eastern idea which had caught the Greeks' fancy. Here the mythical beast is not merely ornamental but functional, and the curved tongue makes an effective pouring spout. The handle neatly balances the opposite curve of open jaws. It is efficient, too, for holding the jug firmly while tipped to pour, and the spherical lower half of the vessel ensures a stable center of gravity. The whole design is a fine illustration of the Greek ability to be practical and artistically pleasing at the same time.

Geometric regularity of pattern is already breaking down and the variety of decorative details on this vase is amazing. The horse and lioness have plausibility without full realism. Their contrasting attitudes of calm and violence lend dynamism and vitality, keeping the viewer's mind alert to the many facets of life which so strongly appealed to the Greeks in this age of re-awakening.

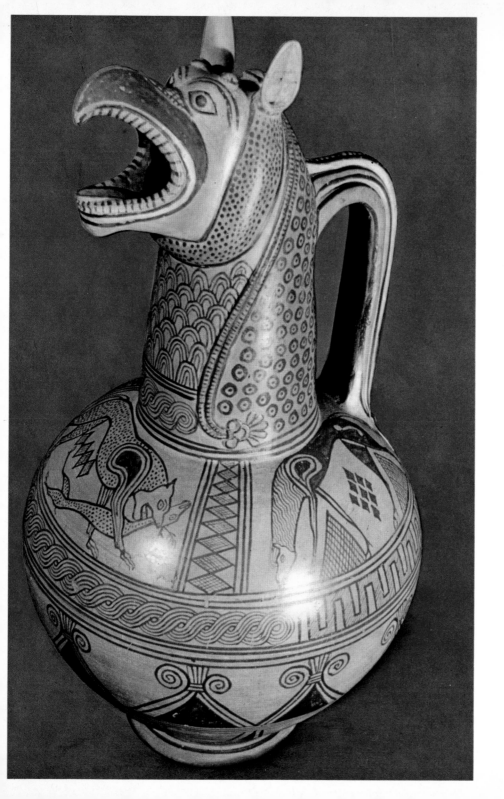

Pottery made in the vicinity of Athens in the eighth and seventh centuries has a fascinating vigor of design and bold imaginative quality. Influences from the East, via Greek cities in Asia Minor and the Aegean islands, are evidently at work, but there is a special manner in the Attic work—strong large figures in lively action, rough but effective drawing, experimentation in geometric decorative details, a tawny character in the local clay. The finest example is this striking large amphora found in 1954 near Eleusis, the sanctuary of Demeter and her Mysteries. It had been used as funeral urn for a young boy.

The upper scene, on the vase's neck, shows the blinding of the Cyclops Polyphemus by Odysseus (in white) and two companions. This is the earliest known illustration of that memorable passage in the *Odyssey* (9.105–566, especially 378–397), of which at least nine others survive in various forms. The Cyclops holds the wine by which his wits had been blunted and gropes for the tormenting white-hot pointed stake. Odysseus is straining his weight forward in the thrust. All are grimly intent on the dangerous business as they twirl the sizzling stick in their cruel foe's eye and he howls with pain. The draughtsmanship may be primitive, but the scene commands attention with its authentic spirit of drama and human tension.

Below is a panel in the finest Geometric tradition, with bristling boar and snarling lion highly effective in their vitality and fierceness.

Even more remarkable is the lively scene on the lower half of the vase. The two Gorgons Stheno and Euryale are in grim chase, for around the left curvature of the urn, here out of view, lies their sister Medusa, just beheaded by Perseus—who is seen disappearing at the right, his boots winged as the myth relates. There is an extraordinary freedom and creative fancy in the conception of the Gorgons, and a manner of drawing strongly suggestive of Braque's. With imaginative humor, the heads are fashioned after the well-known bronze cauldrons of the period, but with heads of snakes and lions instead of the usual griffins. Perhaps there is an echo here of Homer's comparison of the monster Charybdis to a seething cauldron (*Od.* 12.236–9). The eyebrows are double-lined, the noses like griffins' beaks. Their haste is well conveyed by the simple motion of the arms and bare legs extended from the split skirt. Though fearsome in their strangeness, the Gorgons are nevertheless graceful and feminine. The rhythmic balance of the composition lends an interest of its own. At the right stands Athena facing them to bar their pursuit; she is a tall figure in peplos and dotted stole, holding a long spear. This is the earliest representation of Athena known in Attic art. How differently she was conceived two centuries later may be seen in Plate 41.

The border band above and below the Gorgons suggests intertwined snakes, to keep the mood. Openings in the handle imitate early metal work. The vase stands four and a half feet high. It stands even higher in the history of early Greek art and in the list of fortunate recoveries by modern archaeological search.

PROTO-ATTIC AMPHORA FROM ELEUSIS

c. 675-650 B.C.
Eleusis,
Archaeological
Museum

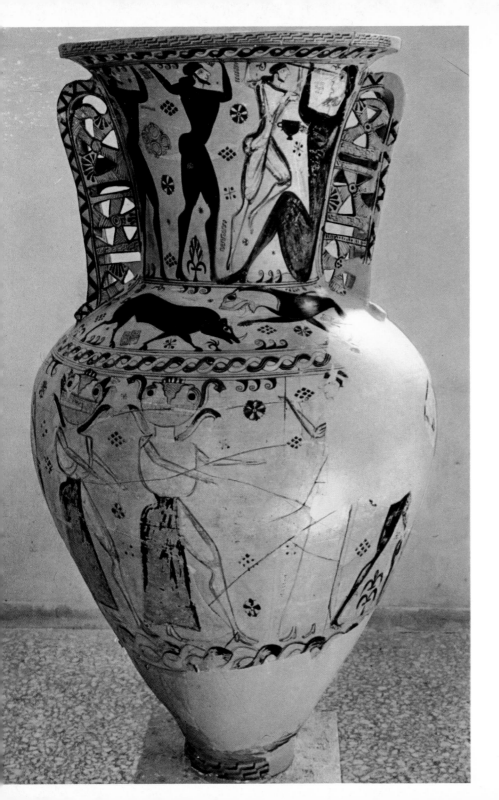

9

RHODIAN-EAST GREEK OENOCHOE

*c. 615 B.C.
Boston,
Museum of
Fine Arts*

A special classification of early Greek vases is known variously as Rhodian, Ionian, or East Greek. Found on Rhodes and other islands along the coast of Asia Minor and in various sites of Ionia, some may have been made at Miletus, Ephesus, Samos and other Eastern cities. Their main characteristics are the cream white background coating on the rough clay and the parallel horizontal panels with birds, goats, ibexes, or bulls in brown and black, surrounded by a flurry of varied geometric spacefillers. Human figures rarely occur. There is almost no use of lines incised through the glaze to etch details. The 'reserved space' technique is effectively employed to make possible a pictorial use of the white area itself—as in the faces of the goats in the illustration here. These animals were so popular for the decoration of East Greek vases that this group of pottery is often termed the Wild Goat style.

The shapes of Rhodian ware are varied and original: plates, bowls, cups, pitchers with a contour all their own. The beautiful lines of this oenochoe (a jug for pouring wine) are evident and are the result of the carefully planned proportion of girth to height and the subtly differing curvature above and below the maximum diameter. By rising gracefully above the rim before curving sharply backward and plunging down to the central bulge, the handle contributes much to the general effect. The whole is delicate yet stable and firm.

A rich, almost lush, quality of this vase, with its ornate decorative scheme and bright coloring, gives it something of the features of an oriental tapestry, such as the Ionians would know from their contacts with neighboring lands to the east. The general spirit, however, and the direct naturalness of the animals is wholly Greek.

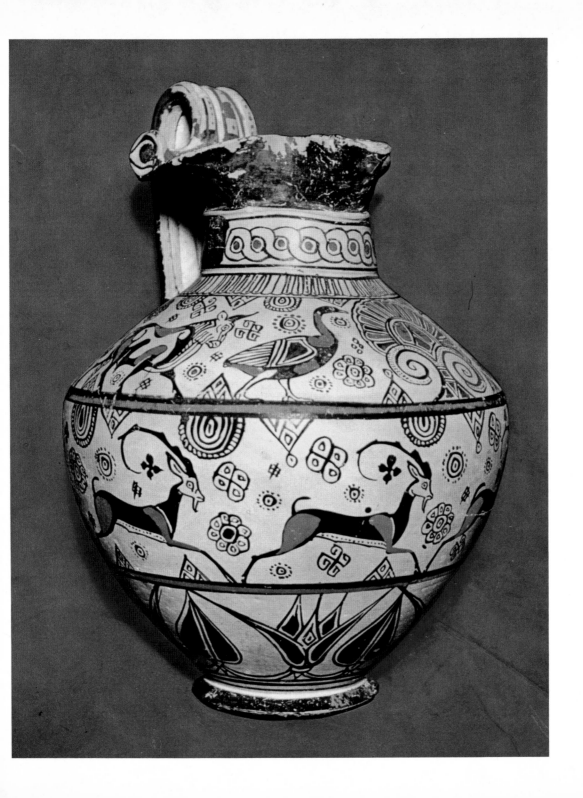

Strategically situated on the narrow isthmus connecting central and southern Greece, and with direct access to the eastern and western sea routes to all parts of the Mediterranean world, Corinth in the seventh century B.C. was a wealthy and important town, especially under the vigorous rule of Cypselus and Periander. Far-flung commercial contacts made Corinthian exports a major element in the trade of the times and brought the city both riches and fame. Chief among Corinthian products desired abroad were the beautiful vases in which her fine olive oil and perfumes were sold. They have been found all over the classical world— a clear testimony to their widespread appeal.

The pale buff clay from local pits carries bright polychrome designs in purplish red, black, brown, yellow, and white. Lively, often humorous, lions, ibexes, birds, sphinxes dominate the scene. Around them simple flower patterns and dots clustered like circular stars fill in the background, usually with restraint. The finest period is before 600. 'Proto-Corinthian' extends for a century from 725 to 625, followed for fifty years or more by the 'Corinthian' style until the brilliant growth of Athenian vase production practically conquered the market.

In the small perfume-jar here illustrated the refined delicacy of mid-seventh century work has yielded somewhat to a more hurried treatment with less precision and a more exuberant use of space-filling petals. But the essential charm of the Corinthian manner remains—the attractive color scheme, graceful shape, and vividly sketched figures. The drowsy owl is unperturbed by the lions' snarling, as though to tell us that it is all in fun, for art's sake—and good business. It is easy to understand why these vases were in such demand that mass-production techniques led to less careful workmanship. Even so, they are delightful.

CORINTHIAN ALABASTRUM

625-600 B.C.
Corinth,
Archaeological
Museum

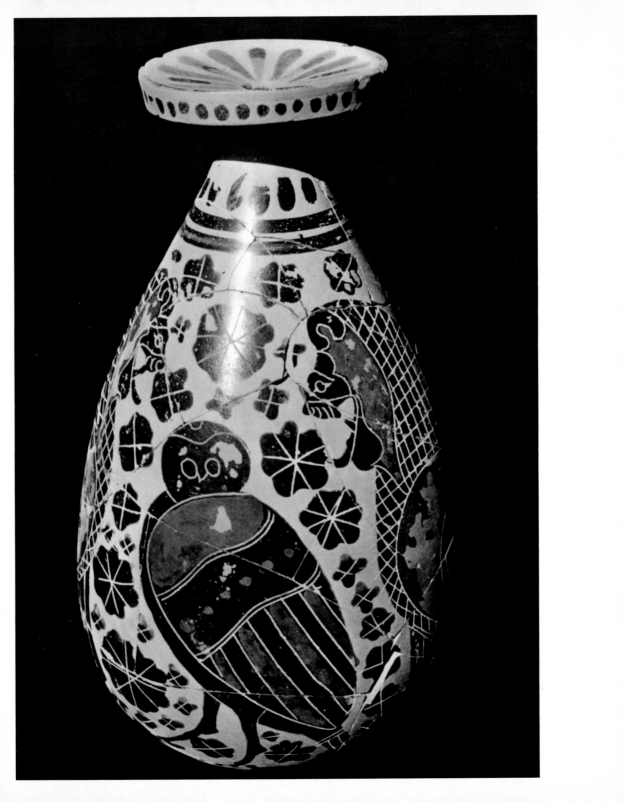

LACONIAN HYDRIA

c. 540 B.C.
London,
British Museum

Sparta was a state which crushed out the artistic impulse so strong in most Greeks, just as it cast out to die on the hills its own infants whose weakness gave no promise of military usefulness. Intellectual training, family life, many personal freedoms were sacrificed to the arid ideal of warlike prowess and physical toughness subservient to a totalitarian militaristic society. With her powerful, rigidly disciplined army Sparta destroyed Athens' political dominance and much of her creative spirit. Certain parallels today are all too grimly clear. Great art can flourish only when man's spirit is more honored than material might.

Before crass militarism constricted Sparta's view, literature and art had made much progress there. Around the middle of the seventh century, Alcman came from Sardis to compose for Sparta his beautiful choral lyrics for great festivals. Tyrtaeus there wrote his stirring poetic appeals for bravery, virtue, and civic order. Local craftsmen produced vases which ranked with any in Greece for beauty and originality. The sample here shown reveals how great was our loss when artistic interest was suffocated at Sparta in the later sixth century.

Laconian ware (as it is termed, after the region around Sparta) is normally of white or creamy background brightly decorated with designs in black, brown, and purple. Some scenes are mythological, but most are of birds, fish, or animals. Corinthian influence is evident, but the style and spirit are distinctive. These vases were widely exported and have been found at Cyrene in Africa, in Italy, southern France, and the Greek islands. Many are strikingly imaginative and show refined taste. In this example, the various types of birds have a formal balance that does not limit their liveliness. An unusual feature is the band of pomegranates on poles, near the base. The effect of the whole vase is one of sensitive elegance masterfully achieved.

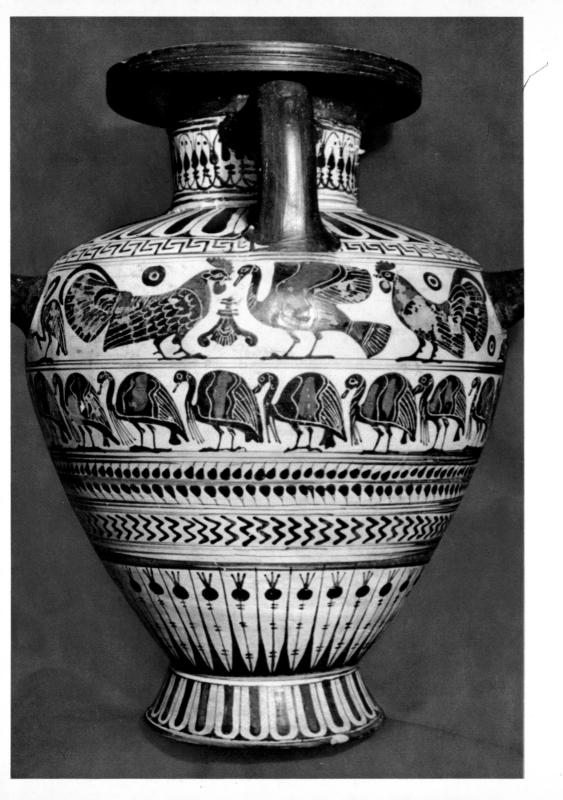

A group of fine vases found along the western coast of central Italy, mostly at Etruscan sites, forms a class by itself known as Chalcidian' on the supposition that they came from Chalcis in Euboea, the long island just north of Attica. But no potteries containing fragments of this style have yet been found at Chalcis, so it seems more likely that the extant splendid vases from Etruria were made in Italy itself, by Greeks of the Euboean colonies at Cumae, Zancle, or perhaps most likely Rhegium. Many, like our example, are ascribed to the 'Inscription Painter.' The best ones date to the last half of the sixth century.

Basically the model is Corinthian ware, but influences of Attic and Ionian traditions are clearly discernible. Where inscriptions occur, they are in a script like Euboean. An unusual russet tone in the clay, the result of a chemical quality, characterizes Chalcidian pottery. The drawing is strong and firm in black and reddish brown. Delicately ornate border motifs define the panels within which are the figures—often horses in carefully counterbalanced compositions, or warriors or cocks, sometimes mythological episodes. Usually a band of black rays spreads up from the base and a wide black ring runs under the upper rim. Handles are of peculiar shape, flat and looped.

The noble example here seen is typical in every way and stands out among the most attractive of ancient vases. The charging horses are well drawn and show their excitement in the race. The rider ahead looks back apprehensively at the other intent on passing him. Birds above him intensify the impression of speed by their swift flight in the opposite direction. Those below are detached from the action, but lend their own points of interest to enrich the whole. The graceful lid is strongly Corinthian in color scheme but Ionic in theme and manner.

CHALCIDIAN
CRATER

c. 540 B.C.
Würzburg,
Martin von
Wagner Museum

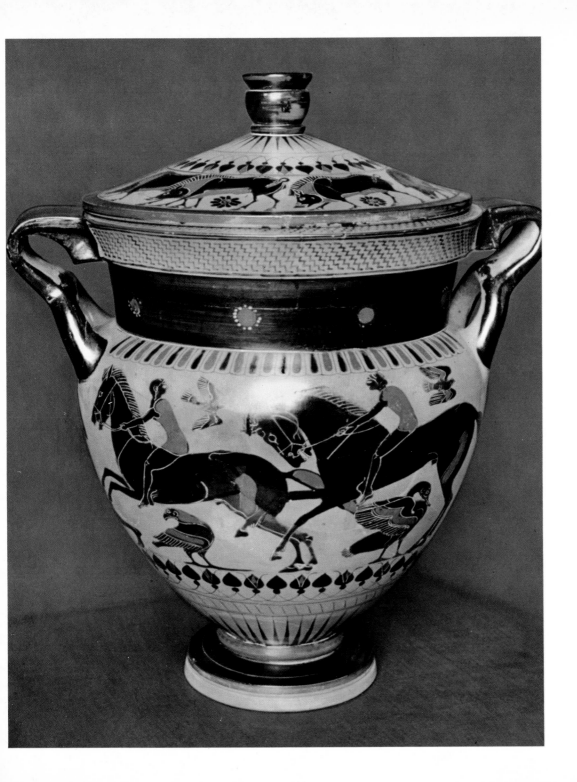

'TYRRHENIAN' AMPHORA

575-550 B.C.
Boston,
Museum of
Fine Arts

Around the middle of the seventh century a new technique in vase painting developed at Athens. Now figures were mostly drawn in black glaze upon the clay, and details scratched through to the reddish surface below the glaze. White was used for the flesh of women (probably because of Homer's 'white-armed Hera' and similar poetic references) and in a few other instances, with brown and purple over-painting also employed for other parts. Human interest now comes to the fore, and the chief decorative theme is usually a scene of battle, hunting, sport, religious ritual, or mythological story. Animal and floral bands remain, but subordinate to the human action, and relegated to the shoulder and foot of the vase. New forms come into use, and some of the traditional shapes gain a more refined outline. This 'black-figure' manner flourished for over a century and produced many great masterpieces. Outstanding artists evolved approaches and mannerisms of their own. The general style of all has much in common with the early archaic sculpture of the same period. The authentic Greek spirit in art is coming strongly forward.

Among the early black-figure vases of special interest is the group called 'Tyrrhenian' because they were found mostly along the coasts of that sea, in Tuscany. They are of Attic origin, however, and imported from Greece. Their shape is egg-like, with a thick neck above. A common feature is the raised collar at the juncture of neck and body. The clay tone is an attractive reddish tan. Friezes of animals and sphinxes are openly imitative of Corinthian style, to compete with those popular vases.

On the present example, the main action is a battle of Amazons with Heracles and Telamon, as the names indicate. Andromache, the Amazon in the center, has an elegantly embroidered dress, to show that her warlike habits have not altogether eliminated feminine interests. Vases very much like this are sometimes depicted on silver Athenian coins of the early sixth century.

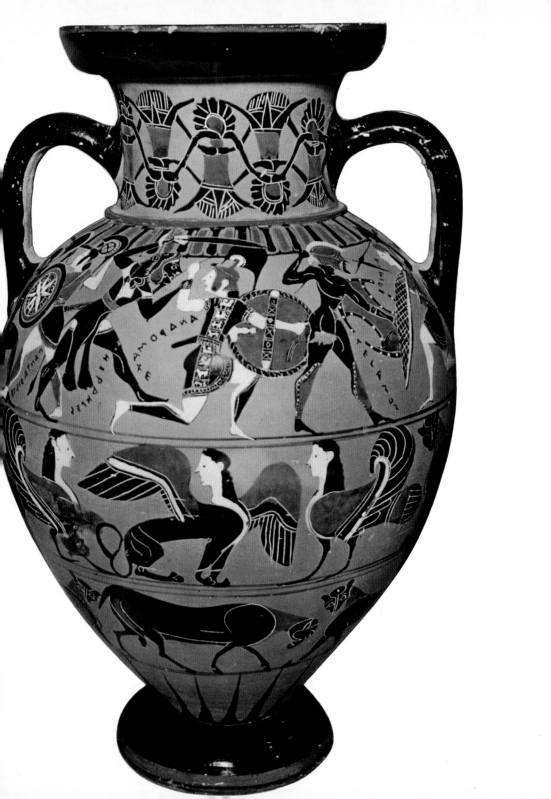

CYLIX
BY
EXECIAS

540-530 B.C.
Munich,
Museum Antiker
Kleinkunst

We see here one of the most attractive and universally admired of all Gree
vase paintings. It is the interior of a cylix, a flat broad wine cup for banquets, b
Execias, who was both potter and painter in the mid sixth century. This is on
of many extant works of his which put him at the very top among black-figu
artists. The composition is strikingly impressive in its clean-cut sophisticate
scheme. The whole is neatly integrated with conscious care for balance an
subtle interrelationships. The grape clusters above match the dolphins swimmin
below, and the two on the sides harmoniously complete the inner circle of ob
jects parallel to the outer rim. Curvature of sail and boat counterbalance on
another around the center and the varied lines of the dolphins in relation to th
rest add to the rhythmic symmetry. The ship's mast forms an axis around whic
all is unified. A mysterious, timeless effect is achieved by the monotone back
ground, unreal in color and in omission of distinction between sea and sky. Ou
eyes are intrigued by this cunning play of lines, our minds challenged by th
problems set for interpretation and analysis. Few works in the whole range o
Greek art have so much to elicit our awe, admiration, and delight.

The seventh 'Homeric' hymn tells a charming tale of the god of wine an
festivity, Dionysus son of Zeus and Semele, appearing one day on a jutting head
land along the 'unharvested sea,' in the likeness of a youth with beautiful flow
ing hair and bright robe. Some passing Tyrrhennian pirates seized him to sell
a slave, but he threw off his bonds, made wine flow from the ship and ivy an
grape-laden vine spring up around the mast. The sailors leaped in terror into th
sea, where they were turned into dolphins, while the god sailed on and brough
his cult and gifts to Greece. Execias has drawn on this story for theme, bu
treats it freely in his own creative way, with the emphasis on mystery rathe
than on action. Certainly it is an apt subject for a wine-cup.

Some of the white over-paint has chipped off the sail, and the god's face
damaged somewhat. The rest is excellently preserved, to our good fortune, an
we can enjoy the smaller refinements of drawing in the god's fine robe, th
ship's rigging and graceful shape, the snout on the prow and curving high ster
the white dolphins along the side, and the gay, lively ones swimming freely t
and fro. Altogether, this is one of the most delightful art works survivin
from the ancient world.

Another masterpiece with Dionysus as its theme is the fine mosaic at Delo
in Plate 75.

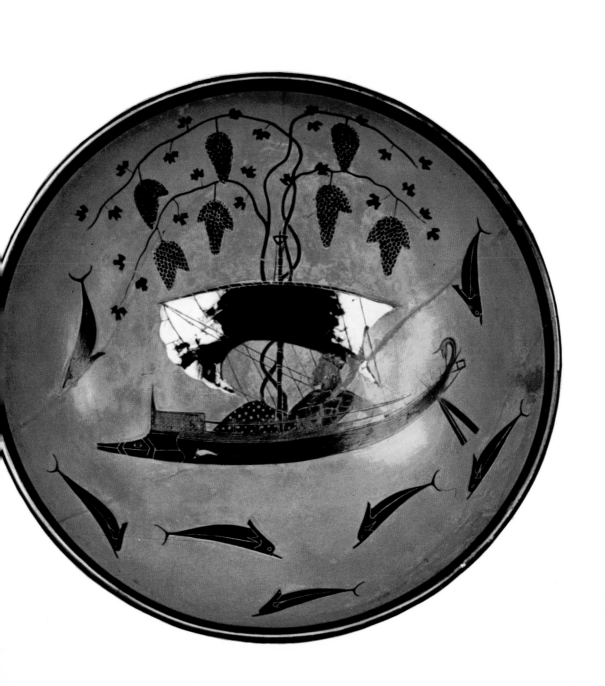

NECK-
AMPHORA
BY
NICOSTHENES

530-520 B.C.
Bologna,
Museo Civico

Nicosthenes was a very active potter during the period around 530–510 B.C. working both in the traditional black-figure technique and later in the new red-figure manner. He did not himself paint the designs, but formed the vases, for whose decoration he employed several painters, among them the famous Epictetus. A large number of his vases survive, mostly of the amphora or cylix shape. A special feature of his amphoras is the wide flaring handle, thin and flat, which imitates those on metal vases. This peculiarity is copied by his follower Pamphaeus. The effect is striking, and provides further space for decoration. (Contrast the usual rod-like handles, on Plates 13, 16).

The potter was proud of his product, and has signed it at the top of the animal frieze: NIKOSTHENES EPOIESEN, 'Nicosthenes made it.' This is the technical terminology often used by potters. When a painter signed his name, he regularly employed the different verb EGRAPSEN, 'painted it.' When a vase-painter is not known from signature or style, he is often referred to as the potter's man (in this case, 'the Nicosthenes painter'), or by reference to some famous vase of his in a particular collection (like the 'Chicago painter' of Plate 34).

The present vase is an attractive example of Nicosthenes' manner. Its graceful shape is very carefully proportioned, and the unusually wide rim at the top fits in neatly with the broad handles. A feature of this style is the raised ridge-border above and below the frieze of animals—which are very Corinthian in style. The lower panels with leaf and ray patterns divide the space pleasingly; that on the shoulder is especially ornate. The finely-garbed lady on the handle dances with lively skill and conveys an air of both joy and dignity.

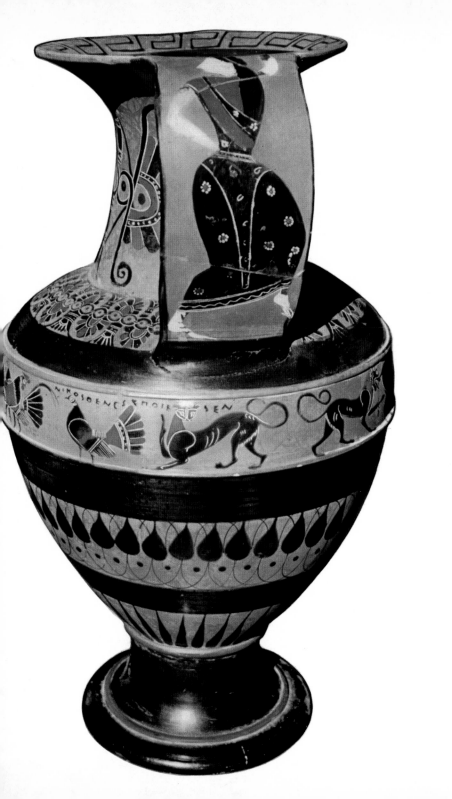

**AMPHORA
OF
OLIVE-
PICKERS**

530-510 B.C.
London
British Museum

The merits and the limitations of black-figure technique are well demonstrate by this vase, produced at the end of the sixth century when the red-figure manner had begun to dominate the field. Ornamentation is under firm restraint, with emphasis on the scene from daily life. The background is untrammeled with merely decorative forms unconnected with the action depicted. This purity and directness of presentation shows the movement of Greek art toward the contemplative simplicity which was achieved in the classic age half a century later.

The sharp contrast of dark figures on the glowing background captures our attention, and we are led to imagine ourselves present at the harvesting of olives which the artist has chosen for theme. Only silhouettes are feasible in the black figure method of painting, but their arrangement here is entirely natural. Enough details are scratched through the glaze to attain basic realism, and the use of reddish brown over-paint for the hair, beards, and clothes produces a more natural effect. There is little of archaic stiffness in the figures, and an obvious effort to impart to them some personality and life.

The vase was meant for storage of olive oil for household needs, and its decorative theme is therefore especially appropriate. To enhance its ornament value in the home, the tone of the clay has been artificially enriched and tasteful embellishment added in the varied bands above and below the central panel. The inside of the handles has been left red as a further touch of color and contrast. The artist was the Antimenes Painter, who also did the only other extant painting of an olive harvest.

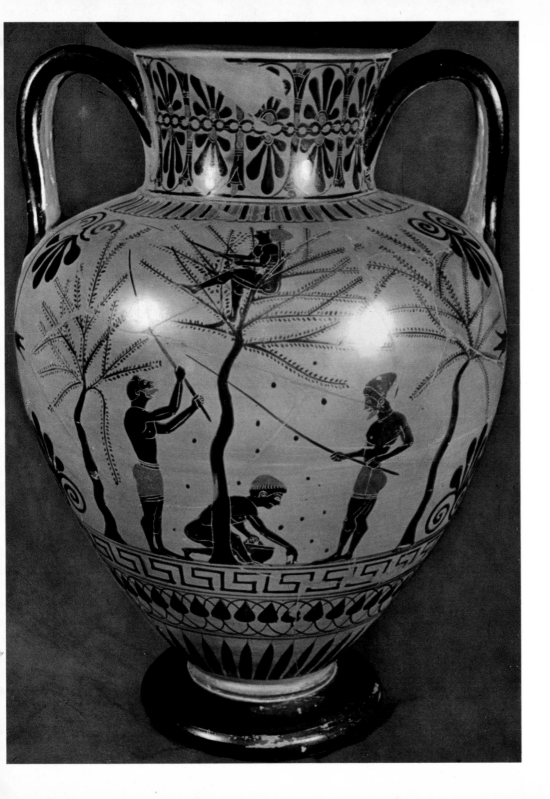

AMPHORA
BY
RYCROFT
PAINTER

c. 520 B.C.
Worcester,
Museum of Art

The goddess Leto, mother of Apollo and Artemis, is here shown mounting her chariot, with Apollo standing nearby. The rest of the painting, omitted in this detailed view, portrays Artemis and Hermes, partly hidden by the four fine horses. The scene is no doubt on Mount Olympus, from which the goddess is setting out for a visit to earth, perhaps to Delos where Apollo and Artemis had been born and were worshipped in a famous sanctuary.

The work is attributed by Beazley and others to the 'Rycroft Painter,' who was active in black-figure painting toward the end of the sixth century. Over thirty other extant vases are thought to be his work. His style is rather similar to that of the famous Psiax of the same period, and he seems to be a follower of the great pioneer known as the 'Andocides Painter' who often decorated a vase on one side in black-figure, on the other with the same scene in the new red-figure technique which he greatly advanced.

We see here a most effective use of incised lines to give detail to the figures and their drapery. The drawing is neat, firm, and meticulous, the composition carefully balanced. A three-dimensional quality is approached by having Leto's head project above the floral border, and part of Apollo's ivory-plated lyre appear between the border and his head. The shape of the eyes is archaic but not notably unreal. In posture and arrested motion, the figures are satisfyingly natural. Preciseness is evident in many items: the contour of hair and garment hems, Apollo's foot and the horses' hooves, the proper seven strings to his elaborate lyre. The artist is clearly proud of his work and seeks to make it worthy of admiration.

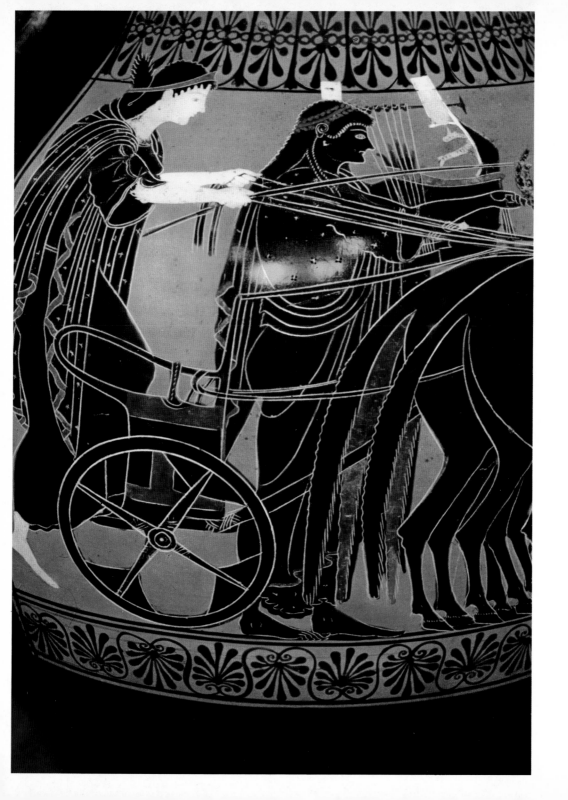

From the later sixth century on, a special variant of vase decoration employed a white background for more ornate effect. Sometimes, as here, the figures are in the black-figure manner. Many later examples follow the red-figure technique or use several colors painted over the white surface (see Plates 35, 36). The impression in all cases is one of added richness and elegance. Such vases were especially expensive, and for limited purposes, and are consequently comparatively rare. They usually were made with outstanding care and show superior draftsmanship. They were obviously admired by the ancients and considered an object of pride in the home.

The white background is a slip of liquid white clay spread over the surface of the vase. On it the figures have been drawn in the usual black glaze, and the incised lines for detail go only down to the white layer, to avoid multiplication of colors. The ivory tone of the white is rich and attractive. The shape is a graceful example of the ovoid type of pitcher, with a trefoil top providing both pouring spout and its own decorative effect.

The artist has used more than half the surface of the body for his broad panel picture. An ornamental border at sides and top has no counterpart below, as that would have weakened the concentration of attention on the scene itself. The action is pictorial, formal, artificial, rather than very realistic. Balance is attained by distribution of the two figures at equal distances from the central axis, but variation is introduced in their stance, type of cuirass, and angle of head. The battle scene is thus purified of its violence and becomes suitable for aesthetic enjoyment.

WHITE-GROUND TREFOIL PITCHER

c. 475 B.C.
Harvard University,
Fogg Museum

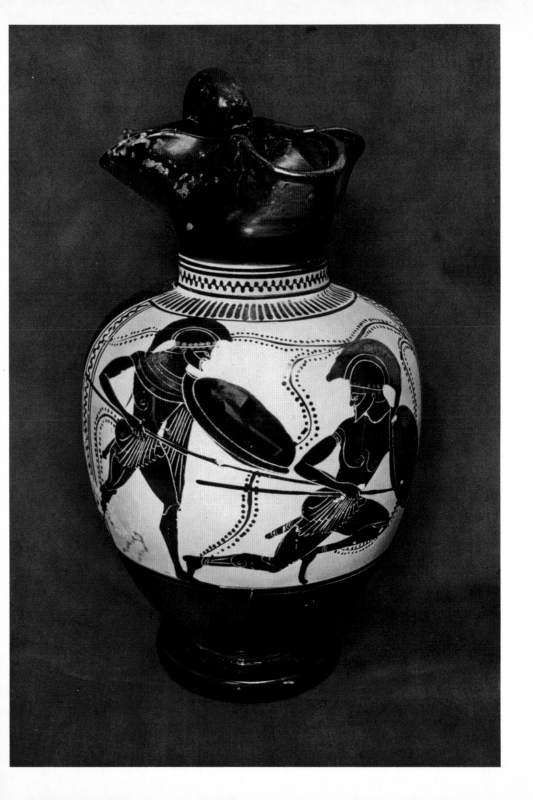

The archaic era in Greek sculpture extends from the middle of the seventh century to the end of the Persian Wars in 479. Within that long span much development occurs, but the general qualities are consistent and largely distinctive from what followed. Long considered primitive and crude in relation to classical art, archaic sculpture in Greece has recently won much attention and admiration. It is clearly of high merit, in its best examples, and in fact has a strength and directness of manner and an authenticity of feeling which much of the more refined later work lacks. The dozen plates here devoted to archaic sculpture will give an opportunity to appreciate the peculiar excellence of Greek art of the period. There is much in common between this sculpture and the contemporary black-figure vases. Studying them together is instructive for both fields.

A fine instance of the fully developed archaic style is the present head, formerly in the private Rampin collection. It has been found to belong to a marble torso now in the Acropolis Museum in Athens, and seemingly is part of a group of two horsemen—perhaps the Dioscuri Castor and Pollux (sons of Zeus and Leda) or possibly particular Athenian nobles of the sixth century. In any case, the artist has made every effort to represent the knights with impressive dignity.

The face is personal and expressive, with a pleasing humane refinement. The strong clear lines of nose, arching eyebrows, almond-shaped eyes, firm chin, and slightly pursed lips produce a manly air which the ornate treatment of hair and beard embellishes without softening. A formal rhythm is maintained in the pattern of parted hair and beard. Traces remain of the paint which originally set off the eyes, lips, beard, hair, and wreath from the snowy Parian marble. The diadem of leaves is probably wild celery, associated with the games at Nemea, as wild olive was with those at Olympia. Some think them oak leaves, however. In any case, they signify athletic achievement, an important glory for young Athenian nobles.

'RAMPIN' KNIGHT

575-550 B.C.
Paris, Louvre

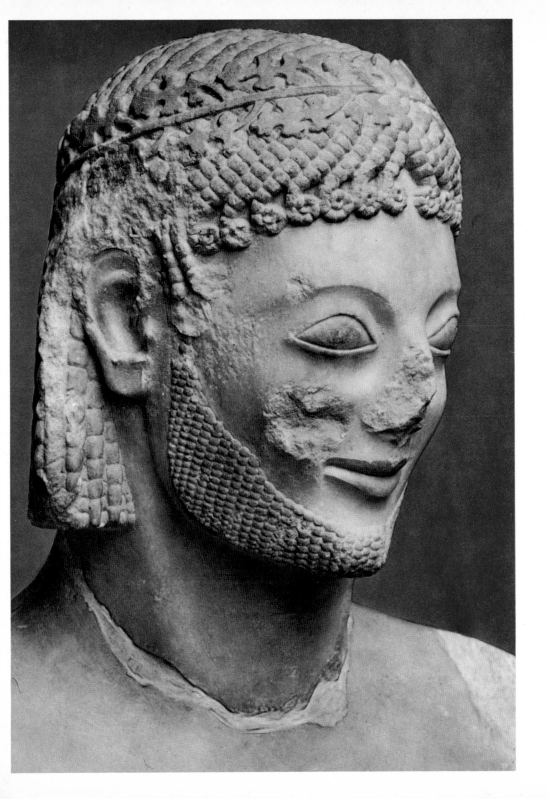

An excellent instance of the later style of female archaic figure, this statue seems to have been made in Chios, the large island near the coast of Ionia, from local marble. It has a soft, ornate quality and richness of detailed drapery which reflect the eastern taste. Contemporary work in Attica was more austere and formal, as many extant examples of the type show. The statue was found, however, on the Acropolis at Athens, where it had been brought as a gift to the temples or imported by Athenian buyers who admired it.

Most ancient marble sculpture was enlivened by bright colors painted on for contrast and more lifelike appearance. This fact was unknown to the Renaissance and to neo-classical sculptors of later centuries, and led to the cold unreal quality of their imitations—a poor substitute for authentic Greek art. Here much of the color is apparent, due to protection from the elements in the special circumstances of the statue's preservation. The girl's ripply chiton was originally a rich dark blue, but has turned green from oxidation. It had a band of reddish brown at the neckline. Blue disks at each ear carried a red circle of volutes (like an Ionic column capital—cp. Plate 46). A palmette and lotus pattern decorated the diadem, and a red and green necklace encircled the throat. Further coloring survives on the lower hem of the white outer garment, which was also spangled with triangles and spirals of red and blue. Eyes and lips were no doubt painted in the usual way.

The young girl has the characteristic 'archaic smile,' which seems to symbolize a general contentedness with life. The waves and beaded strands of hair emphasize the oval proportions of the face, and long braided locks fall over the shoulders in rhythmic grace. Clearly the artist seeks to share a vision of calm beauty and human dignity.

MAIDEN FROM CHIOS

530-500 B.C.
Athens,
Acropolis Museum

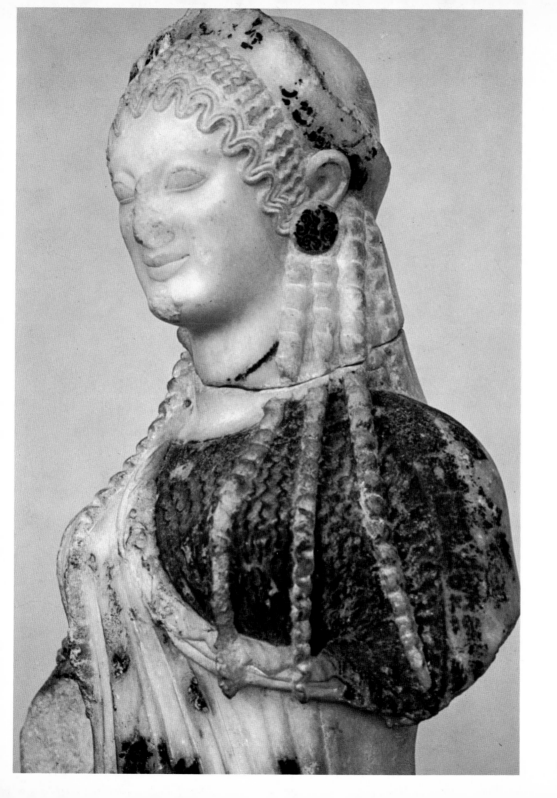

DANCER METOPES FROM THE HERAEUM OF THE SELE

510-500 B.C.
Paestum,
Archaeological
Museum

At the end of the seventh century, the luxury-loving Greek colony at Sybaris in southern Italy founded a commercial center on the western coast of the peninsula about sixty miles south of Naples. This was called Poseidonia, but re-named Paistom (Latin Paestum) by its Lucanian conquerors in the fourth century. It is noteworthy for its well-preserved circuit of walls, but especially for the series of large and small temples in a row at its center, of which one is among the finest of the ancient world (Plate 45).

A few miles to the north, at the mouth of the river Silaris (now Sele) which divides Lucania from Campania, stood, another set of temples at a sanctuary of Hera so ancient that legend said it had been established by Jason and the Argonauts long before the Trojan War. Foundations of a large Doric temple and of some other religious buildings have been excavated since 1934 and a series of carved metopes recovered which form a most important witness to the merits of archaic sculpture. The two here illustrated are from the main temple, dated at the end of the sixth century. They are of local sandstone, a little under three feet in height.

Both metopes present a pair of women in ritual dance. There is rhythmic repetition of stance, with a slight variation in details. The ladies are intent on their symbolic movement and smile with festive exaltation. Garments and hair are treated with ornate opulence of carefully arranged lines. Though the eyes, lips, noses are too heavily emphasized (as is common until the fifth century), the general effect is lifelike and vigorous, with much dignity. The group could almost be an illustration of Sappho's beautiful description, a century earlier, of a similar rite:

Through Crete women once thus to the measure dainty
Feet moved in the dance, close by a lovely altar,
Soft bloom of the grass tenderly treading under...

FRAGMENT 12, LOBEL; MY TRANSLATION, IN SAPPHO'S METER

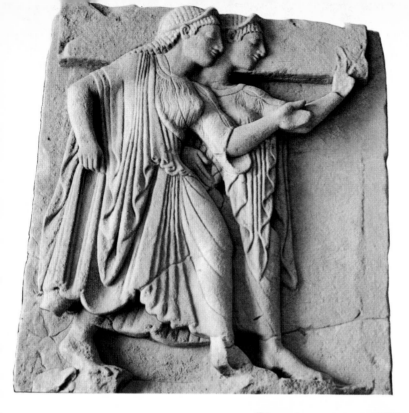

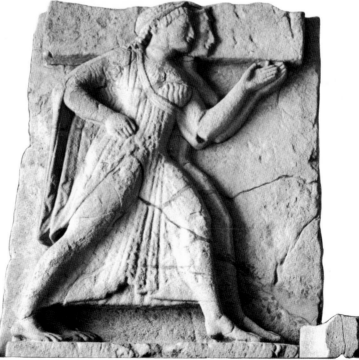

STELE
OF
ARISTION

*510-500 B.C.
Athens,
National Museum*

The quality of Late Archaic sculpture in the 'Transitional' period as it approaches the Classical era is well seen in this much-admired funeral monument of the soldier Aristion. The figure is life-size, in high relief on a standing slab ('stele') of Pentelic marble. An inscription on the base identifies it as 'of Aristion', while the artist has also signed it a bit higher as 'the work of Aristocles'. He is one of the few sculptors of the period whose name we know and whose work can be identified with certainty. The stele was found in the Velanideza area a few miles to the east of Athens, along the sea, where this Attic nobleman had been buried toward the end of the sixth century B.C. It is one of the chief treasures of the great Athens Museum.

The sculptor has immortalized Aristion as an ideal warrior-gentleman. He stands before us in dignified ease and unassuming naturalness, holding his long spear before him, the symbol of his military fame. His head leans slightly forward, to give a sense of action and to eliminate archaic stiffness of pose. The careful treatment of facial details, of ear, hair, beard, and fingers is matched by the fine simulation of stout armor and soft garment beneath it. The rhythmic drapery of the cloth has the same pattern on the upper arm as at the thigh, and manifests a formal balance similar to that on contemporary vase paintings. Traces of the original painted coloring survive on face and breastplate, and part of the design is visible which decorated the latter: a lion head incised as if in bronze armor. A simple cap-like helmet adds realism and prevents any impression of softness of character which too much prominence of the elegantly arranged hair might have produced. The Greek feeling for a reasoned humanism is clearly evidenced.

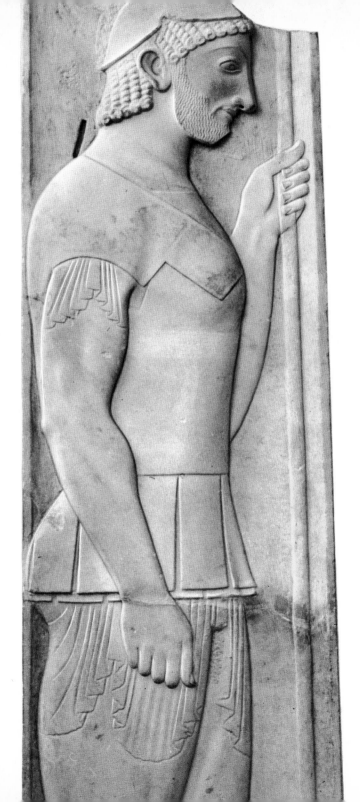

**ORNATE
LADY
FROM
CYRENE**

*c. 500 B.C.
Cyrene,
Museum of
Antiquities*

This little-known statue, from the one major Greek settlement in Africa, has an ornate quality which is found in Greek work only at the turn of the sixth century into the fifth. Earlier sculptors could not manage the problem of elegant embellishment, still struggling for naturalness in the basic realities of the figure's stance and proportions. Their drapery is fairly simple in its dominantly vertical patterns, though often elaborate in its folds (cf. Plate 21). In later ages, taste was more restrained and austere, or in the final epochs after the Classical period less delicate in its renewed love of show. But at this juncture in the Transitional era, the Greeks took special joy in elegance and found beauty in ornate forms which show a rich play of intellectual manipulation of the material as the artist's mind gives it order.

The present statue achieves its tone of refined opulence primarily through the intersecting movements of the drapery. Some of the garment falls directly down in strong vertical folds, but these are neatly interrupted by the central opening which reveals the inner fabric in contrapuntal flow of horizontal and up-sweeping lines. The step effect of the ascending series of marginal folds along the opening at the middle gives added interest to the contrast of lines, and the angular fall of the upper extremity of the dress accentuates this. Three strands of braided hair flowing down from each shoulder maintain a rhythmic symmetry, with just enough variation among themselves to escape formalism.

Bright colors which once enlivened this carefully constructed design are now vanished, but the rich golden patina from oxidation has substituted a mellow honey tone in compensation.

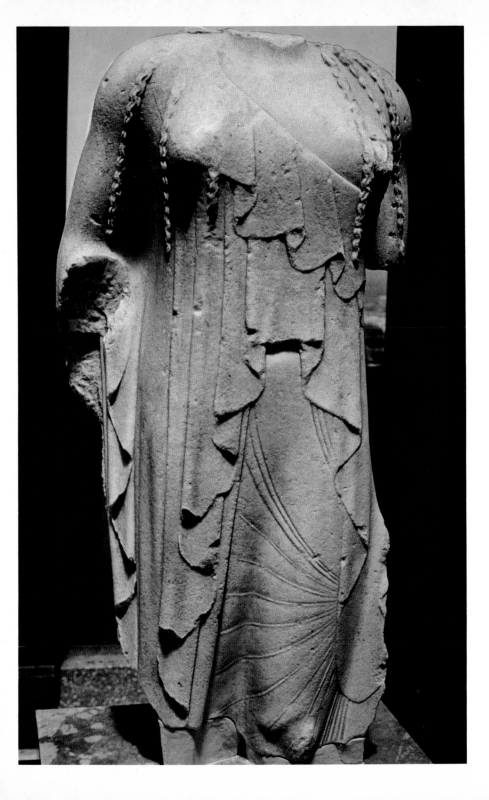

'HARPY'
TOMB
FROM
LYCIA

500-490 B.C.
London,
British Museum

A large monument with relief figures, seemingly a tomb, was found at Xanthos in Lycia—on the southern coast of Asia Minor, to the northeast of Rhodes. It is dated at the beginning of the fifth century, and is a noteworthy example of late Archaic sculpture. Known as the 'Harpy Tomb' because of its birds with women's faces carrying off symbolic souls (like the 'snatching wind-spirits' of mythology), the various sides of the rectangular monument have separate scenes related to commemoration of the dead and to honoring the divinities of the world below. In one panel, a seated man or deity is shown receiving a helmet with high crest from a warrior standing before him. On another a seated woman or goddess, holding pomegranates in her hands, is offered a dove by a standing girl. Along the front is the scene here illustrated—three ladies standing before a seated deity or woman to whom they bring gifts. One holds an egg, another a lotus flower and pomegranate (traditional symbol of immortality because of its countless seeds), the third an object no longer distinguishable because of damage and attrition.

The chief artistic interest lies in the rythmic arrangement of the standing ladies, where the triple repetition of a theme with slight variations gives the combination of balance, order, and diversity which the Greeks of the period loved, since it both challenges the mind's alertness of observation and satisfies its desire of intelligible design. Also of importance in the general esthetic appeal is the harmonious arrangement of the drapery and hair. The sharp vertical lines of the garments' folds, with the few deviations toward the horizontal in both directions, give a clear pattern which is pleasingly regular yet flexible. Since this pattern pleases, it is given thrice, to triple our enjoyment!

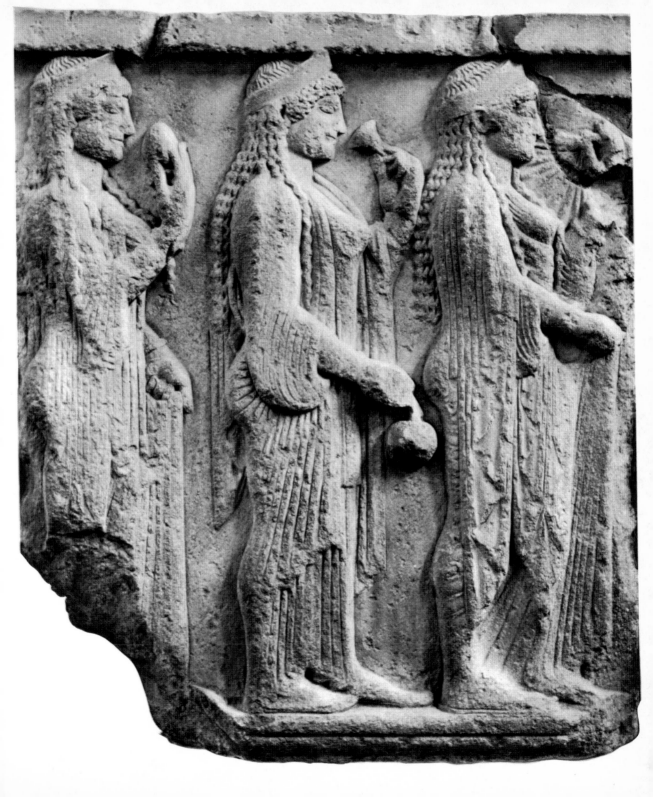

HERACLES
FROM
PEDIMENT
OF
APHAIA
TEMPLE

c. 490 B.C.
Munich,
Glyptotek

The island Aegina, southwest of Athens beyond Salamis, figured prominently in early Greek history, and was the first important center of commercial coinage among the Greek states—the thick 'Aeginetan turtles' (so called because of their shape and emblem) long being a standard of value in Aegean trade. At the beginning of the fifth century, a fine Doric temple was constructed on a high headland of northern Aegina, overlooking the sea, dedicated to the local goddess Aphaia. It was apparently damaged during the Persian Wars in 490 and the eastern pediment sculpture was mostly re-done. This included the Heracles here illustrated.

The hero is shown as an archer in battle—probably in his attack on Laomedon, king of Troy, a generation before the Trojan War. He is crouching and drawing his bow. (A bronze bow and arrow were no doubt part of the original statue, and the holes in the armor over his hip were for fastening on a bronze quiver). On his head is a helmet formed from a lion's head. This is his identification as Heracles, a trophy of his slaying of the Nemean lion. A leather cuirass and hip guards are effectively represented and under them a chiton of linen, visible at shoulder and hip. The left hand, and left leg below the knee, and part of the right arm and foot were made by the famous Danish sculptor Thorvaldsen in 1816, to restore the figure's lost parts.

It is clear that with this fine statue, and its many companion pieces from the temple pediments which have also survived, Greek sculpture is emerging from its archaic limitations and is on the verge of a new era of style and perfection. There is nothing stiff or formal here; all is wholly successful natural action. The body is firm and rounded and in excellent anatomical realism. Weight is accurately distributed and in easy balance. The artist has technical resources to meet all his problems; Greek sculpture has clearly come of age.

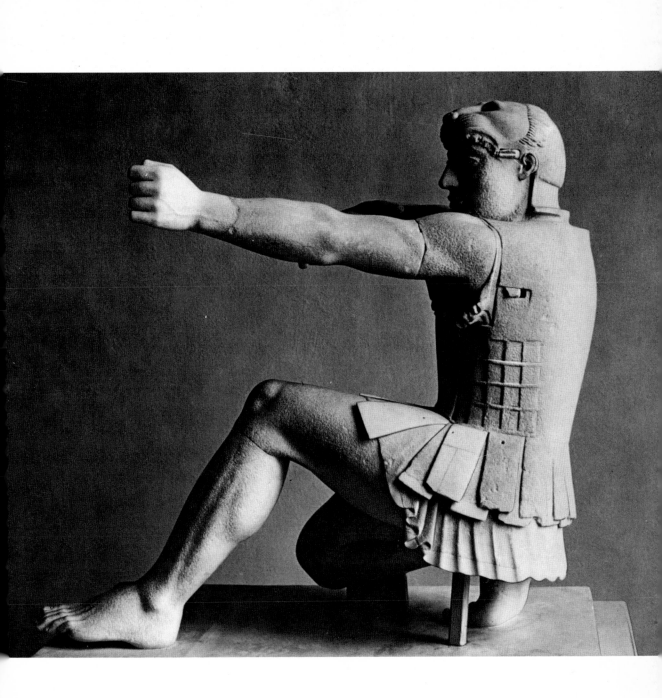

CAST
RELIEF
OF
BRONZE
CRATER
FROM
VIX

*c. 530 B.C.
Châtillon-sur-Seine,
Museum*

In the sixth century B.C. the art of bronze casting reached a high level of competence and it was to continue one of the major branches of Greek art for many centuries. Styles in bronze sculpture are at every period very similar to those of contemporary marble work. Fortunately many originals survive, to allow us direct appreciation of Greek bronzes at first hand.

The example here illustrated is one of the most remarkable from the late Archaic period. It was found a few years ago at Vix in France, near the little town of Châtillon-sur-Seine between Troyes and Dijon, and is one of the most precious additions to our store of Greek art in recent times. It is the largest known bronze crater (a bowl for mixing water with wine), standing over five feet high and more than four feet across. Since it is unquestionably of Greek workmanship—perhaps from the Peloponnesus, but probably from southern Italy—it is a mystery how so huge and expensive an object found its way through the wilds of central Gaul to the tomb of a 'barbarian' princess of the sixth century B.C., where it was found along with a gold diadem and two fine Attic wine cups. A rather similar large bronze crater, now in the museum in Belgrade, is probably from the same Greek workshop. It was imported into what is now Bulgaria, confirming the remarkable fame of these splendid bronze vessels.

The crater's two handles are elaborate volutes ending in amazing Gorgon figures with serpents for legs and fierce snakes entwined about their arms. All around the upper rim of the great vase runs a beautiful scroll-and-blossom frieze, and below that a continuous series of warriors, horses, and chariots as if in procession. These figures were cast separately and attached to the panel. They have a wonderful clarity of outline and great dignity and strength. Details of armor and harness are exact; the motion of the figures is natural though rather formal; and careful design is evident in the arrangement of the horses to allow each to be seen and enjoyed, though this involved enlarging the furthermost one. The treatment of their manes shows the Archaic love of pattern and elegance.

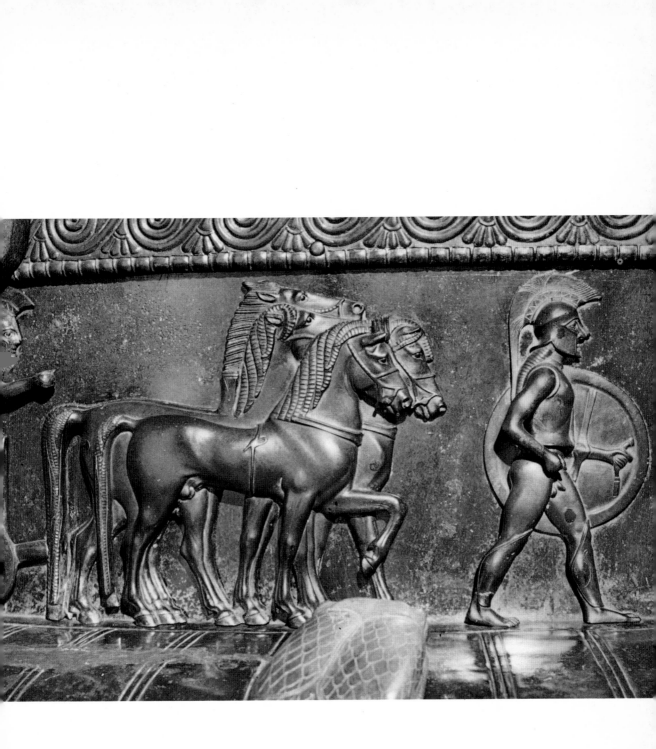

By practically universal agreement, this splendid bronze is among the noble achievements in the history of sculpture. It is strikingly impressive, with grave, austere beauty and its subtle humane quality, and is a triumph of artist mastery over matter. There can be no doubt of the effectiveness with which t sculptor's vision has been conveyed to us—a vision of youthful vitality a athletic grace, of aristocratic dignity and firm self-control, of deep joyous pri in a victory achieved by proven excellence in fair competition. This stat exactly captures the Greek ideal of human perfection: an harmoniously deve oped physique reflecting an inner orderliness and strength of character and sere clarity of purpose. It is a perfect example of that 'noble simplicity and tranq grandeur' which Winckelmann, in his pioneering history of Greek art, saw the distinctive characteristic of Hellenic art at its best. It may be considered eith the culmination of Transitional sculpture or the beginning of the Classic fulfillment.

The statue is life-size (5'11"), cast in several sections which are almost invisib joined. It was found in 1896 at Delphi and was originally part of a four-hor chariot group which stood near Apollo's temple as memorial to a victory in t Pythian Games. An inscription records that it was dedicated by Polyzalos Gela in Sicily, brother of the famous rulers Gelon and Hieron of Syracu (cf. Commentary 61). Pindar's *First Pythian Ode* celebrates a chariot victory Hieron at Delphi in 470, and makes a fine commentary for just such a stat as this and for the philosophical ideals which the Greeks saw in sports—and aristocracy. The statue in turn can help us understand Pindar's high views.

There is a wonderful naturalness, yet formal dignity too, in the long garme —the special *xystis* of charioteers—with its deep vertical folds below the wai and interestingly varied lines above. There is an artful diversity in all these fol which subtly enlivens their seeming regularity and banishes all monotony. T very high waist intensifies the impression of manly height and stateliness, b this would have been less obvious when partly hidden by the chariot's rim. Fee arm, and hand are marvelously real. The nobility of the head is even mo striking, and can be better appreciated from the following plate. The who statue has an admirable simplicity and directness and youthful freshness, ar somehow conveys a sense of dignity in a merely ordinary pose, of calm b vigorous vitality even in the absence of effort or movement. Only a suprem artist can work such wonders.

BRONZE CHARIOTEER OF DELPHI

475-470 B.C.
Delphi, Museum

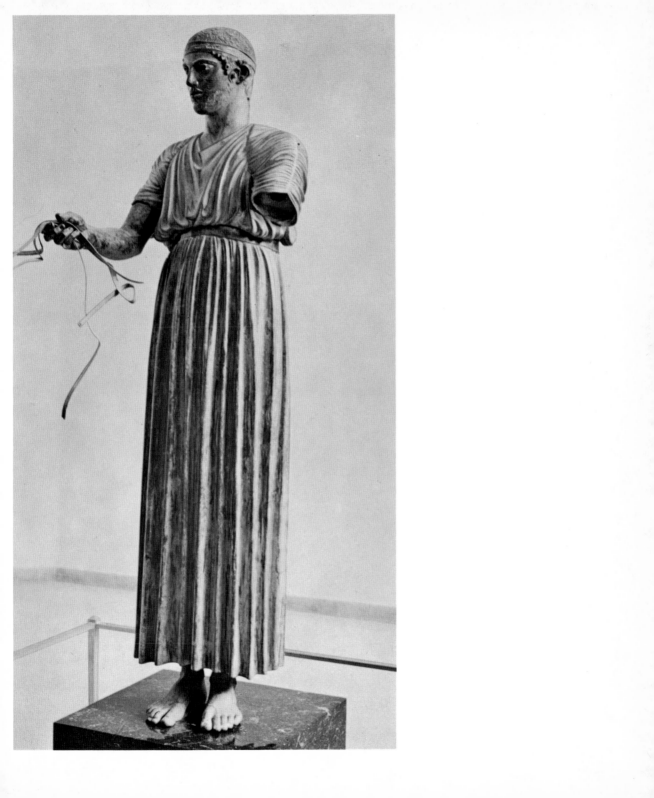

**BRONZE
CHARIOTEER
OF
DELPHI:
DETAILS**

*475-470 B.C.
Delphi, Museum*

Seen close up, the fine head and bust of this young chariot driver show an admirable skill on the artist's part. He has created here a living likeness of a noble Greek youth which goes beyond individual traits to represent a general ideal of male beauty and of cultivated inner balance and firmness. Greek humanism has here come to full flower.

The face has manly strength, serene but determined. Nose, lips, ears and chin are very natural, and the firm arch of the brows gives clarity to the whole pattern of features. The eyes are marvelously real, with their inlay of colored paste for the white and brown areas and black pupils, and their curling lashes. They seem to mirror the life within, and to be concentrating on the challenge of the contest ahead. From the back as well as from the side or front, the robust neck is most satisfying in its strength and suppleness. The hair has a beautiful regularity of scheme yet a life-like freedom and diversity which is especially appealing from the back and in the flowing curls around the ears. A meander pattern of inlaid silver decorates the headband, which has a charmingly natural knot at the back. The rounded contours of the head have just the right proportions for ideal beauty.

Whereas the long gown below the waistband conceals the body with a stateliness like a fluted column (Plate 27), the garment above the cincture is vitally related to the body's action. The strong shoulders press upon it and it billows over the breathing chest and slightly twisting back. Leather thongs (now lost) catch it up under the arms to allow them freedom of motion. The pleated folds flow with all the complexity of a wave of the restless sea, and are a marvel of observation by the sculptor's eye—as is indeed everything else in this supreme masterpiece of pre-Classical Greek art.

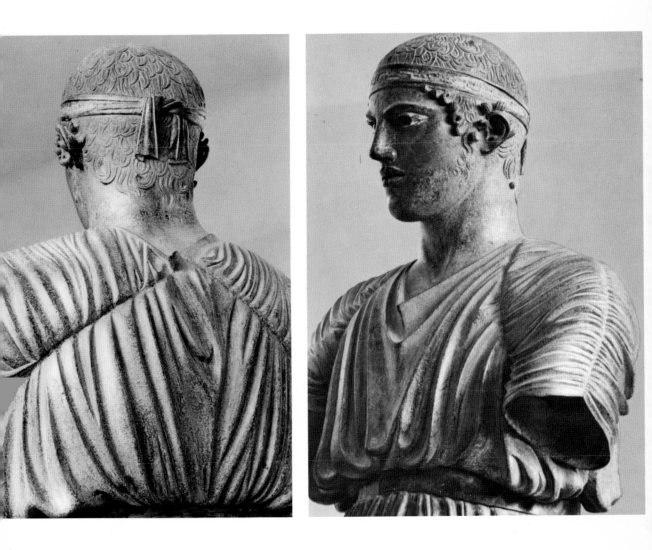

In 480 B.C., during the massive attack of Xerxes on Greece, a large part of the Persian fleet was destroyed by a great storm in the bay between the western tip of Euboea and Thermopylae. Thereafter the Greeks worshipped Poseidon, the god of the sea, under the title of Savior, as Herodotus points out (7.192). It was near the same place, off the coast of Euboea at Cape Artemisium, that a splendid bronze statue was recovered from the sea in 1928. This has proved to be one of the finest of all extant Greek bronzes and is a major treasure of the Athens museum.

The great statue, almost perfectly preserved, is more than life-size, measuring 6′10″ in height and a bit more than that across the extended arms. This fact, along with the special majesty of the head and whole figure, proves that it represents a god—perhaps Zeus, but more likely his brother Poseidon, the mighty 'earth-shaker' and lord of the ocean depths in Homer and mythology. He stands in magnificent grandeur of pose and mien, his powerful body in balanced tension poised to hurl a devastating blow of his divine trident (or thunderbolt, if this is Zeus) in defense of the Greeks. His left foot is firmly on the base, his right touches it only at the toe, the muscles of legs and torso shown in finely coordinated tautness in unison with the strong right arm drawn back for the hurl. The left arm is extended straight ahead, parallel to the weapon's course, as a guide in aiming and to keep the body weight in balance. The head is turned in concentration on the target. All is a marvel of organically correlated movement in exact anatomical detail.

Our plate gives a close-up of the god's head, to show in fuller scale its majestic lines. The strong features and beautifully modelled hair and beard combine to produce an effect of awe, of reverent admiration tinged with fear of superhuman grandeur and power. This is perhaps the most effectively religious statue that we possess from the ancient world, and it makes us wonder what the great Zeus at Olympia by Phidias must have been, to make the Greeks forget this one in speaking of sculpture that increased the beholder's veneration for the gods.

The sculptor is unknown. Some scholars have attributed this work to Calamis, others to Onatas of Aegina, yet others to Ageladas of Argos, all of whom were active in the period before the mid fifth century, the epoch of 'severe' style on the verge of the Classical Age. In any case, we have here an original of the highest merit, and can be grateful for that ancient shipwreck off Artemisium which kept this masterpiece from reaching its intended new setting in Rome, where it most likely would have eventually perished, like so many others. Poseidon's sea claimed his likeness for a score of centuries until it could give him back in our day for renewed admiration!

BRONZE
POSEIDON
OR
ZEUS

470-450 B.C.
Athens,
National Museum

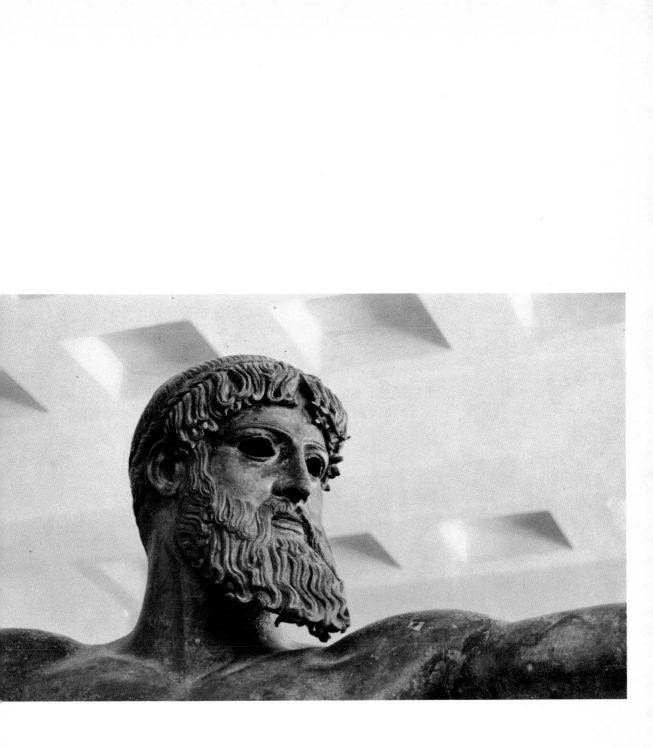

**BRONZE
APOLLO
FROM
PIOMBINO**

*c. 475 B.C.
Paris, Louvre*

Also rescued from the sea (like the objects in Plates 29, 58, 60), this fine bron
was found off the coast of northern Italy opposite Elba. It was probably made
one of the Greek cities of south Italy or Sicily, or possibly in the northern Pel
ponnesus, since the inscription dedicating it to Athena is in Doric dialect. Styl
tically, it is at the end of the transitional movement—which had already be
outgrown in Attica but which lingered a bit longer elsewhere. Archaic qualit
are still manifest in this work, but mellowed and blended with new flexibilit
The stance is very natural, with the advanced left leg turned slightly outwa
and a hint of movement of the head. The arms and calves have just the rig
muscular tension and the contours of their flesh are pleasingly realistic. A fi
chest and neck, and a well-proportioned curve of the back, show careful stud
of a living model. Divisions of the torso are not strongly outlined (an Archa
survival) but are accurate in their general aspects. The inner bulge of the ank
is properly a bit higher than the outer, and the fingers are very well execute
To achieve a tone closer to flesh, the lips, eyebrows, and nipples are inlaid
copper. As in the Poseidon statue (Plate 29), the eyes have not survived; the
were of colored paste or stone, like those of the Charioteer at Delphi (Plate 28

The right hand seems to have held a cup of offering (to Athena?) and the le
a bow. It is therefore Apollo who is represented, in very youthful guise. F
glorifies the young human body as something worthy of a god. His gentl
friendly face shows cultivation and thought and he seems absorbed in kind
reflection. The twin row of curls over his brow and the careful pattern of tl
hair above and at the back convey delicacy and refinement without loss of ma
liness. Here is the Greek ideal of youthful beauty, presented with calm assuran
that this representation of it will be appreciated.

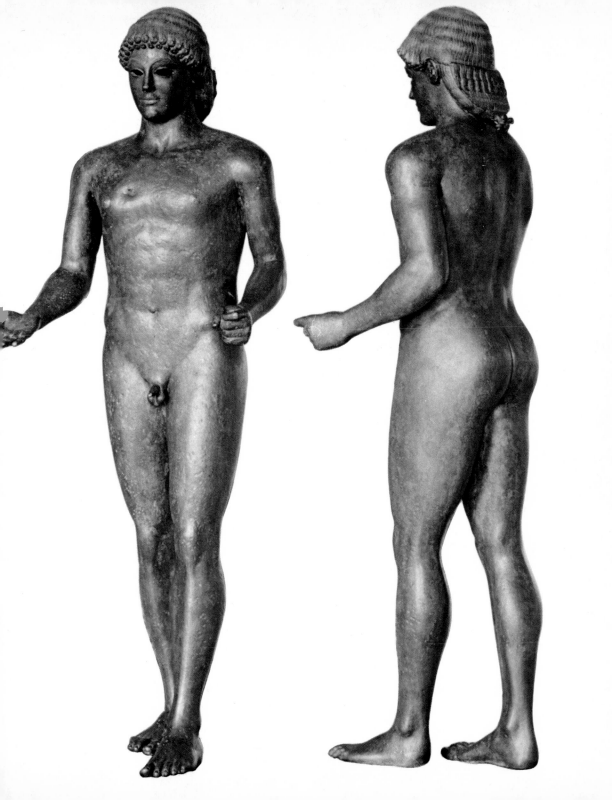

A revolution in Greek vase painting occurred around 530 B.C., when the figure technique was introduced. Probably influenced by the effects l achieved in contemporary mural painting, vase decorators began to revers traditional black-figure procedure. They now outlined the scene with a dra point on the leathery unfired clay, then working out from that line they in the background with black glaze, leaving the figures reserved in the na red of the clay (sometimes intensified in tone by a chemical additive). The details of the figures were then drawn in thin relief lines of black glaze, or sionally in brown for some parts. Vase and design were then fired for perma hardness, and subtler details scratched through the glaze. The result was more life-like: the figures were no longer dark, earth-bound, massive silhou against a light background, but now luminous and airy, the chief attraction the eye in their brightness, and closer to normal flesh color. There was also more scope for perspective, depth, and motion and for finer details. Once g a chance to show its merits, this manner of vase painting rapidly predomi and the black-figure style largely died out.

The painting here illustrated belongs to the 'Ripe Archaic' style of the fifth century. It is a little more advanced in freedom of movement than con porary Transitional sculpture, though the present example is more lively most vase painting of the time, and therefore shows this progress more strikii It is ascribed to the 'Berlin Painter' (so named because of a famous examp his work in the Berlin Museum), who may have worked for the potter Go since a vase recently found in the Agora at Athens bears Gorgos' signature an the style characteristics of the 'Berlin Painter' vases. This artist was one of finest of his day in the field of vase decoration, at a period full of famous na in that art.

These battle scenes are on opposite sides of the neck of a large wine-mi vessel, now in the British Museum. Under an elaborate floral border and al a row of rectangular 'teeth' like dentils in an Ionic architectural frieze, renow heroes of the Trojan War are represented in vigorous combat. Achilles is poising his long spear against Memnon, who holds up his shield and lu forward with drawn sword. Behind him his mother Eos (the Dawn) hold her hands in distress, while Achilles' mother Thetis shows her own ang and worry at the left. The participants' names are painted over the g for identification. On the other side, Achilles rushes against Hector, who back under his onslaught. Athena stands behind Achilles in support, and Ap (not here shown) aids Hector. Achilles' shield is the same in both scenes, bu stance is slightly different and he has changed helmets. The emotions of all effectively conveyed, and the artist shows great technical skill and vigoro original powers of composition. He has captured Homer's mood: 'Thus fought, like blazing fire.'

BATTLE
SCENES
BY
'BERLIN
PAINTER'

c. 480 B.C.
London,
British Museum

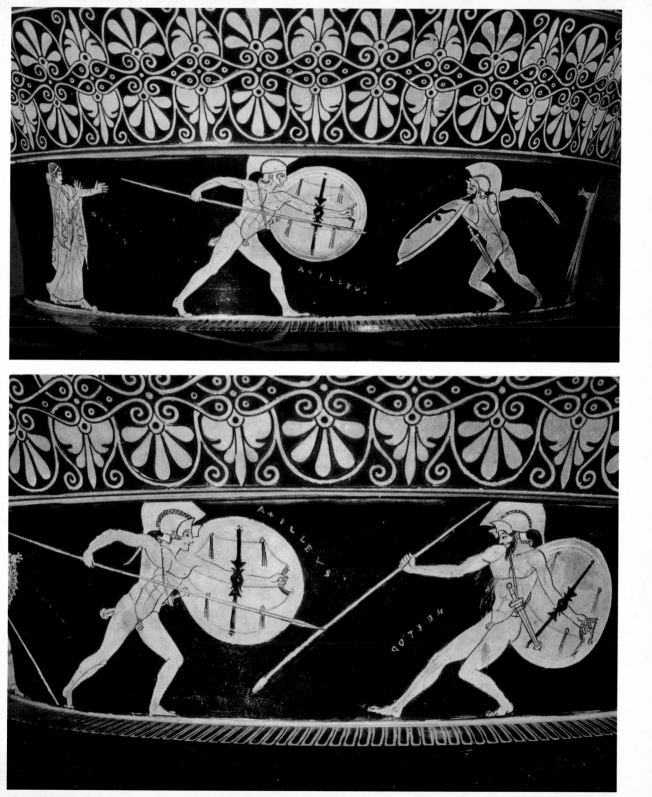

**CRATER
OF
THESEUS
AND
AETHRA**

*460-450 B.C.
Bologna,
Museo Civico*

Painted considerably later than the preceding vase (Plate 31), this bowl for mixing wine shows the great Athenian hero Theseus with his mother Aethra, as the inscriptions indicate. Probably the scene is her plea that he avenge the grieving mothers of the slain Argive chieftains after the failure of the attack of the Seven against Thebes. Moved by this entreaty, Theseus marched against Thebes and forced Creon to give burial to the leaders of the expedition.

The scene is attributed to the 'Methyse Painter', an associate of the 'Chicago Painter' whose work is illustrated in plate 34. There has been considerable restoration and touching-up on this vase since ancient time, in an attempt to recover its original calm grace.

In the painting Aethra is holding libation bowls, on her way to pray at an altar with the Argive women. It is clear that the Athenian king is receptive to his mother's pleading. His face reveals respect and affection, as hers does confidence. Both figures have a statuesque quality, accentuated by the vertical lines of the drapery and armor. They stand in graceful ease and dignity. Theseus is given heroic stature, and he dominates the viewer's attention despite the charm of Aethra in her flowing robe and simple beauty. The clarity of the composition is enhanced by the totally unadorned background, whose classical restraint and freedom from distraction allow the figures to exert their full human interest. An enriching framework is provided by the attractive borders above and below the scene. The vase well illustrates the dignified beauty which made the better Attic red-figure pottery so widely popular in the ancient world and still wins it admiration.

Theseus was a favorite subject for Greek artists, because of his fame as a founder of Athens' glory and his varied adventures. Many vases, mosaics, and mural paintings represent him in combat with the Minotaur in Crete, slaying the bull which was devastating Marathon, descending to Hades to seize Persephone, winning or abandoning Ariadne, and in other episodes from the multiple legends which rival those of Heracles himself in number and daring.

**CYLIX
INTERIOR
BY
DOURIS**

*c. 480 B.C.
New York,
Metropolitan
Museum of Art*

Among the finest of red-figure vase painters, Douris was active from around 490 to 460 B.C. Over two hundred extant vases are ascribed to him, many of them bearing his signature, the rest identified by his characteristic style. The example here illustrated belongs to his middle period, when his manner of painting had reached full development and sure control. Douris' style is somewhat academic in its careful purity and balance and its neat design exactly fitting the available space. His drawing is firm and confident, with an easy naturalness that reveals a clear, fastidious mind and a serene outlook on life. A conversation scene like this one is a favorite subject in Douris' work—and surely popular with the Greeks, who had such a love of discussion and talk. Here, an older man is making an agreement with a seated youth, and holds a money-bag for bargaining. In the background is a sponge and a net bag. The chair on which the youth sits is of a type often seen on Greek vases and reliefs, and has been copied by modern designers.

The two men are intently looking at one another as they converse. Their hands are very agile and expressive—a special feature of Douris' style. Details of muscle and body-structure are sketched with care, but not elaborately. We see here an instance of the use of brown paint, as well as black, for some of the surface features. The rounded zig-zag made by the border of the garment (himation) is characteristic of Douris' manner and adds strength to the general delicacy of the composition.

The lettering above the figures says that 'the boy is handsome,' a common inscription on Greek drinking cups, in accord with the national admiration for youthful beauty. Often such vases were meant as a gift to a friend after the banquet at which they were used. In any case, to be served from one was a graceful compliment.

STAMNUS
BY
'CHICAGO
PAINTER'

460-450 B.C.
Boston,
Museum of
Fine Arts

The elegant vase here seen is an example of the 'early free style' manner which was in vogue in the second quarter of the fifth century B.C. A leading master of that style was the 'Villa Giulia Painter,' many of whose fine vases survive. One of his outstanding disciples or associates is known as the 'Chicago Painter' because of a stamnus—very much like the present one—now in the Art Institute at Chicago. This Boston example is even more attractive, and an excellent illustration of the artist's characteristics. The stamnus shape (for storage of oil or wine), with its extensive open areas and pronounced shoulder curve, poses special problems in the choice and arrangement of figures. The solution here is to distribute three standing women at equal intervals in each panel between the handles, with an elaborate floral design in the handle areas themselves.

From the vine sprigs and thyrsus (a staff with pine-cone top) which some of the women hold, it is evident that the scenes represent a Dionysiac festival. The stance and direction of the figures are artfully varied, as are also their headbands. There is careful effort to create both balance and beauty, and to enliven the composition with some motion rather than to present merely statuesque individual figures. The faces are delicately drawn, and the hands are given a lively role. Drapery lines add to the long vertical forms a pattern of their own, to keep the viewer's eye active. This artist is not as successful as some others, however, in achieving complete naturalness in the arrangement of the garments and their folds.

The floral scheme around the handles is almost opulent, but stays short of excess. It is cleverly adapted to the available space, and adds significantly to the overall effect of controlled elegance.

WHITE-
GROUND
ALABASTRUM
BY
PASIADES

c. 520-510 B.C.
London,
British Museum

The use of a white surface slip over the clay, to give special richness and distinction to a vase, goes back into the early period of Attic pottery (Plate 18) and continues throughout the fifth century. The example here shown, from the archaic era of red-figure work, reveals a developing technique. The figures are drawn in outline with brown or black paint, then partly filled in with solid colors—brown, yellow, red, green, blue are the most common tones. The result is particularly attractive, and such vases must have been more than usually expensive. It is mostly for special purposes that the white-ground style is employed: fine personal items such as toilet-boxes or drinking cups, or oil-flasks to be buried with the dead or offered at their tombs. In the present instance, the vase is a scent-bottle (5¾ inches high), in the elongated oval form known as an alabastrum because many such vases were carved from alabaster. (It was an alabastrum of precious nard which the reverent woman poured on the hair of Jesus at Bethany, as St. Mark specifies: 14.3). The normal contents would be some sort of perfume or ointment, and shape and design are aimed at a lady's taste.

The drawing is sharp and animated, its lines few but sure, giving figures of effective clarity. The lively faces of both girls, and their forceful action, attract our attention to the human element of the picture, despite the strong interest of the graceful bird with its emphatic black silhouette and bright dangling feathers. Part of the general appeal of this vase is surely the color itself—the rich ivory tone of the body and the luminous yellow of the garments. Without the firm lines above and below the figures, much of the design's satisfying stability would have been lost, for they serve as a frame to concentrate our attention on the essentials. Pasiades' signature near the top indicates the potter's justifiable pride in this delightful vase, which was painted by one of his best artists.

Some interpret the scene as a ritual cleansing of a house by use of a leafy branch dipped into lustral water from the cup (phiale) which is shown. The tame heron may symbolize the domestic setting, and the panther skin worn during the sprinkling implies that the ritual is connected with the cult of Dionysus.

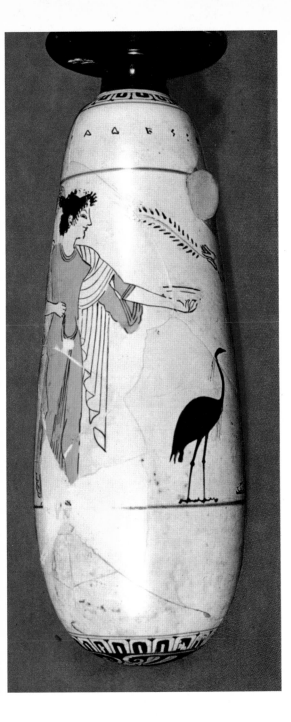
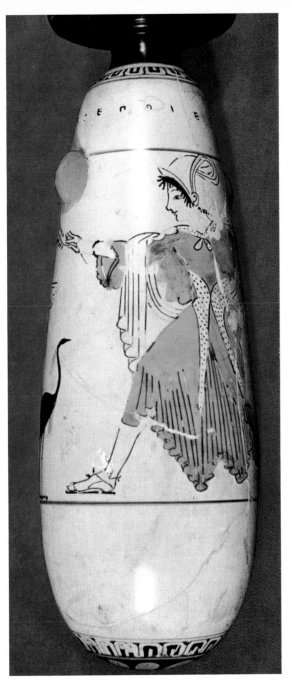

WHITE-GROUND PYXIS

460-450 B.C.
New York,
Metropolitan
Museum of Art

Found in a Greek tomb at Cumae in Italy, this excellent example of a lady's box for toilet articles further illustrates the special qualities of white-ground pottery. The shape is attractive, with its balanced proportions and strong sweeping curve at top and bottom. The fine lid, with its neat knob and pleasing decoration, adds much to the general effect of refinement and subdued elegance. Three notches in the inset base break up the supporting rim into triple feet, providing stability without massiveness. A little under six inches in height, this vanity-box must have been treasured by its owner and was buried with her as a cherished possession and a tribute to her love of beauty.

The ornamentation is by the 'Penthesilea Painter,' whose other works show similar delicate sensitivity of drawing and gay humorous treatment of traditional subjects. Here the theme is the Judgment of Paris, that first beauty contest—a very suitable subject for a cosmetics box. Paris is seen seated on a rock in the guise of a youthful shepherd. He holds a club to protect his flock, and is dressed in a chlamys mantle, which like the petasos hat slung over his shoulders is indication of his rustic role, since these garments were worn for working, hunting or travel. He has knit stockings on, with high-laced sandals over them. Hermes stands before him, with his messenger's staff (the kerykeion) and winged boots, explaining the proposed competition to the chosen judge. Beyond Hermes is Hera, queen of the gods, in Ionic chiton and mantle, with a long veil. On the far side of the vase, here out of view, are Athena in her traditional peplos and wearing her aegis, and Aphrodite in Ionic dress, carrying a perfume jar and accompanied by little Eros or Cupid. Behind Paris stands Priam, king of Troy, with a long gnarled staff.

The drawing is deft and individualized. Faces are interestingly vivid, with psychological subtlety in character depiction; the eyes, brows, and nostrils are effectively sketched, and the poses of all are very life-like.

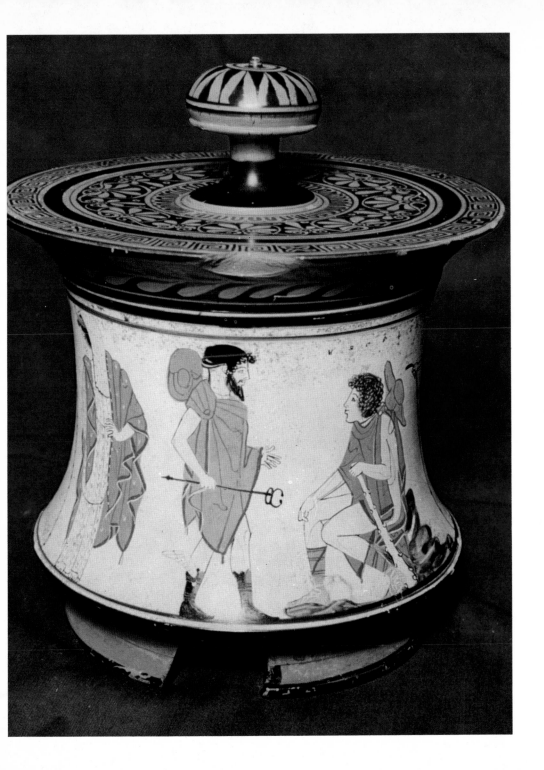

PAINTED AMAZON RHYTON BY SOTADES

*c. 440 B.C.
Boston,
Museum of
Fine Arts*

The potter Sotades, who has signed the remarkable vase here illustrated and several others, specialized in unusual shapes of drinking-cups—one in London is in the form of a knuckle-bone, another is a crocodile attacking a negro boy, others are a ram's head, a sphinx, a cow's hoof, etc. The present sample of his work is a conical drinking-horn with strong handle, fastened to a mounted Amazon who serves as its support. It was found at Meroë in Ethiopia, a clear testimonial to the distant markets for Athenian pottery.

On each side of the cup is a red-figure scene, in the mid-fifth century manner, of combat between an Amazon and a Greek. The crescent shield and mailed leggings of the warrior maiden are intended to stress the Amazon's foreign origin. The same subject, battles with Amazons, had also been used to decorate the metopes of the Parthenon a few years before this vase was made.

The main theme of interest is the molded support and its bright coloring. Surviving bits of paint show that the horse was white, like the rider's face and hands, the reins and bridle red. The Amazon's trousers were a rich purple, her sleeved jacket blue with scattered dots of red, her helmet and its crest also red, with projecting violet ears. There is indication that her shoes were white, with red soles and purple thongs. The horse's eyes and nostrils were likewise colored. On the green base below the horse is a snarling lion in white (on the other side, a wild boar). A hunting spear was once held in the rider's right hand, as the opening for its shaft indicates. The modelling of horse and Amazon is very careful and realistic—much superior to most terracotta figurines, with which it might be classed. In this respect it is comparable to good bronze statuettes of the Classical period.

This must have been a rather heavy and cumbersome vessel to drink from—especially wine! But it was surely a prized curiosity and conversation piece at any banquet in its owner's home.

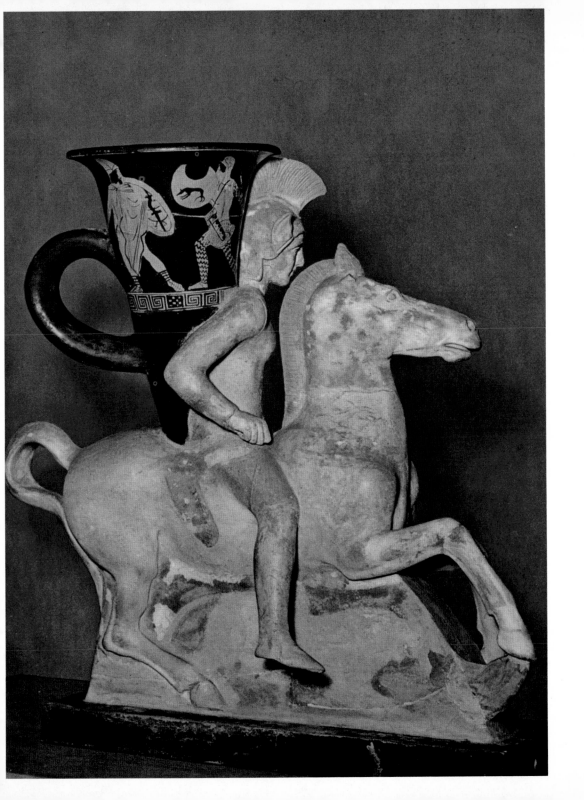

**BRONZE
OENOCHOE**

*c. 450 B.C.
Boston,
Museum of
Fine Arts*

The use of bronze for household vessels, instead of more fragile pottery, was not very widespread in Greece until the fourth century and after. This was probably due to its expense, but a liking for the graceful shapes and attractive decoration of the easily obtained clay vases must also have been a reason for their popularity, as we can readily understand. Some bronze vessels were produced, however, in the fifth century and earlier, of which one of the finest known is this wine-pitcher in Boston. It is eleven inches high, with a trefoil pouring lip similar to that on the vase in Plate 18. The rim border borrows from architectural frieze motifs for decoration, and the orderly row of incised petals on the shoulder, with dots and spirals beneath, takes the place of the painted scene ornamentation of the better-class clay vases.

Of special interest is the decoration of the handle, which was a separately cast unit soldered onto the vase's rim and shoulder. The girl is a graceful addition, bringing the expected human touch to the composition and an element of variety. She is carefully molded, with clean-cut lines of face and body. Her Doric peplos and hair style (with rolled pleats under the head-band) reveal the influence of Peloponnesian traditions, which were strong in south-eastern Italy where this pitcher was found and probably produced. To each side of her, at the rim's edge, is an upright disk holding a *phiale,* the type of saucer used in libations and votive offerings. The lotus bud above her head, and the sphinx with outspread wings which decorates the handle's base at the back of the vessel, are echoes of remote Egyptian and Eastern influences long since assimilated into Greek art as symbolic ornaments. Beneath the sphinx is a floral palmette, adding one more detail of tasteful elegance.

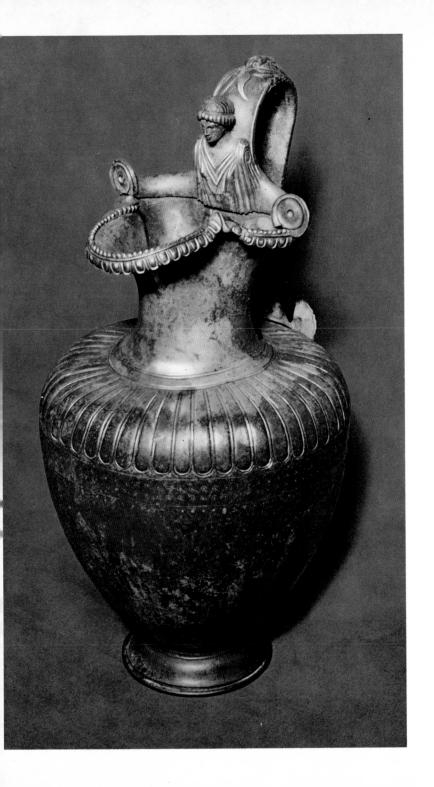

DISCUS-THROWER BY MYRON

460-450 B.C.
Rome,
National Museum
(Terme)

With this splendid statue, we are clearly in a new age of Greek sculpture. It is the beginning of the Classical period, when the limitations and progressively more confident technique of the Archaic and Transitional epochs have given way to complete mastery of the sculptor's art. It is doubtful that any more perfectly satisfying study of the intrinsic beauty of the male body has been produced than this magnificent presentation of its harmonious symmetry and proportion. Here, caught at the moment of balanced poise just before their unified exertion in hurling the discus, the youth's torso, limbs, and muscle are all depicted in lithe action and vitality. The composition of the figure is admirably unified into a strongly conceived whole. The artist knows exactly what he wants to represent, and his acute observation of every detail of his living model is matched by his ability to suggest pent-up energies on the verge of bursting into vigorous but smoothly controlled motion. He has captured the body's dynamism by choosing precisely the right moment of the athlete's action, when every force of his superbly developed physique is in co-ordinated readiness for the throw.

Surface modelling is equally masterful. The muscles have just the right tautness and prominence, the flesh is firm and lively, major veins of hands and arms show their pulsing vigor, and all contours of the body are beautifully proportioned in their rhythmic flow. The sweeping arc of arms is continued by the inner leg and counter-balanced by the torso's curve in the opposite direction, completed by the outer thigh. The round discus is balanced by the circle of the head, at equal distance from the center of gravity on which the body pivots. The vertical line of the lower right leg provides dynamic contrast to these correlated curves, and is an element of stability and strength. It is paralleled by the vertical left foot, resting on its bent toes, and is given effective counterpoise by the horizontal line of the right foot and supporting base. This attention to intelligible pattern, to repetition and variety and pleasing inter-relationship of lines, is characteristic of the Greek mind in its best literature and art. In Myron's brilliant statue, the Greeks could see these qualities of the national taste achieved with eminent clarity. The Discus-Thrower made a deep impression on them, as several ancient references to it reveal. Some earlier sculpture had begun to express motion and to break away from archaic poses, but nothing so dramatically active as this had yet appeared. It marked Myron as a great creative pioneer and major artist.

The original statue was in bronze. Of the several copies that survive, the one best preserved is shown here. It formerly belonged to the Lancellotti family collection. The supporting tree-trunk behind the figure, and the marble brace in back of the fingers, are additions, unnecessary with bronze. Fine as this copy is, the original must have been even more brilliant and satisfying.

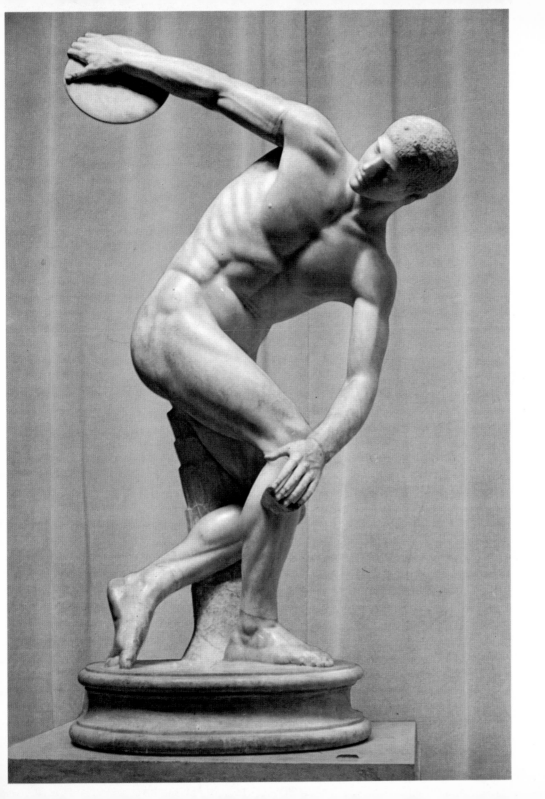

CENTRAL
WEST
PEDIMENT
OF
ZEUS
TEMPLE
AT
OLYMPIA

c. 457 B.C.
Olympia,
Museum

About ten years after the Persian Wars, a great Doric temple was begun at Olympia, the site of the ancient religious and athletic festivals which we know as the Olympic Games. Completed in 456 B.C., the huge limestone structure housed the colossal gold and ivory statue of Zeus by Phidias which the Greeks and Romans considered the greatest of all religious sculptures. Above the columns at the front and back of the inner cella, inside the surrounding peristyle pillars, ran a series of rectangular relief panels ('metopes') depicting the labors of Heracles. In the triangular pediment areas above the front and rear colonnade were two large groups of statuary in Parian marble. That on the east facade showed preparations for the chariot race between Pelops and Oenomaus, the legendary basis of the Olympic Games. On the western pediment was presented the battle between Centaurs and Lapiths which broke out at the marriage feast of the Lapith king Pirithous and his bride Hippodamia. The Centaurs, excited by too much wine, tried to carry off some of the Lapith women and youths, but were eventually overpowered, partly by the aid of king Theseus of Athens who was a guest, but mostly because of Apollo's protecting influence.

The pedimental sculpture is the work of several artists, but these cannot be identified with certainty. A master craftsman evidently planned and supervised the whole project, and probably did the central divinity of each group. Many of the figures were found, badly damaged by their fall from the high building, in the excavations at the site in 1875-1881. Pausanias has described them at length (5.10.5-8), as he saw them intact in the second century A.D. They are now displayed in the Olympia Museum.

Our illustration shows the center of the western pediment. A Centaur is trying to abduct a Lapith woman, who desperately pushes him away by his ear and beard, making him grimace with pain. At the left, Theseus intervenes (he was shown with an axe raised high in both hands); his fine head has heroic nobility, his face reveals intense concentration on his task. To the right, towering above all at the highest point of the triangular tympanum of the pediment, stands Apollo in majestic grandeur. His raised arm signifies an imperious disapproval of the drunken Centaurs' wild lawlessness. His head is peculiarly awesome in its stately beauty, with an austere simplicity and super-human dignity befitting the god of light and culture. It is one of the noblest remnants of Greek art, fortunately in nearly perfect preservation.

The bodies show careful anatomical correctness, in the early Classical manner with its emphasis on the muscles of the lower abdomen and its continuation of the forehead contour into the line of the nose. Some of the earlier formalities linger, in the treatment of the hair and drapery, and the poses are an interesting compromise between Archaic rigidity and the new stress on realistic motion. Some traces of red coloring are still discernible, especially in the drapery and hair.

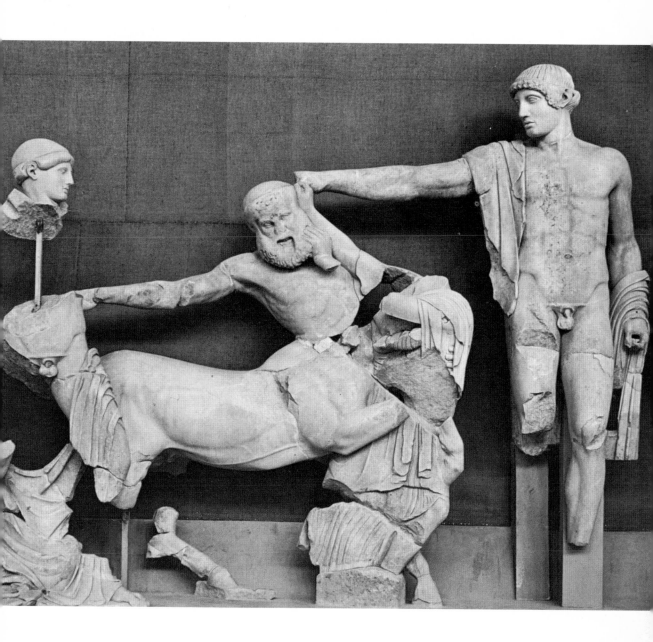

ATHENA
LEMNIA
BY
PHIDIAS

c. 450 B.C.
Bologna,
Museo Civico

This nobly beautiful head is a Roman-age copy of a Greek statue of a goddess probably the famous Athena Lemnia by Phidias which stood on the Acropoli in Athens. Ancient writers like Lucian, Pausanias, Pliny, who knew a vast number of Greek masterpieces now lost to us, speak of the Lemnian Athena as the most beautiful work of the greatest of classical sculptors.

From their descriptions and other sources, it appears that this statue, dedicate by Athenian colonists on Lemnos Island shortly after the middle of the fift century B.C., was of bronze, a full standing figure with helmet in one hand and a lance in the other. It bore Phidias' signature. They speak with admiration o its lovely countenance, delicate cheeks, and finely proportioned nose. Pliny say 'it was of such outstanding charm that it was called "The Beautiful".'

Furtwängler has identified the marble head in the Museo Civico at Bologn (here illustrated) and two full statues in Dresden as copies of the celebrate Athena Lemnia. Although some scholars hold out against this theory, many ex perts accept it, and it seems highly plausible. Even the second-hand impressio inevitably given by a copy marks this lovely head as worthy of a supreme artis in the high classical period. It is the perfect expression of that purity of taste simple directness, and dignified humanism which was the Greek ideal in litera ture and art of the Periclean Age. Here the essence of classical art can be seen and enjoyed. No wonder that the better original was so admired!

The copyist, probably a Greek artist of the first century before Christ, ha translated into marble some of the qualities of the bronze: the special waving o the hair, the distinct lines of eyebrows and nose, the natural contour of the lips the hollow eyes (the original would have inset eyes of stone). Many subtle re finements of Phidias' own work must be missing in this imitation. Enough sur vive to indicate how fine an artist he was.

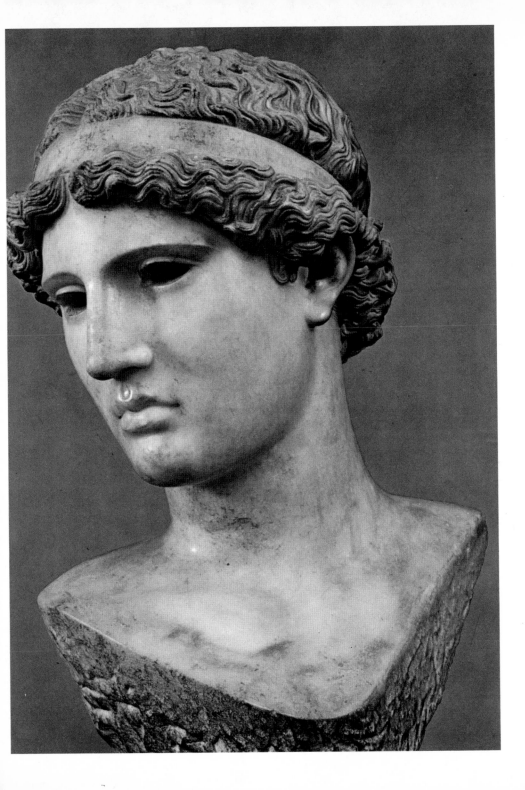

Dominating the Acropolis at Athens, the Parthenon is the noblest of all Greek temples, unmatched in the combination of its subtle refinements of design, beautiful Pentelic marble, and magnificent sculptural decoration. It is in the Doric style, sharing the harmony of proportions and stately strength characteristic of that order (cf. Plate 45). Ictinus was the architect, Callicrates the masterbuilder, and Phidias was in charge of the decorative sculpture. He also made the gigantic statue of Athena covered with gold and ivory which stood, nearly forty feet high, in the eastern inner hall of the building.

The illustration is from the south-eastern corner of the frieze which ran along the outer wall of the temple's cella—the rectangular room inside the colonnade. This frieze was an Ionic feature added to the more austere ornamental traditions of Doric buildings. It extended for well over five hundred feet, around all four sides of the temple, as a continuous strip (forty inches high) of figures in low relief. The theme is the Panathenaic procession, in which the sacred peplos was ceremonially brought to Athena, the city's chief patroness. Among the hundreds of figures on the long frieze—knights, horses, magistrates, musicians, maidens, bearers of trays and pitchers, and sacrificial victims—this lowing heifer could easily be overlooked in the thronging multitude. But like so many others in the long procession, it has been carved with the utmost care, as if meant to be an object of primary attention. With marvellous naturalism, the animal seems alive, not merely stone. It strikingly exemplifies the superb technical skill of the high Classical age, and its sympathetic feeling for animals as well as human subjects. The beast's apprehensive feelings, and its plodding patience, are graphically depicted, and the significant details of its wrinkled skin, sad eyes, and sensitive nose are masterfully wrought. Even the best of Egyptian reliefs, with their millennial traditions in animal sculpture, are not more effective. The unknown Greek artist of this evocative figure, one of many who worked on the frieze under Phidias' supervision, has added to the high fame of his nation by this demonstration of what it could produce.

Though some of the frieze is still in place on the Parthenon, most of it is now in London, among the celebrated Elgin Marbles. It was there, in the British Museum, a few years after they were put on public display, that Keats saw these Parthenon sculptures and was deeply impressed by their timeless beauty. He seems to have singled out and remembered this figure above the others, and incorporated a reference to it, among quite different recollected scenes, in his *Ode on a Grecian Urn:*

> To what green altar, O mysterious priest,
> Lead'st thou that heifer lowing at the skies...?

PARTHENON FRIEZE: LOWING HEIFER

442-438 B.C.
London,
British Museum

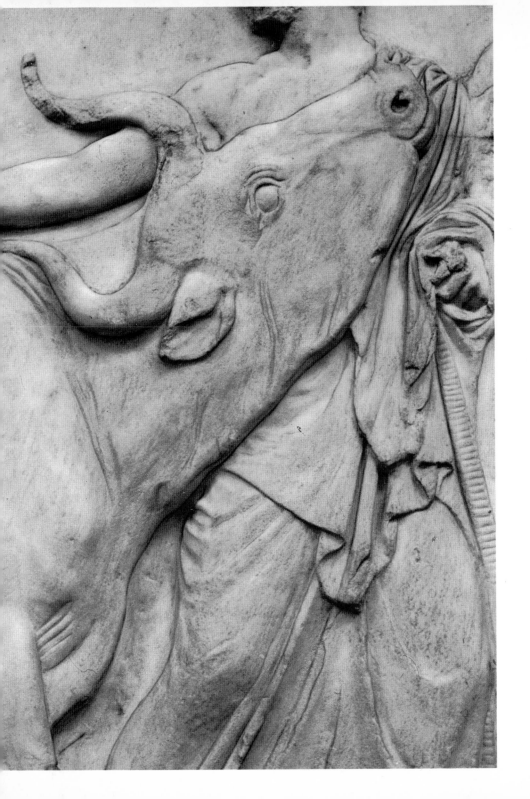

Plutarch said of the great buildings and sculpture produced at Athens on
initiative of Pericles that 'they seem to have within them some everlast
breath of life and an ageless spirit intermingled with their composition' (Peri
13). He meant primarily the Parthenon and its sculptural ornamentation. H
justified was his admiration is clear from this example, now among the El
Marbles in the British Museum. It is one of the horses of Selene, the m
goddess, shown exhausted and panting after a hard night's work drawing
chariot across the sky. Wonderfully realistic, the tired steed's head is a triun
of animal sculpture. The bulging eyes, flaring nostrils, drooping mouth, a
pulsing veins under the sagging skin unerringly achieve the effect of wearin
while retaining a sense of the horse's noble spirit and proud physique. T
sculptor is unknown, but Phidias' guidance toward such perfection of refinem
and ethos may be presumed, since he was general supervisor of all the Parther
sculptures in their design and execution, as Plutarch and others record.

The triangular pedimental areas at each end of the Parthenon, above the ou
row of eight Doric columns, measured nearly ninety-three feet across and o
eleven feet high at the central peak. Into that space were fitted groups of sta
ary forming unified scenes. On the western pediment was represented
contest between Athena and Poseidon for being chosen patron of Athens, w
several other divinities present. The eastern pediment showed the birth
Athena, who stood near the central throne of her father Zeus, while other ge
and goddesses filled the remaining space. At the south corner was the sun-g
Helios and his four-horse chariot, rising from the sea to bring a new day,
horses snorting with fresh vigor. At the opposite corner, in the angle at
north end of the pediment, the moon-goddess Selene was seen sinking belo
the horizon in her chariot after traversing the night sky till dawn. Her stee
weary heads contrasted with the lively eagerness of the horses of the sun, a
the implied motion of emergence from the sea and of setting into it, at oppos
ends of the pediment, gave vitality to the scene and the effect of symbolizing
whole expanse of the heavens from one horizon to the other. Clearly it wa
brilliant composition, neatly fitting the triangular space available, and of t
highest artistic merits in its execution—as this marvelous horse head prov
and the other remaining figures in the Elgin room in London.

**PARTHENON
EAST
PEDIMENT:
TIRED
STEED
OF
SELENE**

*438-431 B.C.
London,
British Museum*

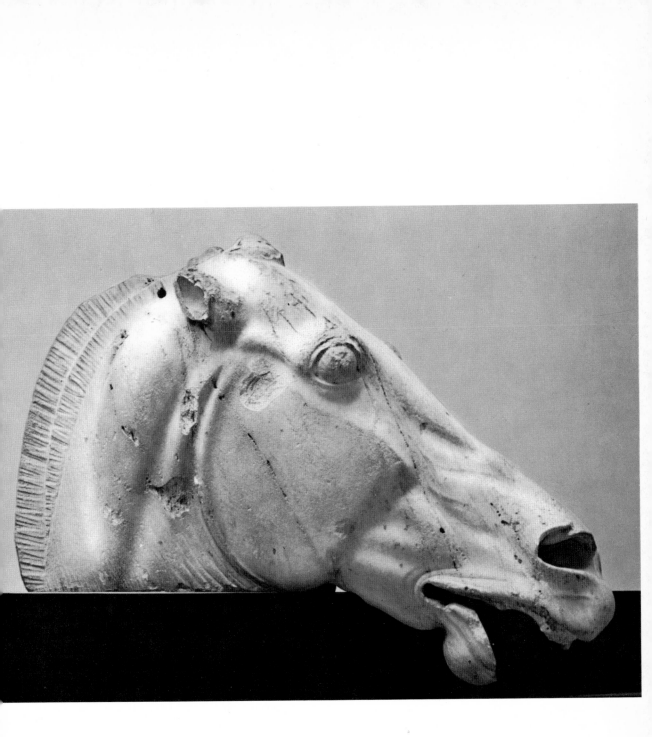

**BRONZE
ATHLETE
HEAD
FROM
BENEVENTO**

*5th century B.C.
manner
Paris, Louvre*

Found at Benevento, this beautiful head is probably a fine Augustan-age imitation of the Greek style of mid-fifth century B.C. It combines excellent physical naturalism with a nobly idealized treatment of the realities, producing a life-like head that is raised above the ordinary level of life to become an image of man at his best. That was essentially the Classical ideal in Greek literature and art, and the explanation of their universal and timeless appeal. The young athlete here depicted with such serene clarity of gracefully proportioned features lets us enter into the Greek conception of human worth. He stands for an attitude that looked on man with intelligently founded respect, that was sanely balanced and constructive. There is no exaggeration or distortion here, nor any weakness of sentimentality. The strength and soundness of the piece lie in its wholesomeness the sculptor's art has made transparent the inner qualities of manly beauty which are intrinsic to man's nature when properly developed and realized. This statue is more than a representation of an individual youth. It goes beyond that into the realm of philosophy.

Apart from the clean contours of the face, with its harmoniously proportioned nose, lips, and eyes, a major element in the head's attractiveness is the masterful treatment of the hair. It seems entirely natural in arrangement, with no suggestion of artificiality or pretense. Yet analysis of its pleasingly varied lines in three dimensions reveals a most carefully thought-out design, which unobtrusively succeeds in both fascinating and rejoicing the eye as it follows the pattern. The mottled surface tone of the skin is due to oxidation and abrasion. The missing eyes were originally of life-like hardened paste or stone, as in the Charioteer or other bronzes where they survive (cf. Plates 28, 58, 60). The lips were inlaid in copper for a more natural effect, as on the statue seen in Plate 3. It is likely that the style of the head is modelled on the noble classical works of the great sculptor Polyclitus, a contemporary of Phidias.

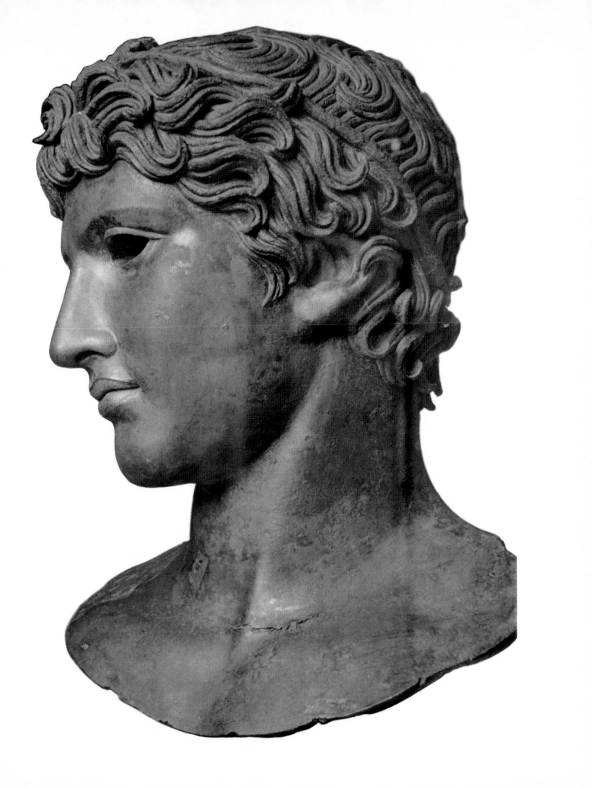

The Doric style of architecture may be thought to have reached its finest artis[t]ic achievement in this splendid temple at Paestum in Italy, some sixty miles sou[th] of Naples. The Parthenon at Athens is a greater structure in several ways, b[ut] has Ionic elements. This masterpiece at Paestum is pure Doric, and surely one [of] the noblest and most beautiful buildings ever constructed. In the rosy glow [of] sunset its stately grace and dignity take on a further charm of golden warm[th] and richness. The background of blue sky and red oleanders fits in naturally, [to] make a visit to this site in good weather an experience which thrills even t[he] most widely traveled, and a memory which no others can eclipse.

This glorious temple is fortunately almost completely preserved. Its roof a[nd] cella wall are gone, and no decorative sculpture survives (it is not certain tha[t it] had any), but all its major elements remain in place. It is built of a porous lim[e]stone that originally had a covering plaster of ground marble. Perhaps its pe[di]ments and metopes had painted figures. Bright blue and red and gold on[ce] colored the upper architectural details.

Long ago mistakenly named Poseidon's temple (the Greek city was call[ed] Poseidonia), it seems from votive remains and other evidence to have been [in] honor of Hera. So also were most of the many other temples here, including t[he] 'Basilica' which partly appears to the right, farther south. Most likely the temp[le] was built around 460 B.C., half a generation before the Parthenon. It measu[res] 79 × 197 feet, with six columns along the east and west ends and fourteen do[wn] each side. These columns are 29 feet high, 7 feet in diameter at the base, taperi[ng] to 5 feet at the top. This proportion of height to diameter ($4\frac{1}{4}$: 1) is considerab[ly] lower than for most fifth-century Doric—the Parthenon, for instance, is in [a] $5\frac{1}{2}$: 1 ratio.

The aesthetic merits of the whole design and its interrelated dimensions a[re] of the highest order. The beholder's mind is adroitly enticed to notice the ha[r]monious proportions and rhythmic order, and led to rejoice in the lucid inte[l]lectual pattern. Men of all centuries and cultures feel a common awe and delig[ht] in the presence of this pure beauty, a triumph of Greek universality and hum[an] insight.

PAESTUM, 'POSEIDON' TEMPLE AT SUNSET

c. 460 B.C.
Paestum

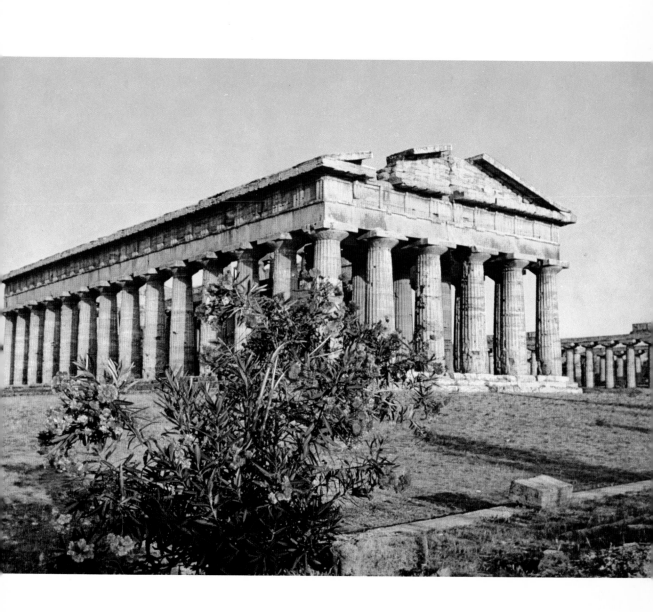

The Erechtheum was constructed, near the north edge of the Acropolis, in th
troubled period after Pericles' death when the Peloponnesian War was goin
badly for Athens and funds were limited. Despite these handicaps, and the extra
ordinarily difficult architectural problems involved by the necessity of inco
porating earlier shrines into the structure, the Erechtheum ranks as the finest (
all Greek temples in the Ionic style. It later suffered badly from fires, fro
adaptation into a Church and then into a Turkish mansion, and from the carryin
off of much of its materials for use in medieval and later buildings. Even so, th
remains have a noble beauty all their own.

Where Doric temples like the Parthenon or that at Paestum (Plate 45) hav
an austere simplicity of line and an air of dignity and masculine strength, th
Ionic order is more delicate and ornate, with a somewhat feminine quality (
gracefulness. The columns are thinner in proportion to their height, and n
noticeably larger in their lower sections as are the Doric. The fluting seen
deeper because in narrower bands (24 fluted grooves in a column, where Dor
usually has 20) and because of the flat ridge between them instead of the shar
Doric form. The upper portions of the column, and the whole entablatur
system above the colonnade, are distinctively different also. The capital is in th
shape of volute scrolls to left and right of the column, joined by a handsomel
curved bolster over the shaft. The round 'echinus' cushion under the bolster ha
an ornate moulding in egg and dart pattern, which is repeated with variatio
in other elements above it. A special feature of the Erechtheum is the adde
'anthemion' band immediately capping the column, with its flowery leaf desig
of sculptured decoration. The architrave is in three horizontal bands, the upp
two each projecting slightly beyond the one below it. Between the upp
moulding of the architrave and the overhanging cornice is the frieze, which o
the Erechtheum was of blue-gray Eleusinian marble on which separately carve
figures in white marble were fastened by pegs, to give a most attractive contras

The base of the Ionic column is also designed with exquisite symmetry (
related curves. These sweep out and in and out again with rhythmic grace, an
make a most effective transition from the vertical lines of the shaft to the horizon
tal plane of the stylobate steps. All is most carefully worked out for the mo
pleasing inter-relations of form and measurement. The flutings, projection
grooves, and relief ornamentation have the further purpose of creating interestin
shadow patterns, to relieve the eye from the bright glare of white marble. A
the sun moves across the sky, these patterns shift and change, giving an illusion o
endless variety to the building, and almost of life.

The Erechtheum took over the functions of a primitive temple to Athen
which was largely destroyed by the Persians when they captured the Acropol
in 479 B.C. It was also a shrine to Poseidon, and to the legendary early king o
Athens, Erechtheus – whose strange story was made into a poetic tragedy b
Swinburne.

ERECHTHEUM: IONIC COLUMN DETAILS

421-405 B.C.
Athens, Acropolis

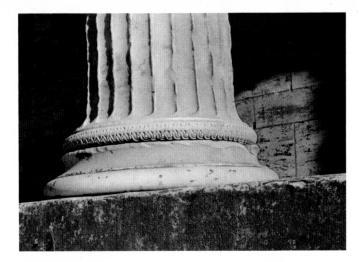

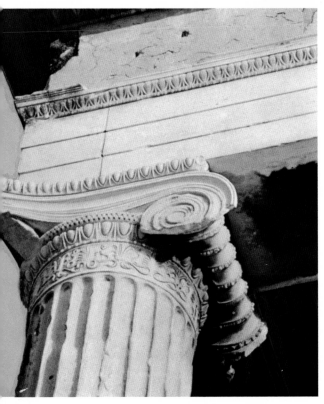

A clear refutation of the false notion (especially current in the Renaissance) Classical art means fixed adherence to established conventions, on the score they represent fully achieved perfection, is the remarkable South Porch of Erechtheum. Here, at the peak of the Classical Age, is bold originality and crea experimentation for new effects. The idea of substituting standing maidens structural columns had occurred earlier in Greek architecture (it was used the porch of the Siphnian Treasury at Delphi, around 525 B.C.), but was tainly not customary. Another known use in Ionic buildings is here in the Ere theum, where it gives striking variation from the elegant but traditional col nades of the porches on the eastern and northern sides of the temple (Plate . In their own special way, these graceful figures emphasize the feminine delic of the building's whole design and ornamentation, and give to it a unique hun touch which has charmed all beholders by its quiet effectiveness.

There are six maidens in all, four across the width of the projecting porch, behind each of the corner figures. They are basically similar in stance and pearance, but each has subtly individual aspects, too – in the drapery of tl flowing garments, in the arrangement of their hair, and in physical featu Furthermore, each is supporting her weight on her outer leg (as viewed fr front center), which is fully vertical and hidden behind the straight folds of peplos dress, while the inner leg in each case is relaxed and bends slightly at knee, thus pressing against the long garment and altering the depth and conte of its folds. This adds an ingenious variety to the balanced arrangement, as v as a hint of motion.

Seen from the side and rear, the figures are equally attractive. Their fin proportioned bodies and the simple dignity of their dress establish an impress of serene beauty and human interest. There is no effort or awkwardness in th posture as they support the upper structures on their heads. They seem utte natural, indeed somehow appropriate here, and would certainly cause no surp to ancient Greeks, accustomed to people carrying bundles or baskets or water-j balanced on their heads with effortless unconcern, as may still be observed in Mediterranean world. The architect has cleverly lightened their burden omitting on the South Porch the figured frieze which elsewhere runs abc the architrave. He has substituted for it a row of rectangular serrated 'dent and added a series of rosettes along the uppermost step of the architrave. The m of hair over the shoulders provides necessary supporting strength, without ne of making the necks unnaturally thick.

The figures, whose vertically pleated garments resemble the fluted Io columns which they have displaced, are somewhat over life size. The te 'caryatid' is a later name for any such architectural supports in the guise women. These on the Erechtheum were originally known simply as 'T Maidens.'

ERECHTHEUM: CARYATIDS OF SOUTH PORCH

421-405 B.C.
Athens, Acropolis

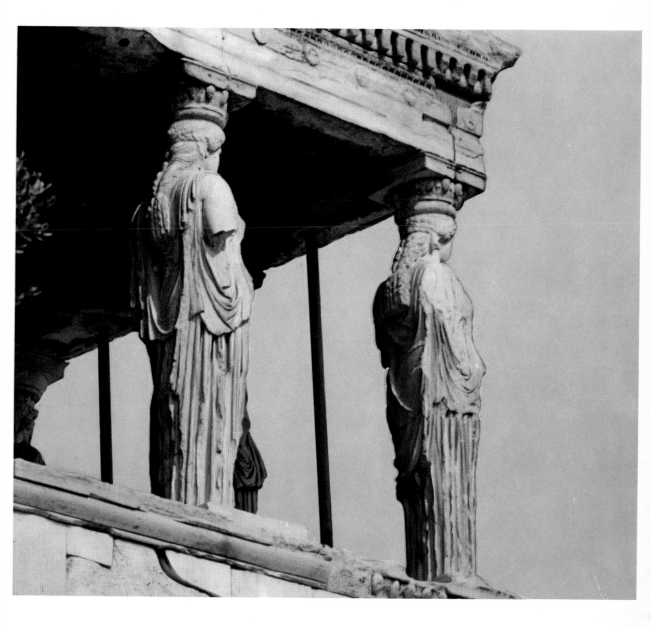

Architectural taste in Greece normally led to rectangular buildings, which fitted neatly into the mountainous background and afforded scope to the Greek love of orderly design and rhythmic repetition. Some notable exceptions in the shape of round buildings are however known—the Philippeum at Olympia, the Arsinoeum on Samothrace, and the Tholoi at Delphi, Epidaurus, and Athens. No doubt the great 'beehive' tholos tombs at Mycenae and other early sites served as inspiration and model. Roman architects occasionally constructed round temples or memorials after these Greek patterns, for instance the Temple of Vesta in the Forum.

Seen here in the soft afternoon light, against the background of olive trees and hills of the Pleistos gorge which conceal Mt. Helicon beyond, the partially restored Tholos at Delphi makes a fine human mark on a splendid natural setting. Just beyond the Tholos lie the foundations of an archaic temple to Athena, Guardian of the Delphic Sanctuary, in the area known as Marmariá, 'The Marble Quarters.'

The Tholos was probably designed and built by Theodorus of Phocaea, who in any event wrote a book about it. Three concentric marble circles form the base and steps. Around the top one was a ring of twenty Doric columns supporting a circular architrave surmounted by metopes and triglyphs and a decorative cornice with lion-head rain spouts at the edge of the sloping roof. Inside the round colonnade was a circular cella wall with its own conical roof. Around the interior, close to the wall but not engaged in it, was a row of ten Corinthian-style columns, their bases resting on a bench of black limestone running around the foot of the wall. A door opened to the south. The floor was paved with black stone, except for a round slab of white marble in the center. Thus an attractive variation of color combined with the harmonious design to produce one of the most original and pleasing buildings of the Greek world.

THOLOS ROUND TEMPLE AT DELPHI

c. 390 B.C.
Delphi

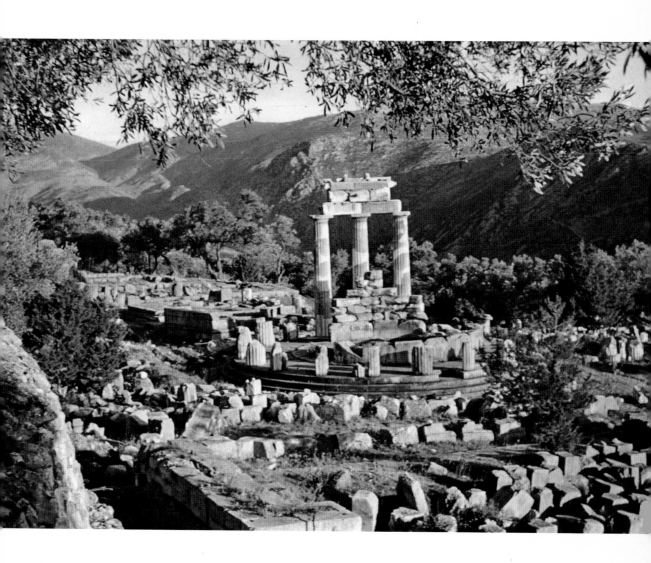

Though small in size, these engraved gems rank with much larger works
major products of fifth century Greek art. Their wonderfully delicate lines a
pure design entitle them to the highest respect as representatives of Classic
style, and the special skill they required by reason of their smallness and t
intaglio technique is a further cause of admiration. The patterns are incised in
the hard stone in reverse depth to the relief figures they are intended to produ
in sealing wax or other material formed by their mold. For these are person
seals by which to identify documents and precious possessions. They are of t
'scaraboid' type: oval, with a convex back perforated for fastening to a me
holder or to a ring. Both measure 3/4 inch in long diameter. The stone used f
the horse is chalcedony, of a smoky quality; the portrait is done in yellow jasp
with red mottling. Both are by the finest of Classical gem-engravers, Dex
menus, who has signed his name above the portrait; the horse is recogniz
as his work by its style and by the form of the lettering of the owner's nam
Potaneas. It is curious that while the latter is meant to be read on the relief so
(as seen here in the plaster cast illustrated), the artist's signature of the portra
is reversed on the relief but in proper order for reading on the gem itself. Th
is perhaps because the owner's name is part of the design, which the signature
not.

The horse which Potaneas commissioned is splendidly carved, and not u
worthy of comparison to the famous ones on a larger scale which were produc
at just this period for the Parthenon frieze (cf. Plate 43). It is a race-horse wi
broken rein, walking in freedom, both farther legs advanced in accurately d
picted motion. Details of ribs, veins, muscles, rippling flesh and wrinkles of tl
skin are most adroitly managed, and the animal's discipline is as evident as is l
spirit. The clean background allows concentration of attention on the hor
himself, while the hatched border encircling the design neatly frames the scen
and the indication of ground beneath the feet removes a danger of unreali
in the composition.

The portrait is equally masterful in conception and technique, and even mo
precise. It is unusually individualized for its period, since the aim of Classic
portraitists, as Aristotle said (*Poetics* 1454b9–11), was 'while reproducing tl
distinctive features of the person, to present him as more handsome than he
without sacrificing a real likeness.' There is surely some of this idealization her
but it is not dominant. This is not a generalized type, but a very definite ind
vidual. He had unusual eyebrows, which fused above the nose, and even mo
uncommon lashes, prominent and curling downward. The contours of his no
are likewise distinctive, and his hair somewhat unruly despite efforts at its organ
zation. The clearly defined ear, and the lines on the brow, further help make tl
tiny but fully developed portrait marvellously life-like and a masterpiece
its kind.

GEMS
BY
DEXAMENUS

440-400 B.C.
Boston,
Museum of
Fine Arts

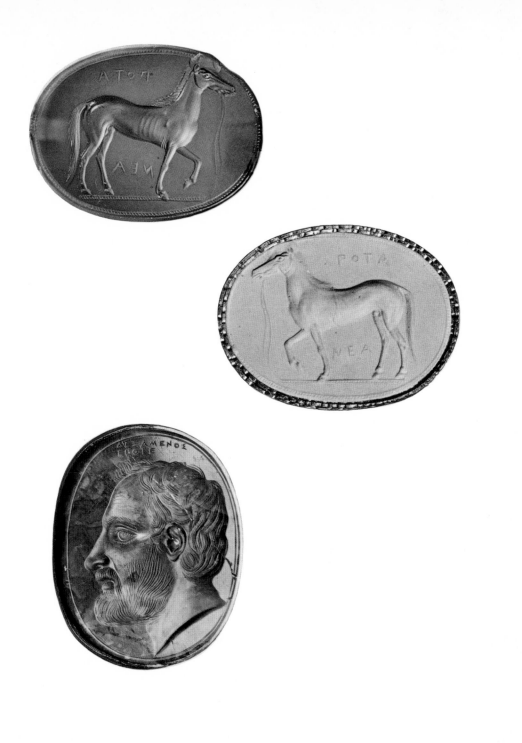

Fine gold work was an old art in Greece, having produced necklaces, engrave pins, and embossed decorative plaques in the Mycenaean and even in the Geo metric age. From the seventh century on, it became more popular, and numerou finds (mostly from tombs) show its considerable range of styles and frequentl exquisite workmanship. Large-scale objects such as the magnificent Vaphei Cups from Cretan-Mycenaean times (Plate 2) are rarely attempted later, but th smaller items created are often of special delicacy and sumptuousness. Jewelr predominates, naturally, and was often buried with its owner, thus survivin in many instances for modern archaeological recovery.

The crown here illustrated was fabricated in southern Italy in the Classic era. It is a magnificent example of Greek goldsmiths' art and of their abilit to combine luxurious elegance with tasteful moderation. The richness here primarily in the precious materials and the varied abundance of decorativ elements. But nothing is over-done or gaudy; the stress is on ultimate refinemer of artistry, on quality and brilliant design. The tiny details within the flowe and rosettes and on the bead-and-reel borders are all the more remarkable i view of the lack of magnifying glass to aid the craftsman's minute manipulation Blue, green, and red enamel has been employed to make additional patterns o the gold flowers and leaves, and to make attractive berry-like spots of colc throughout the design. The spiraling tendrils and diminutive wire stems intr duce a lively variety of line and give an effect of natural plant growth, eliminatin artificiality and any danger of monotonous regularity of pattern. Ancient literar references show that such crowns were sometimes given as prizes for athleti or musical competitions, or worn in processions. Some were intended a offerings at shrines or as tomb memorials. The present example is of a size whic would fit a man's head, and may have been worn on some special occasion; bu it is too delicate to bear repeated use.

The necklace was found at Olbia, in Sardinia, an illustration of the widesprea circulation of Greek jewelry. Dated in the early Christian era, it comes towar the end of the creative period of Greek art, but certainly does justice to its sti flourishing powers in the working of gold. These three cylindrical drum apparently fitted around a cord suspended from the neck. Their delicately intricat floral and bead decoration provides a very suitable setting for the many garne insets, whose rich clear red translucence glows brightly against the gold. Th tear-drop shape of several of the inset stones is particularly felicitous in the overal pattern, and the large central oval of radiant red in the middle piece is especiall opulent in effect. This is jewelry of a high order of excellence.

GOLD CROWN AND NECKLACE

Crown
5th century B.C.
Taranto,
Archaeological Museum

Necklace
1st century A.D.
London,
British Museum

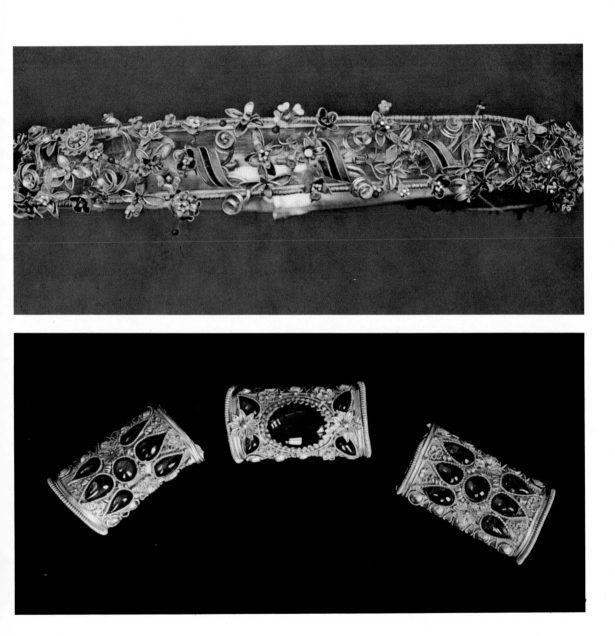

GOLD
EAR-
RINGS

Chariot
c. 390 B.C.
Boston,
Museum of
Fine Arts

Animal Heads
c. 2nd century B.C.
Leiden,
National Museum
of Antiquities

Among extant Greek jewelry, ear-rings are prominent both in number and in interest. A great variety of forms is found, some of them very elaborate. The examples here illustrated show the imagination and craftsmanship which characterize this field of art in Greek times.

The chariot is perhaps the most remarkable item of its kind which has survived from the Classical world. Two inches high, it is of amazing refinement of detail, with its delicate precision of wingfeathers, structural accuracy of horses, rider, and chariot, ornament of the harness and chariot front, long wavy hair of the goddess, tiny reins, and wheels which can be spun on their axles. The whole is attached by a ring to an elaborate palmette with cups and incurving petals and central bunch of seeds. Similar palmettes are employed on other ear-rings of the fourth century, for instance those with Ganymede and the eagle in the Metropolitan Museum, New York. A further clue to the dating is the resemblance in style to the winged chariot figures on the sculptured frieze of the Mausoleum, done in the third quarter of the fourth century. There is a vivid sense of eagerness and animation in the tiny steeds and their driver, and a surging upward motion to the whole composition. Perhaps this is Psyche, symbol of the soul, driving the forces that rule men's conduct, as in Plato's analogy in the *Symposium* (253–254), or leading man's composite of body and spirit into the world of the dead: an apt theme, if this was made as a tomb offering. Others would interpret the charioteer as Nike, the goddess of victory (cf. Plate 66), and think that the purpose of the piece was as ornament of a statue, since it is hard to believe it could be worn by a living woman without damage to its delicate construction. Whatever its symbolism and intended use, this tiny masterpiece of the goldsmith's art is a revelation of Greek taste in jewelry.

The pair of loop rings is much less pretentious, but not without its own special interest. The heads are mythical lion-griffins, with blunt wrinkled noses and sad eyes. They each have an ornamental band behind their cheeks and another around their necks, besides the row of dots along the rim of their ears and the concave plate decorated like a frieze, which rests on the top of their heads. Somehow, this does not strike us as too unrealistic, and the general effect is attractive. The curling tails fit into clasps under the jaws, and give a pleasing circular unity to the design. In date, these seem to be later than the chariot, and there is likely some oriental influence on their style, so they are probably Hellenistic work, perhaps from Alexandria. The Boston museum has a very similar piece, which may indicate that the design was commercially available to many owners. The lion-griffin motif has roots in Persian mythology and art, and was popular in Cyprus also, where very similar ear-rings have been found at Amathus and Curium.

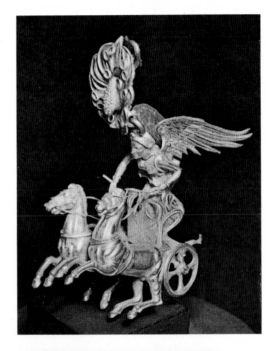

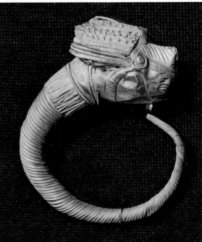

This magnificent example of Greek craftsmanship in ornamental gold
aroused the utmost admiration of modern experts in that art, not only fo
wonderfully perfect workmanship and minute details but for its techn
achievement also, without the aid of tools, dies, melting equipment,
bonding substances now considered indispensable for any such delicate work
gold. It is a mystery how the ancient goldsmith produced the extremely t
gold wire, in several degrees of fineness. And how did he solder on so m
tiny elements: the beaded bands, rosettes, necklace, ear-rings, hair-chap
jewel settings, attached rings, and many items in the raised decoration of
circular main bands? There is no trace of different color at these junctures, s
as is visible with modern soldering. Probably the technique was used wh
Pliny describes (*Natural History* 33.5), where a mineral exudation called chry
colla, mixed with verdigris, nitrum, and an adhesive element and knee
with a pestle, is affixed in tiny globules between the pieces to be bond
holding them in place and slowly fusing with them as the right amount of h
is applied.

The central figure is probably Aphrodite, because of the swans, her spe
bird. She is in repoussé, to the unusual extent of ¾ inch relief. Her pleasar
smiling features are attractively set off by the triangular forehead and wavy h
above. She wears ear-rings and a garland of vine leaves and grape clusters. (T
has led some to identify her as Ariadne, bride of Dionysus, god of the vi
cf. Plate 14). Her diaphanous garment, slipped coyly off the left shoulder,
marvel of varied surface texture and it creates an effective illusion of differ
from the flesh.

Six carnelians add greatly to the general opulence of the piece, their lustr
red glow beautifully contrasting with the surrounding gold. The swans, in th
oval frames like an Egyptian cartouche, are designed in three pairs, of wh
one group (at the upper left) is resting quietly on the water with folded wi
and probing beaks, while the two below the bust are stretching their win
and the pair at the upper right is in the first stages of taking off for flight.
the outer band, the series of grape clusters, vine leaves, and tendrils is artfu
varied in details, and is a skillful change from the groups of buds or lot
blossoms encircling the carnelians above. The rosettes on the woven chain h
six petals each, in distinction to the seven-petal type near Aphrodite's he
The pendants from the chain are miniature loutrophoroi—the special form
vase placed on the tombs of unmarried women. The rings at their base
probably for loops of thread attaching the ornament to the back of a hair-n
or possibly to a garment front as a pectoral—though some scholars have wan
to explain it as an ornate cover for a pyxis-type jar for ointments or cosmeti

The diameter of the main plaque is just under four inches. Several su
gold medallions with chain-net borders of rather similar design have be
found, but the present one is unrivalled in beauty. Its authenticity has be
questioned, but strong arguments have been made in its defense. It is
brilliant triumph of the goldsmith's art, exquisite in design and craftsmansh

GOLD
MEDALLION

c. 280 B.C.
St. Louis,
City Art Museum

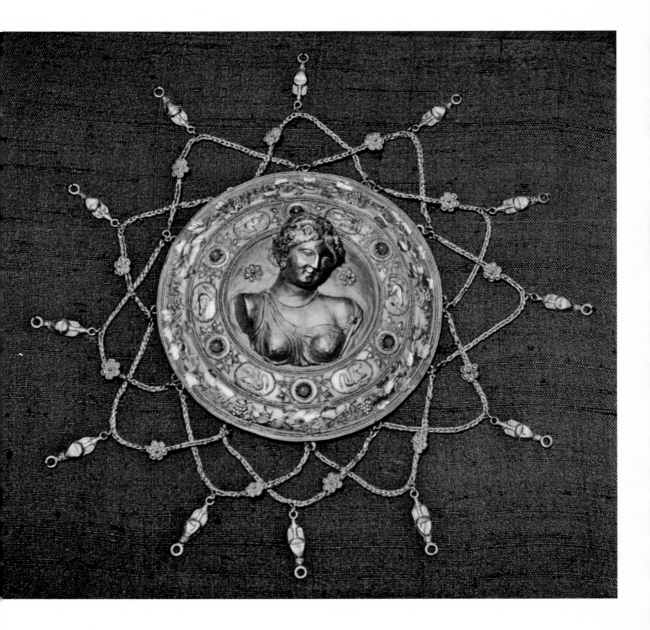

IVORY ATHENA STATUETTE

*Late 2nd century B.C.
Paestum,
Archaeological
Museum*

Ivory carving does not seem to have been much practised in Greece, in comparison with the innumerable works produced there in stone and bronze. Nevertheless, fine examples of this difficult art do occur, from the very earliest period in the Mycenaean age down all the centuries to the end of ancient Greek art—and it flourished in the Byzantine world, which was a direct offspring from Classical and Hellenistic traditions. Since ivory is a very hard material, and ancient cutting tools were of limited scope, the results achieved by the best ivory carvers are all the more remarkable.

The present example, found in the Greek settlement at Paestum or Poseidonia (cf. Plate 45), is of the Hellenistic era, and a fine representative both of that cultural epoch and of Greek work in ivory. It is tiny, less than two inches high, and part of a group with the giant Enceladus (also extant), who is even smaller but equally well carved. The two were no doubt shown in combat, for Athena clearly held a spear and in Enceladus' right hand are remains of, what seem to be a sword hilt. According to primitive Greek legend, the Giants were sprung from Earth when drops of Uranus' blood fell upon her. They threatened the sovereignty of the Olympian gods, and fierce battles occurred which are favorite themes of Greek poetry and art (for instance, Hesiod, Pindar, and the archaic frieze on the Siphnian Treasury at Delphi). Eventually, with the aid of Heracles the gods triumphed. Athena hurled all of Sicily on top of Enceladus, and his writhings were later said to explain the volcanic activity of Etna! Our artist knows better than to attempt such colossal clash of forces in his miniature figures, and is content with having Athena repress her adversary with a spear.

Details are delicately managed, and the drapery is especially well handled. The goddess' body is lithe and active, though her countenance retains Olympian calm. Her wrist and arm are a bit too large, perhaps, but this emphasizes her strength. The face is somewhat round and full—an interesting contrast with Phidias' concept of her beauty (Plate 41). Traces of coloring remain on the helmet, and some of the gold-leaf survives in place on her breast-plate and arm band. The whole composition combines delicacy of scale with lively action, thus holding our interest by both its hints of motion and its refined skill of workmanship.

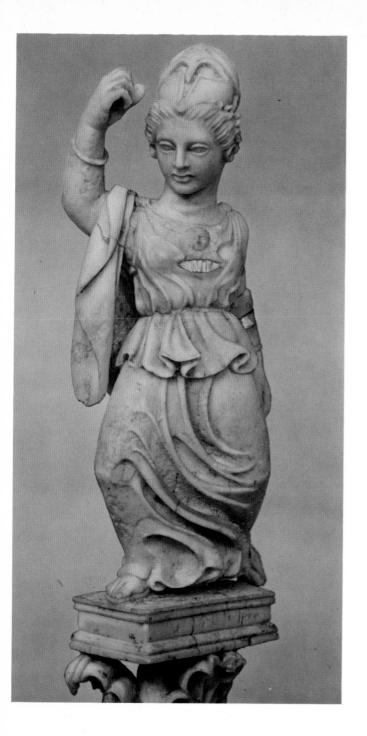

LYCIAN SARCOPHAGUS: HORSES RELIEF

c. 400 B.C.
Istanbul,
Museum of
Archaeology

Much important Greek sculpture is found on funeral monuments, both of the free-standing type like that in Plate 56 and relief work – either on a marble-slab 'stele' such as that of Aristion (Plate 22) or decorating a sarcophagus, as in the present illustration. Naturally, the sculptors were rarely the very best, since few could afford their services for private memorials. But the excellent work on many Greek tombs shows that a high level of competence was widespread even among the ordinary Greek sculptors.

Several very fine sarcophagi from Greek settlements in the Levant are now in the archaeological museum in Istanbul. One has scenes from the battles of Alexander the Great, and preserves much of its original coloring painted on the marble. Another, here illustrated, has hunting scenes along the sides. Four-horse chariots are shown on one panel in pursuit of a lion. A young Amazon holds the reins while another poises a spear against the dangerous beasts. The horses, as our close-up view demonstrates, are executed with superb skill. Although there is not extensive detail in the representation of their physical structure, their spirit is captured with eminent success. The raised hooves and tensed forelegs pulse with vibrant energy. The tossing heads, with manes thrown vigorously back, nostrils flaring, and mouths fretting at the bit, are carved with outstanding insight and sensitivity. Realism is augmented by the prominent veins, swollen from the horses' exertion, and by the life-like eyes. A basic symmetry governs the arrangement of the horses' heads, bodies, and prancing legs, but there is enough diversity among the similar elements to achieve an aspect of naturalness.

It is likely that the sculptor, seemingly a Greek from Lycia on the southern coast of Asia Minor, was influenced by the lively horses of the great frieze and eastern pediment of the Parthenon (Plate 43). Although he has not attained to their perfection of workmanship, he has certainly gone far in that direction, and has learned well from the example of Phidias' disciples. The whole sarcophagus is a noble monument to the cultivated taste in art of the man who commissioned it, for himself or for a departed relative. It was found in the Royal Cemetery at Sidon in Phoenicia. In shape it is like the special kind common in Lycia, with high ogival lids and sculptured pediments and panels.

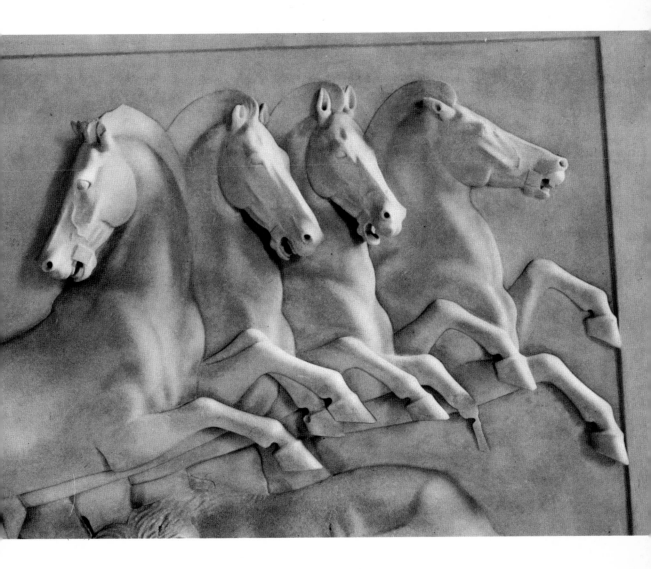

The great Ionic temple of Artemis at Ephesus was one of the Seven Wonders of the ancient world. Primitive cult shrines and early temples to the goddess had been replaced in the sixth century B.C. by a huge structure which took over a hundred years to build. The famous king Croesus of Lydia contributed funds for its construction, which was completed around 430 B.C. A devastating fire destroyed the great edifice, reportedly on the very day in 356 on which Alexander the Great was born. Many rulers gave money for its rebuilding, which was supervised by local architects named Demetrius and Paeonius. The new, fourth-century, temple followed closely the plan of its predecessor, but on a higher floor level. There were two rows of tall fluted columns around all sides of the building, instead of the usual single colonnade. Additional columns before the porches at each end made the effect even more massive. A series of nine steps, extending across the whole width of the eastern and western fronts, led up to the platform on which the gigantic temple stood. All was of fine marble, with much splendid sculptural decoration. The temple's inner room or 'cella' was open to the sky, another rare feature – perhaps because it was too wide to span safely with wood or stone. This world-famous edifice was burned down by the invading Goths in the late third century after Christ, and its ruins were absorbed by an encroaching swamp, from which a few fragments were rescued by English excavations between 1869 and 1905 and put on display in the British Museum.

The most impressive piece to survive is this sculptured column drum from the later temple. A peculiarity of the Artemisium at Ephesus was that many of the structural columns (probably those along the front and before the two porches) bore relief figures on their lowermost drum – an oriental influence from the ancient cultures to the east. On the one here illustrated, the scene is of Hermes and a winged youth (probably Thanatos, personification of death), and between them a young woman in a beautifully arranged robe, who is presumably some deceased heroine of mythology. Other figures around the circumference seem to be Heracles, Hades, and Persephone. All are nearly life-size, an indication of the temple's enormous height, since this is only the bottom drum of the many in a column.

Our illustration is a detail of the Hermes, who is identified by the special herald's staff which he carries. The sculpture is of the very finest quality, with the gentle refinement of line and cultivated humanity which mark the best Classical work of the fourth century. Despite bad surface weathering, the physique of the god is impressively noble in its perfect proportions and tranquil strength, and the up-turned head has a gracious beauty that is peculiarly Greek. It is known that Scopas made one of the sculptured drums at Ephesus; though there is no proof that it is this one, it would be worthy of that great artist. It has the deep pathos and up-turned gaze for which he was famous. The fine treatment of the athletic body shows the influence of Polyclitus' style.

SCULPTURED
DRUM
FROM
NEW
TEMPLE
AT
EPHESUS

355-330 B.C.
London,
British Museum

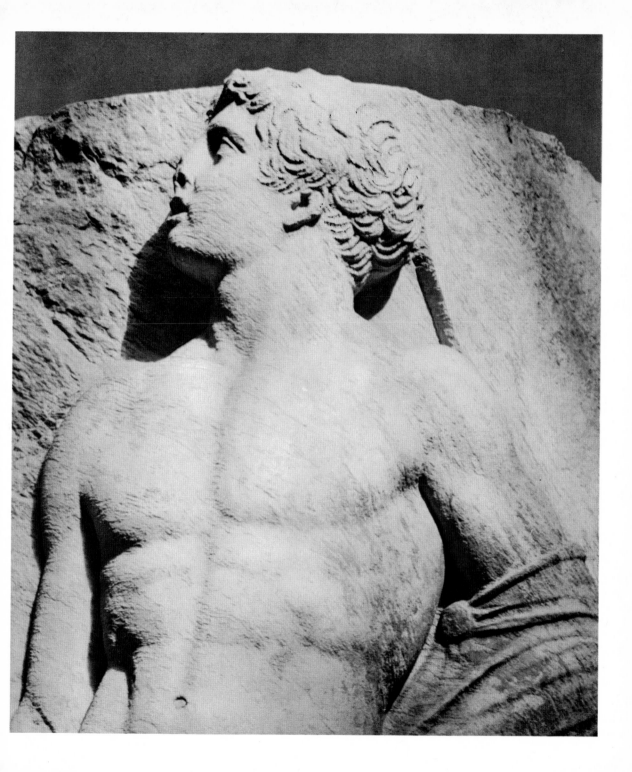

During the fourth century B.C., funeral monuments at Athens became more and more elaborate. Bereaved relatives sought to prolong the public memory of their dead with memorials so worthy of attention that passing citizens would pause to admire the art and to read the commemorated person's name. An element of rivalry and show of wealth came into this practice, leading Demetrius of Phaleron, the Macedonian king's governor of Athens at the end of the fourth century, to pass sumptuary laws severely restricting such luxury. Thereafter, for a long time, tomb ornamentation was much simpler in Attica, and private use of sculpture declined.

Late Classical grave monuments have a number of features in common. They normally show the deceased as though still living, in some familiar context. The Greeks loved life, and even their funeral art represents some scene from the living world rather than themes of death. However, the deceased are regularly shown as very weak, like Homer's 'dead shades bereft of strength' (Od. 10.521, etc.). They are always seated, or leaning on a staff or against a wall. Their eyes gaze off into a different world, distant and mysterious. Yet they are not wholly gone from the realms of earthly life, and are portrayed in some characteristic situation or activity of the existence they led in this world. Usually they are not alone, but in the company of some relative, servant, or other person – whom, however, they cannot see. It is a tradition in mortuary art which is both tender and consoling, casting a glow of cherished life across the chasm of the grave. It lacks the solace of Christian hope, which had not yet dawned upon mankind. Here is an illuminating aspect of Greek humanism, revealing its strength and its inadequacies.

The present example, from the middle of the fourth century, still stands in the ancient cemetery of Athens in the Ceramicus or Potters' Quarter. Around it are the typical cypress trees, whose tall cylindrical shapes seem so suitably grave and solemn, a quiet reminder of life among the memorials of the dead. Inscriptions identify the lady as Pamphile, with her kinswoman Demetria. The deceased is given an impersonal, generic appearance rather than direct portraiture. She is presented as a beautiful and cultured representative of womankind, and it is implied that her passing is a regretted loss to her friends and family. She sits with noble dignity and poise on a chair whose finely contoured leg is surmounted by a sphinx, that frequent ancient symbol of mystery and of protection beyond the grave. The ram's head terminating the chair's arm is a more directly Greek form of ornament, but may also have a symbolism of its own. The sculptor's management of the garment is particularly effective, and the whole work shows a very high level of competence and taste.

FUNERAL MONUMENT OF PAMPHILE

c. 350 B.C.
Athens,
Ceramicus Cemetery

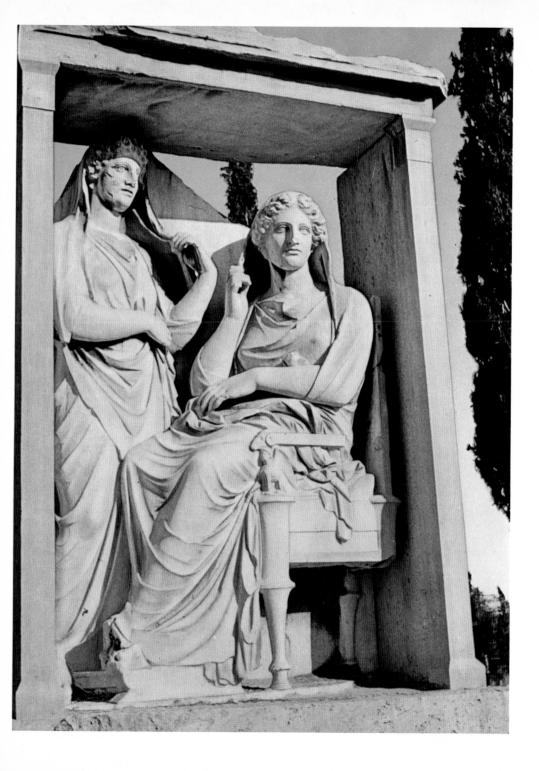

When this noble statue was discovered in May 1877 during the German excavations at Olympia, it caused great interest among all concerned with ancient Greek art, for it seems to be an original work by one of the supreme Classical sculptors. There are scholars who consider it a copy to replace the original carried off in Roman times, while some hold that it is a work, not of the great Praxiteles but of another with the same name two centuries later. The argument is still lively among the experts, and probably can never be decisively settled. The surface working of the tree trunk, and of Hermes' back, is unfinished and rough, and the hair is rather carelessly executed. But the statue is so far superior in technical accomplishment to the usual Roman era copies, and so much in the style and spirit of fourth century work, that the best interpretation seems to be that it actually is an original work of the famous Praxiteles, though not one of his best, on which his great fame rested. Pausanias mentions seeing 'a marble Hermes with the infant Dionysus, by Praxiteles' in the Hera temple at Olympia, precisely where this statue was found by the excavators. He obviously thought it an original.

Praxiteles was considered by the ancients a supreme master of sculpture, and for centuries his influence on art was enormous. His style was described as less grand and remote than that of fifth century artists, more concerned with direct enjoyment of bodily beauty than with the human or divine spirit within. He achieved a new level of delicacy in representing living flesh, and a soft grace of figure that is temperately sensuous. A characteristic of his style is the celebrated 'Praxitelean curve' which gives an air of supple languor to the pose. Another is the oval shape of the head, with a dreamy indefinite look in the eyes. Gentleness, humanism, and the direct appeal of physical beauty are Praxiteles' specialty, combined with a peerless mastery of technique.

These qualities are evident in the present statue, whether it is directly from Praxiteles' hand or a careful copy of his original. The surface modelling is unusually sensitive, the youthful athletic physique admirably natural, the fine head lovely in its delicacy yet not unmanly. The drapery of the cloak thrown over the supporting tree stump is an unsurpassed triumph of effective handling of that complex and challenging problem. Less masterful is the treatment of the child, for it was not until Hellenistic times that the peculiar qualities of the very young and the very old were given serious analysis and suitable representation in art. Hermes' right foot is very realistically carved. The other, and both legs below the knee, are modern restorations. The statue is over life-size.

Hermes is shown resting on his way to deliver the infant Dionysus to the nymphs who had been chosen to bring him up. A bronze staff was likely held by his left hand, while the right, as is clear from ancient imitations in bronze and in a Pompeian painting, dangled a bunch of grapes before the infant wine-god, who is naturally intrigued by them. The recovery of this statue was a bright day for our understanding of Greek art.

HERMES
BY
PRAXITELES

350-330 B.C.
Olympia, Museum

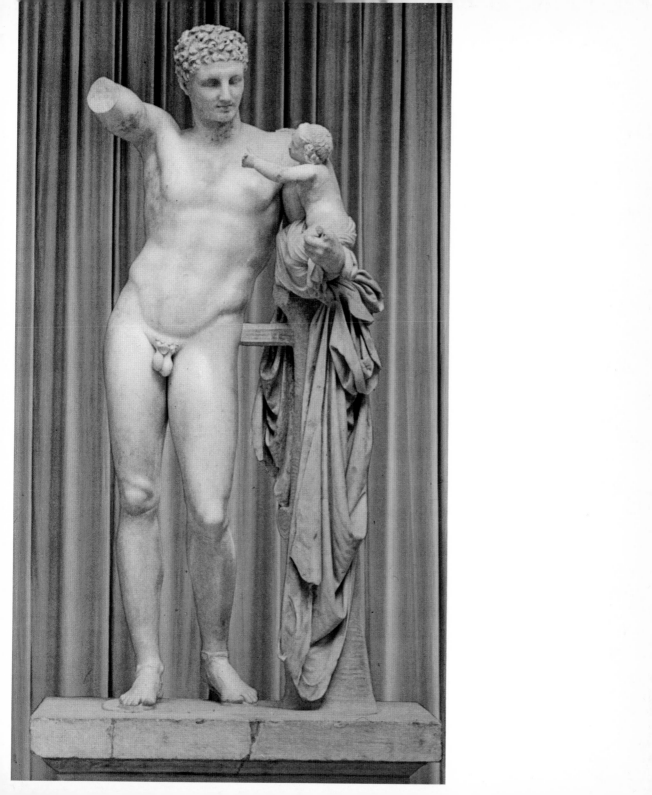

BRONZE YOUTH FROM ANTICYTHERA

350-330 B.C.
Athens,
National Museum

Though the creator of this splendid statue is not now known, it is clear from stylistic qualities that it belongs to the middle years of the fourth century B.C. It was rescued from the sea, the ancient ship on which it was being carried to Rome having been wrecked near Anticythera, an island between the southern Peloponnesus and Crete. Badly damaged and corroded, it has been skillfully repaired, so that its excellence is again evident except for the surface appearance, which has lost its original smooth texture and burnished glow.

Standing somewhat larger than life, the young athlete has a magnificent physique. He is a personification of the Greek ideal of harmoniously developed body and firm inner forces of the spirit, a synthesis of lithe physical discipline and well-ordered psychological resources. The powerfully built body is subtly modulated in contours of muscle and flesh, but there is no exaggeration or worship of mere physical strength, such as is often seen in Roman statues and some later ones, particularly in the Renaissance. The head is manly yet refined and delicate, its clear features admirably proportioned, the hair a lively pattern that is realistically casual but not without a pleasing orderliness. The eyes are very natural, with black pupils and brown stone irises inset into a white compound like porcelain. Separate eyelids, with short lashes, are formed from bronze plates and neatly fitted into place.

The youth is standing, with a slight curve of the body, resting on his left foot, the right leg flexed and the foot touching the base only at the toe. The right is extended forward and to the side, and the position of the arched fingers shows that they held a round object, perhaps a ball being thrown in an athletic contest. Some would interpret it, however, as Paris holding the apple which was the prize at the famous beauty contest among the goddesses which he judged. It is known that the eminent sculptor and painter Euphranor, active at the middle of the fourth century, did a much admired statue on that theme, and it is tempting to think that perhaps this is his work, but it cannot be proved. In any case, it is an original bronze of that period, and an eloquent witness to the high level of naturalistic sculpture which the Greeks then achieved.

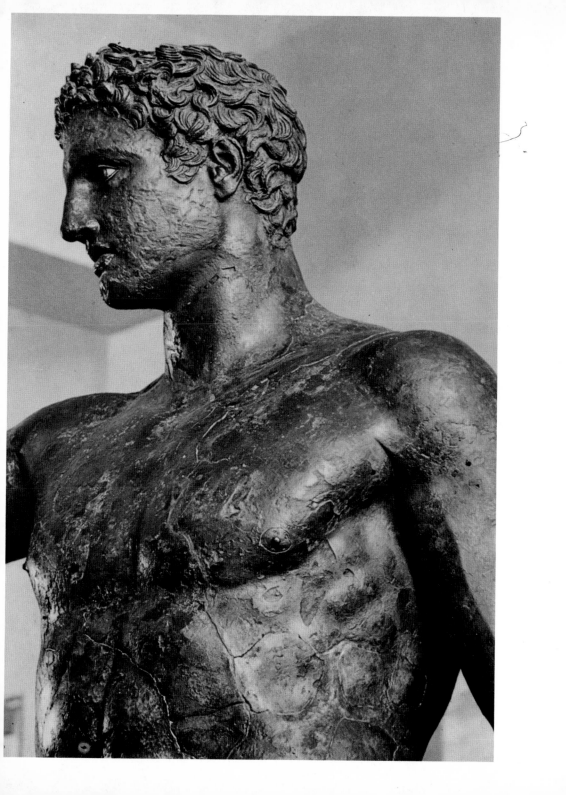

'HYGIEIA'
FROM
TEGEA

c. 340 B.C.
Athens,
National Museum

This nobly beautiful head is one of the clearest testimonials we have to the Greek concept of feminine grace and loveliness. It has an exquisite refinement and serene charm that give it a timeless appeal. All is most carefully proportioned toward an ideal harmony of lines, but it is not an abstract study; rather, it may be considered a representation of universal qualities of beauty in a particularly perfect individual manifestation. It is enough to make us wonder what the best of Praxiteles' female heads must have been, which were so much more famous as the supreme achievement in interpreting womanly beauty. Perhaps they influenced this work, which certainly seems to contain many of the qualities for which Praxiteles' statues were so admired.

The artist is unknown, and even the subject is not certain. Since it was found among the remains of the Athena temple at Tegea in the central Peloponnesus, where it is known that Scopas worked on the pedimental sculpture and for which he did a statue of Hygieia, the goddess of health, which stood inside the temple near the cult image of Athena, many have sought to identify this head as the Hygieia of Scopas. Certainly its general aspect would suit that goddess admirably, and the artist's masterful achievement is not unworthy of that distinguished sculptor. But there is less vigor and emotion here than was characteristic of Scopas' work (some heads from the Tegea pediment seem to be his on that score), and it is more likely that this fragment is from some other artist's hand. It probably belongs to a free-standing figure outside the temple proper but in its precinct. The base of such a statue was found near the temple's southeast corner.

The placid beauty of this marble head has made it one of the most beloved pieces of surviving ancient art. Copies of it grace many homes today throughout Europe and the Americas.

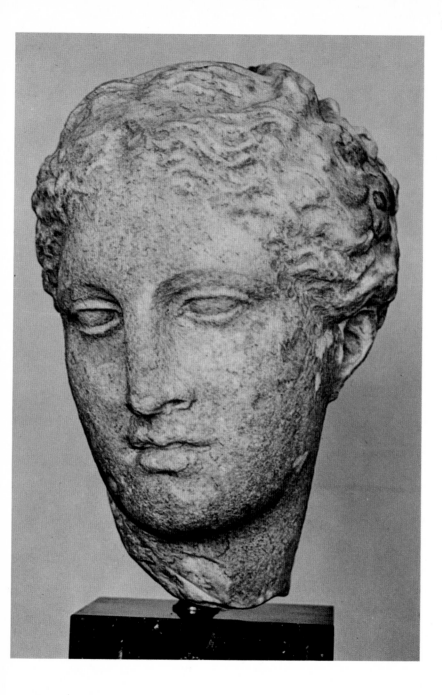

BRONZE BOY FROM MARATHON

340-300 B.C.
Athens,
National Museum

The fresh, clean lines of this youthful head illustrate perfectly the late Classical spirit in sculpture, before the new mood of the Hellenistic Age had effected its modifications. Here is all the serene, fully natural beauty of a fine young body, presented with that special refinement and gentle humanism which is the distinctive mark of Greek art at its best. This is a creation to admire for many reasons, and to enjoy without effort or hesitation. Its appeal is direct and instantaneous, a result of its obvious perfection in every aspect.

The statue is rather smaller than life-size (4' 3"), which gives it an added delicacy and emphasizes the figure's youth. It is not clear where it was intended to be displayed, perhaps in a private home or garden. The boy is standing, with his weight mainly on the left foot, the right leg relaxed and bent at the knee so that only the toes touch the ground. He is looking at some object which he once held in his left hand, while the right arm is raised in the plane parallel to chest and shoulders, as though he were leaning on a wall or tree or a building's column. The pose is graceful and entirely natural. Its curve at the hips shows the influence of Praxiteles, being like that of his Hermes (Plate 57) but in the opposite direction—since there the supporting leg is the right. The head, too, has a Praxitelean grace, but is a bit smaller in proportion than was usual with that artist and may have been influenced by the new style of Lysippus. The fine nose and chin, and the slightly opened lips, are well set off by the strong lines of the brow and pleasing contour of the cheek. The eyelids are more than usually stressed, to give definition to the life-like eyes of stone and glass. The tousled hair is kept in basic pattern by its resilient curls and by the encircling band with its upturned point at the front like a tongue or wave. This last detail was a characteristic of the fashion for youths competing in the athletic contests of the palaestra, in imitation of their patron, Hermes.

Rescued from a shipwreck near Marathon, the bronze has acquired a rich green oxidation patina which is far different from the original gold-like glow, but somehow seems more attractive and mellow, and has not aged the statue's delightful impression of a timeless youthful bloom.

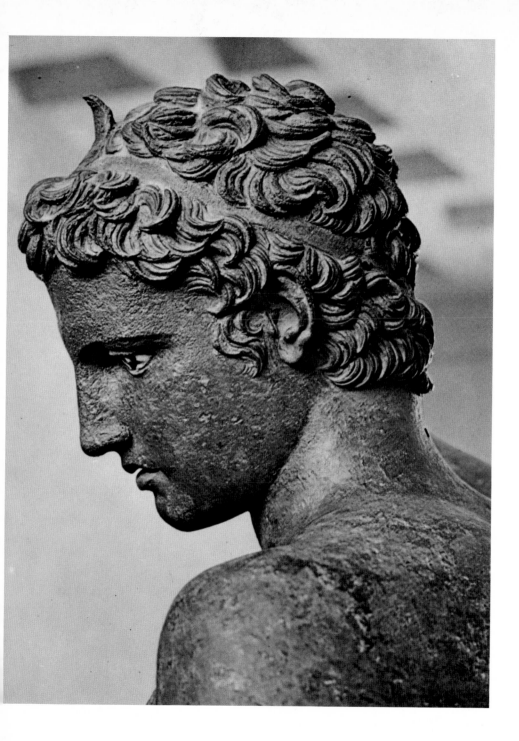

61

SILVER COINS OF SYRACUSE

A. Arethusa Head on Demareteion

479 B.C.
*Boston,
Museum of
Fine Arts*

B. Arethusa Head by Euaenetus

*c. 412 B.C.
Syracuse,
National Museum*

Nothing is so matter-of-fact as money. Yet the Greeks made even that beautiful. Many of their coins are authentic works of art, executed with a care and sense of dignified beauty rarely even approached in the history of coinage. Two striking examples from Syracuse show why.

The patron divinity of that greatest and wealthiest of Greek cities abroad was Artemis, under the aspect of the nymph Arethusa. A charming legend told how, near Olympia, Arethusa had fled from the river-god Alphaeus, who had become enamored of her when she bathed in his stream. Coming to Sicily, she was protected by Artemis, who transformed her into a fresh-water spring in Ortygia, the harbor of Syracuse. This is an imaginative way of explaining the phenomenon of the surge of pure water at the edge of the salty bay which still bubbles up gaily at Syracuse. A head of Arethusa/Artemis was the usual distinctive symbol of local coins.

The earlier one here shown has a pleasant story of its own. After the great naval victory at Himera on the northern coast of Sicily in 480 B.C., where Gelon of Syracuse and Theron of Acragas destroyed the menacing fleet of Carthage, Gelon's wife Demarete was prevailed upon by the Carthaginians to obtain for them easier terms. In gratitude they gave her a splendid gold crown weighing a hundred talents. This Gelon exchanged for silver which was used in producing an issue of magnificent commemorative coins of the ten-drachma category for treasure-reserves and expensive negotiations. They were known as Demareteions in honor of the queen. It is thought that the fine Arethusa head on these coins is modelled on her likeness. Only twelve survive. Of these the most perfectly preserved is this one in Boston.

The patroness' head is engraved with great skill. Its simple dignity is impressive. The eye is presented in full view as from the front, though the face is in profile—a traditional device on early coins to give due prominence to the eye, so important in conveying a sense of life. Her hair is in the late archaic manner, adorned with a wreath of olive leaves. The jewelry is moderate but effective. Around this symbol of freshness and calm swim four lively dolphins who represent the surrounding sea. They cleverly vary the effect of the concentric circles and add the interest of motion. The ring of letters SYRAKOSION identifies the coin as 'of the Syracusans.' The thick silver disk is an inch and a half across.

Sixty six years after the great victory at Himera, Syracuse won another notable naval triumph, over the mighty fleet of Athens. It put out new commemorative coins, among them elegant ten-drachma pieces by the engraver Euaenetus, one of the supreme masters of his art. Here the head of Arethusa/Artemis has a classic purity and humanism. The features are more softly modelled and approach an ideal of beauty with no attempt at particular portraiture. The hair is now ornate and flowing, the ear-ring elaborate and necklace more delicate. Part of the artist's name appears below, the Syracusans' in an arc above. This design was much admired in antiquity and often copied on later coins. It still ranks as a masterpiece of the classic age in Greece.

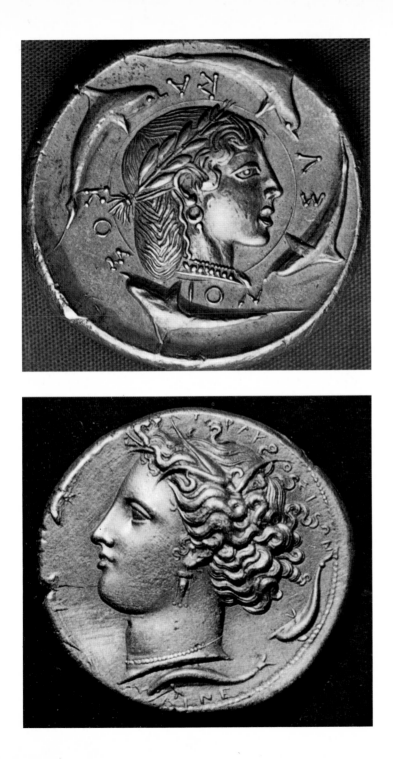

GOLD
AND
ELECTRUM
COINS
OF
PHILIPPI
AND
IONIA

4th and 6th cent. B.C.
London,
British Museum

Coinage in the true sense—precious metal stamped with a government's guarantee of its weight and value—first appeared in the latter half of the seventh century before Christ, in Lydia. Nearby Greek cities of Ionia and elsewhere, notably Aegina near Athens, quickly took up the revolutionary invention and soon brought it to full development on both the commercial and artistic levels. Most Greek coins were of silver or bronze, though early ones are usually of gold or electrum, a natural alloy of silver and gold. The purity of Greek gold was very high. Designs on this most precious of ancient metals are normally simple and sturdy because of the material's softness. Most gold coins are small. Large numbers have survived, in temple deposits and in buried personal hoards. The representative samples here illustrated are widely separated in time and in place of origin. Both are now in the great collection of the British Museum.

The earlier piece is dated around 560 B.C., and comes from some Greek city in Ionia. It is thick and carefully bevelled, with a moderately oval outline. For design, a shark-like fish is centered between garlands of beads and lotus. An effective parallelism is achieved by their open blossoms and the fish's splayed tail. The circles at the garlands' ends form a variation from the linear theme and enliven its predominant directness. The material is not pure gold, but electrum: a natural alloy of gold and silver in varying proportions. The coin follows the weight-standard set by Phocaea, a coastal city important for commerce and colonies—one of which was Marseilles in southern France.

Philippi had been founded in 357 or 356 B.C. by the powerful Philip II of Macedon, wily strategist and ambitious ruler, father of Alexander the Great. In a fertile plan of southern Thrace near the Aegean Sea, the town became important. There in 42 B.C. the Roman Republic died, in the defeat of Brutus and Cassius by Antony. There St. Paul first preached Christianity in Europe some ninety years later. On this gold coin of the period 356-348 B.C., a fine tripod is decorated with a garland. The leafy branch above may symbolize a victory: perhaps in the games at Delphi, where Apollo's tripod stood. The Phrygian cap at the right is seemingly a control-mark, a code for the particular magistrate responsible for the coin's issue and reliability. The strong details and good perspective are noteworthy. Both coins gain added beauty from the glistening metal itself.

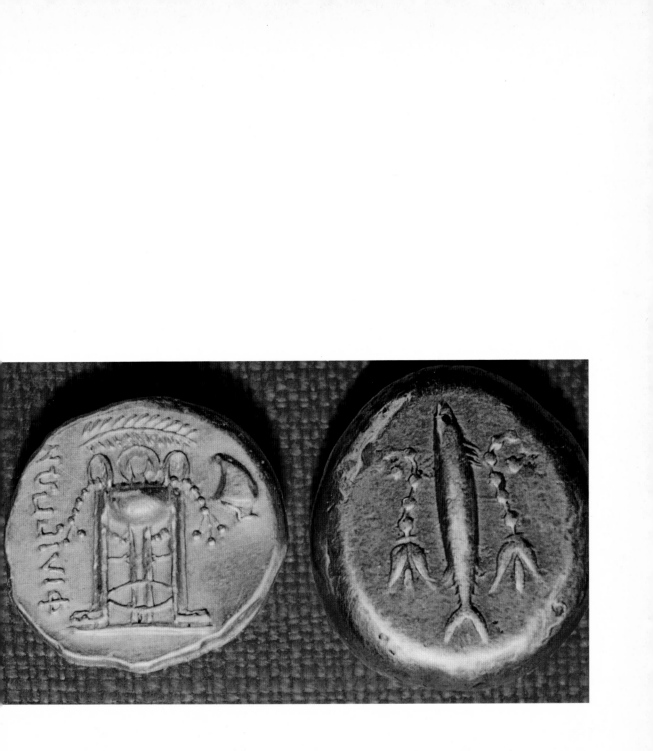

63

This vivid portrait is commonly called Etruscan work, but it is so superior quality that I am strongly impelled to consider it a Greek original. It is kno that Greek artists did portraits of famous Romans, and many of them b Greek signatures. Etruscan sculptors often imitated Greek art, just as th tomb painters followed Hellenic traditions of mural painting and frequen borrowed its themes. There is a distinctively Etruscan element, however, in style of these imitations which distinguishes them from direct Greek produ If the present bust is actually by an Etruscan sculptor, he has caught the authen spirit of Greek portraiture better than any of his fellows (to judge from ext examples) and has rivalled its special perfection of detail to an unusual degr The portrait's merits, then, are essentially due to established Greek techniqu and most likely this bust is of actual Greek workmanship, probably of the f century B.C. or just before, though some would date it as far back as the fou century.

The person represented is clearly some noble Roman of the early period, a it is plausibly presumed that he is Lucius Junius Brutus the 'Liberator', traditio founder of the Roman Republic. He led the revolt against Tarquin the Prou last of Rome's kings, in 509 B.C., which abolished the monarchy and brou; basic democratic rights to the people through elected representatives. Traditi said that Brutus was the first Consul of the new Republic, and died later battle against the Etruscans at Silva Arsia, which ended in Roman victory. was revered throughout later Roman history as a great champion of the peop rights and as a model of the stern virtues and incorruptible civic responsibil which had given Rome that strength and organization that underlay remarkable growth to world domination. Portraits of Brutus on Roman c of the first century B.C. are very similar except in small details. Both coin ; bronze portraits would of course be imaginary representations long after subject's time—and therefore important testimony on how the famous Roman heroes were conceived and idealized.

The artist has personified here those early Roman traits of *gravitas* and *sever* which were the special characteristic of the outstanding men of the early I public. Later generations rarely practised these virtues, but they recognized th as the solid foundation of the nation's greatness, as the pioneer Latin poet Enn had done:

Moribus antiquis res stat Romana virisque.

The strong features of this portrait—the firmly closed lips, jutting brows a chin, stern eyes looking resolutely forward, and taut lines of cheek and nose unerringly convey an impression of sturdy character and unswerving devot to duty. Yet there is an obvious humanity about the person which softens sternness without diminishing our awe. The fine management of hair and bea and inset eyes makes the head seem very life-like and provides us with a fas nating study of distinctively Roman qualities of character.

BRONZE PORTRAIT OF 'LUCIUS JUNIUS BRUTUS'

*4th-1st century B.C.
Rome,
Sale dei Conservatori*

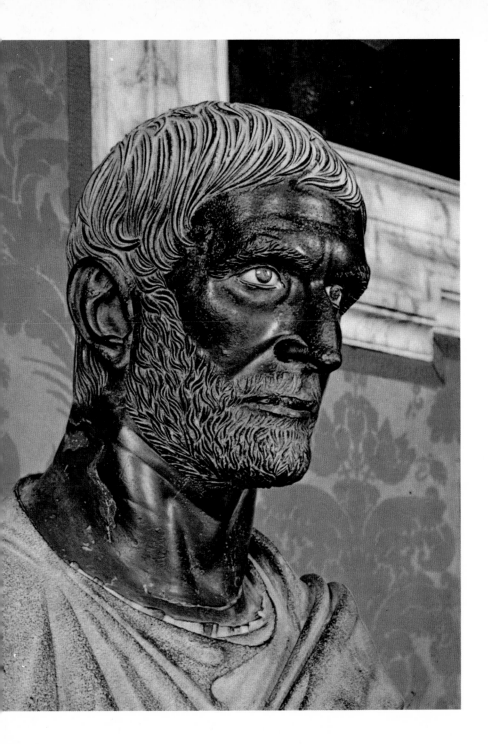

Portraiture in fifth century Greek sculpture tended to idealize the subject
some extent and to sketch general or typical qualities in the midst of indivi
alizing traits (cf. Plate 49b). In the fourth century, portraits became progr
sively more realistic, culminating in the subsequent period in such strikin
vivid studies as those seen in Plates 71, 85, and 94. The present example see
to belong to the beginning of the Hellenistic Age and to represent one of
powerful generals who ruled the Greek world immediately after Alexan
the Great. It is probably a portrait of Lysimachus of Thrace, whose own ro
coins show Alexander with just this sort of upward look as though to
stars or his heaven-sent destiny. The pose emphasizes the man's dynamic vi
and strong sense of domination. The tense muscles of his neck, the chin thr
firmly forward, the lowering brow and deep lines about the mouth all add
the impression of intensity and power. This is skillfully reinforced by the brus
arrangement of the hair, especially by the clump which projects forward abo
the ear and seems to express a driving force within the personality itself.

Lysimachus was one of Alexander's close associates and a member of
personal bodyguard. Once on a hunt he had killed a lion at close quarters, thou
already wounded himself. He accompanied Alexander on his sweeping co
quests abroad and proved himself a man of great daring and vast ambition.
Alexander's death, he became one of his successors in power, ruling over Thra
and northwestern Asia Minor. He extended his realm through northern a
central Asia Minor by his defeat of king Antigonus, with the aid of Seleuc
and later added Macedonia and Thessaly also, which he seized from Demetri
He was harsh and autocratic in governing and hated for his high taxes. He d
in battle in 281 B.C., little mourned but long remembered. This bust, a Rom
age copy of an original made from the life, forcefully portrays the kind of m
Lysimachus was.

PORTRAIT
OF
'LYSIMACHUS
OF
THRACE'

c. 320 B.C.
Naples,
National Museum

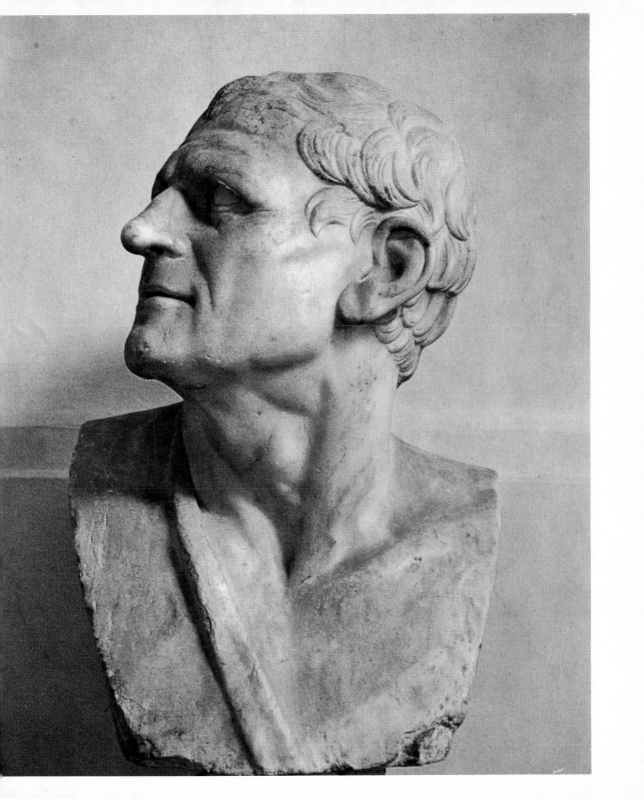

Many visitors to Venice no doubt never advert to the four splendid bronze horses which stand on the façade balcony of San Marco cathedral, for they are easily overlooked amid the exuberant ornateness of that remarkable building. Of those who do notice them, how many are aware of their adventurous story?

The horses are likely of Greek workmanship, of the fourth or third century B.C., to judge from their style; or at least accurate copies of Greek originals of that period. Accounts of their history are divergent. Some say that they were brought from the Greek island of Chios to Constantinople in the fifth century A.D., where they stood on the towers of the Hippodrome (race-track). Other reports are that they belonged to some monument at Alexandria in Egypt, a great center of the later Greek culture. Some argue that they were part of the great Rhodian chariot of the Sun that once stood near Apollo's temple at Delphi, since their hooves would fit the holes in the surviving base of that bronze group, one of the glories of Delphi. Eventually, like so many other products of Greek art, they were brought to Rome. There they stood on a triumphal arch until Constantine brought them to his new capital Constantinople as eminently worthy to add to the artistic tone of the New Rome. When Constantinople was pillaged and almost totally destroyed in 1204 during the Fourth Crusade, these horses were among the very few ancient objects spared. The Venetian contingent in the expedition admired them so much that they demanded them as part of their loot and transported them proudly to Venice to be a further trophy for their famous shrine to the evangelist St. Mark, whose body had been 'borrowed' from Alexandria in the ninth century by two patriotic merchants of Venice. When Napoleon turned Venice over to Austria in 1797, he carried off these noble horses to Paris for the glorification of his own capital. They were at length restored to Venice and to their high platform overlooking the Piazza San Marco and its milling throngs of tourists from nearly every nation. The admiration which has made so many glory-seeking rulers covet possession of these horses has at least preserved them for us through all these vicissitudes.

The horses are somewhat over life-size, and are of outstanding realism and vitality. They are prancing spiritedly and show a vibrant nervous energy in their eyes, flaring nostrils, mobile jaws, and active muscles as they toss their heads in restless motion. An ancient tradition ascribed these horses to Lysippus, one of the greatest of Greek artists and court sculptor to Alexander the Great. He worked primarily in bronze, and was famous for his animal statues, athletes, and portraits. If these masterfully cast steeds are not his actual work, they may at any rate have benefitted from his technique, and they seem worthy to be associated with his name and influence.

BRONZE
HORSES

4/3 century B.C.
Venice,
San Marco
cathedral facade

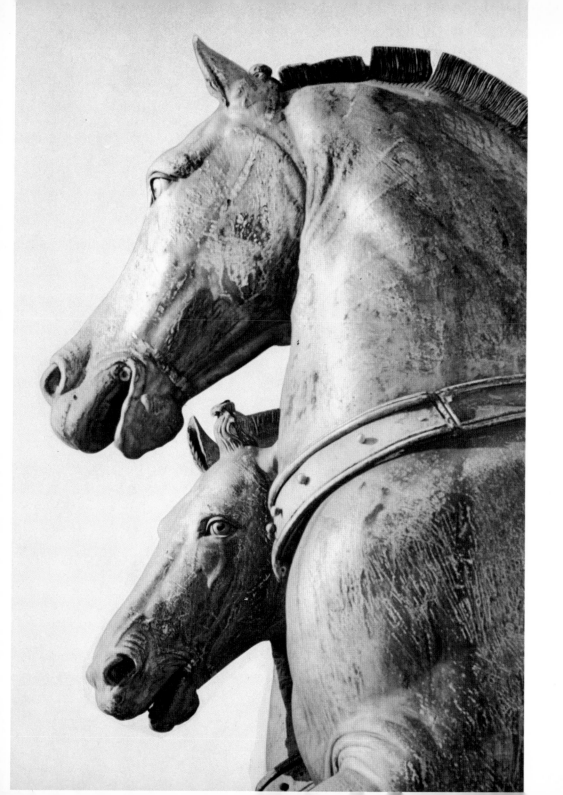

Since its discovery in 1863, this striking statue has been one of the best known and most widely admired objects of Greek art. Its dramatic setting in the Louvre, at the top of a long flight of stairs at the end of a lengthy corridor which tends to focus attention on the statue, has helped its fame, but does not properly display it, for it is seen straight on and with all lighting coming from its right. Study of the original site shows that the figure was meant to be seen from below on its left, as in this photograph, which was specially taken with artificial light from that perspective. The goddess looked out over the sea across a deep gorge, and was apparently reflected in a pool of water around the marble prow on which she stood.

The statue is very large (8′ tall), of Parian marble, probably by Pythocritus of Rhodes. It seems to commemorate a naval victory of Rhodes over Antiochus III of Syria, early in the second century B.C., though some experts would date the work a generation earlier. An interesting parallel is a coin of Demetrius Poliorcetes in honor of his victory at Salamis over Ptolemy I of Egypt in 306 B.C., extant examples of which show a winged Victory on a ship's prow, blowing a trumpet held in her right hand. The statue is somewhat different, for it is clear that the head was turned to the goddess' left, and the fragments of her right hand suggest that it held something between thumb and forefinger, perhaps a metal banner fluttering in the wind.

The composition of the figure is most effective. Nike's body is strong and firm and she opposes it vigorously against the stiff wind. Her weight is distributed equally on both legs, but the right one is more forward, for better balance. The line of the left leg and thigh is artfully carried in an S-curve across the torso to flow into the up-thrust right shoulder and raised arm. A skillful balance for the heavy wings is achieved by the counter-thrust of the powerful chest and forward leaning of the upper body. The goddess is presented at the moment of alighting on the flagship's prow, bringing the victory which she personifies.

The artist's technical mastery is evident, especially in the wonderfully natural wings and magnificent drapery. The single block of marble is made to seem like soft cloth in varied folds and at the same time like living flesh beneath the garment. Where the wind presses it against the thigh and stomach, the cloth seems transparent. In design and execution, this statue is one of the greatest achievements we know of in the art of the Hellenistic age.

WINGED VICTORY FROM SAMOTHRACE

c. 190 B.C.
Paris, Louvre

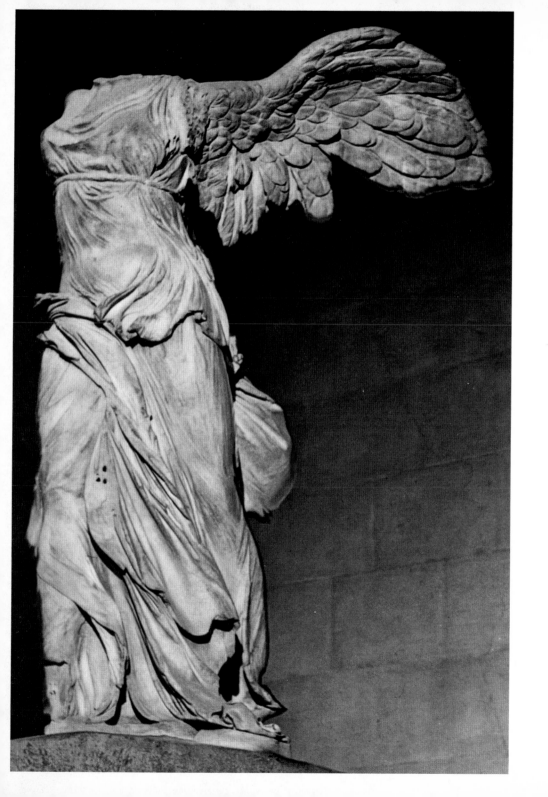

**DYING
GAUL
FROM
PERGAMUM**

c. 220 B.C.
Rome,
Capitoline Museum

A special branch of Hellenistic sculpture is that produced by the school of Pergamum, the powerful Greek city on a high citadel in Mysia to the east of Lesbos. Here in the third and second centuries the wealthy kings (alternatingly named Attalus and Eumenes) were ambitious patrons of the arts and commissioned many major works for the ornamenting of their capital city and of Athens, to which they were devoted for its unique cultural importance. Pergamene sculpture shows unusual emotional intensity, in the traditions of Scopas, and a pre-occupation with themes of violence, suffering, and death. It has a vigorous style, sturdy rather than refined, and is a bit heavy in general effect. Purely Greek qualities are modified by the encroaching influences of the surrounding cultures in Asia Minor. The many extant examples of Pergamene sculpture establish it as a special sub-division of Hellenistic art, with distinctive traits and topics.

The present instance is a marble copy of an original bronze which was part of a group of sculptures set up at Pergamum in the last half of the third century, to commemorate the decisive victory of Attalus I over the invading Gauls. This was a fierce and warlike group of Celts who had made a massive incursion into northern Greece and upper Asia Minor and were a serious threat to the survival of Hellenic civilization in the area. At the same time, they were making a final, unsuccessful invasion of Roman Italy, as they had on several earlier occasions since the early fourth century when they nearly captured Rome itself. After Attalus' campaigns, they were confined to the area of central Asia Minor which came to be known as Galatia, of which Ancyra (modern Ankara) was the capital. Attalus was very proud of his achievement, and had statues of dying or captive Gauls erected in Athens as well as at Pergamum.

The one here shown is of a Celtic warrior sinking toward death from a mortal wound. He is seated on the ground, leaning heavily on his right arm, his legs bent in pain. The artist has portrayed him with sympathy, giving him a natural dignity which rises above the usual Greek prejudice against 'barbarians'. True, he is a rough, uncultured man, with disorderly matted hair and the foreigner's mustache, and wears for ornament a torque of twisted gold around his neck. But he is human, too, and bears his agony with manful spirit. All this no doubt enhances the significance of the Greek victory over such formidable foes; but it is also a tribute to the artist's humanism. The powerful body is given very realistic treatment in structure, muscles, and tough taut skin. Blood flowing from the wound was indicated by red coloring. Yet the effect is restrained, moving but not gruesome. Since a broken trumpet lies at the Gaul's feet, he probably is the famous Trumpeter by Epigonus which is praised by Pliny (NH 34.88). Great numbers of fine statues were brought to Rome from Pergamum at the end of the second century B.C., where they had a profound influence on the growing Roman interest in Greek art.

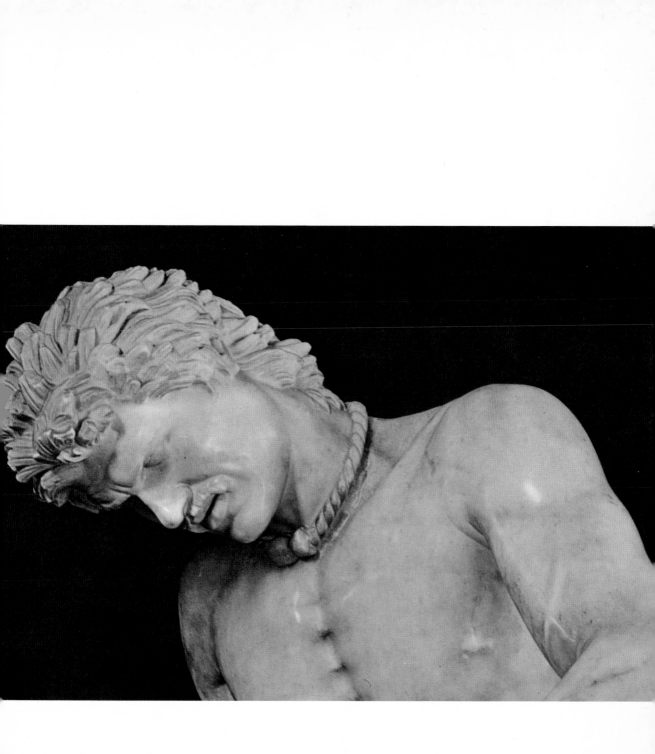

Found in 1820 on the island of Melos, this statue aroused world-wide enthusiasm as a new revelation of the authentic Greek ideal of feminine beauty, until then known only indirectly in Roman copies of various other representations of Aphrodite. Under its French name, Venus de Milo, it has become universally famous and probably the best known single object among Classical sculpture. This is to over-rate it somewhat, for fine as it is, it does not rival in technical perfection many items of Greek sculpture which we now possess.

Carved from Parian marble in two main pieces (joined at the drapery line), the goddess of love and beauty is presented as taller than human women (6′ 8″), and as a personification of physical perfection. The less careful working of the left side of the face and torso indicates that the statue was meant to be viewed from a ¾ angle to the right, as in our plate, which also does best justice to the contour of the head. The body is slightly twisted and the left shoulder raised, with similar contrasting motion conveyed by the outward curve of the right hip and the lifted leg and knee opposite. The torso is carved with careful naturalism and a studied effort to achieve ideal proportions and harmony of line. The total effect is one of refined sensuousness, an enjoyment of bodily beauty; it is firmly kept from being merely sensual, however, for there is no exaggeration or unbalanced emphasis, and the figure's essential dignity is evident. The goddess' look is serene and detached. She is aware of her beauty, and rejoices in it, but she maintains an Olympian calm. Here is human beauty sublimated by artistic vision and made an object of esthetic contemplation rather than of sensual appeal. In this it preserves the best traditions of earlier Hellenic art.

The tall body, the relatively small head, and the twisted stance suggest the influence of Lysippus, but the soft modeling of the flesh is more like Praxiteles' manner, and the composition as a whole is likely patterned on one of his Aphrodite types. The drapery is not eminently successful. It is rather heavily managed and somewhat artificial, and not well integrated with the figure, having no support except the expedient of the raised knee. (The lost right arm seems to have extended across the body, not holding the garment). Its primary purpose is to set off the smooth flesh by contrast and to provide a sharp division of the statue into equal halves.

Unless some original by Praxiteles is somewhere discovered, this work of an unidentified later artist will continue to be the most widely admired direct representation of the Greek concept of feminine beauty. It has deservedly achieved that role by its placid charm.

APHRODITE FROM MELOS

2nd century B.C.
Paris, Louvre

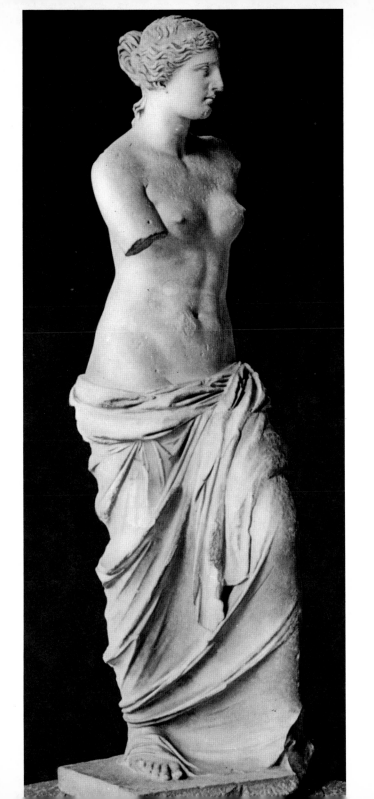

One of the aspects of Hellenistic art is its frequent choice of humorous or ever day subjects to represent. This is a facet of its unpretentiousness and realism wh it is in those moods rather than in the more sublime traditions inherited fr the Classical era. Figures from the popular New Comedy plays of Menand Philemon, Diphilus, and others were often made the theme of sculpture a painting. The bronze statuette here shown is an instance of this.

It was likely produced at Alexandria, as the peculiar color of the bro (reddish-brown, but green where rubbed) would indicate, as well as the gene style. About eight inches high, it depicts a comic actor in the role of a sla seated on an altar, impudently smirking and swinging his legs. His hands crossed in what seems a gesture of anxiety or nervousness, which the bravado his general bearing seeks to belie. Very likely he represents a stock character Hellenistic comedy, the saucy slave who accompanies his young master various escapades and gleefully enjoys their success but is always in danger being caught out and painfully punished. Here he perhaps is taking sanctua on an altar, where he cannot be seized for fear of sacrilege. He boldly defies threats and takes great satisfaction in his temporary safety. He enjoys the r so much we are necessarily amused just watching him in it.

The comic mask gives his face an absurdly distorted look, with the enorm mocking mouth, bulging eyes, exaggeratedly heightened brows, and humoro bulb-like nose. Of special interest is the thick ring around his neck over the ou garment (a short-sleeved chiton). The two notches at the middle show wh a disk was attached. This would bear his master's name and a request that t slave be turned over to him if caught running away. A second-century B. papyrus from Alexandria records just such a provision against the likelihood a slave's escape, and several of these disks have been found at Rome, some them promising a reward for return of the fugitive.

We have here a welcome ancient illustration of comic situations which c scanty literary evidence only partly preserves for us. It is also a delightful lit masterpiece of Hellenistic humor which once enlivened some family's livi room, and now provides a light moment for visitors to Princeton's museu

**BRONZE
ACTOR
AS
SLAVE**

*2nd century B.C.
Princeton,
University Museum*

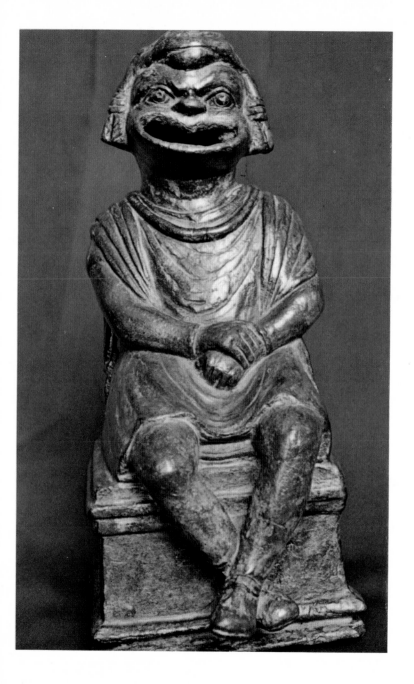

BRONZE
DANCING
FAUN
FROM
POMPEII

2/1 century B.C.
Naples,
National Museum

The large and sumptuous 'House of the Faun' at Pompeii is named after this bronze statuette which was found there in 1830 as the ornament of the impluvium pool in the center of the atrium under the opening in the roof—a characteristic design of Pompeian mansions. Standing two feet four inches high, this much-loved bronze is probably a Greek original, made for the wealthy merchant's home directly, or perhaps as a small-scale re-creation of a larger Hellenistic work. It has a marvelous dexterity of craftsmanship which raises it high above the usual mediocre copies of Greek sculpture found in so many other houses of ancient Italy, though it is not without rivals from the several homes at Pompeii, Herculaneum, and Rome which profited from real artistic taste in their decoration.

The chief merit of this statuette is its spontaneity and vigor, coupled with technical execution of the highest order. It is likely by a late follower of Lysippus, with complete mastery of the third dimension. There is a dynamic vitality in the lithe, resilient body which aptly expresses the mixed animal and human nature of the fauns and satyrs of mythology. He is dancing with exhuberant joy, full of animation and high spirits, snapping his fingers and springing lightly on his toes. There is an artfully designed spiral twist to his stance which emphasizes his muscular grace and general vitality. The rough, uncultured face is not uncouth or savage, being humanized somewhat by its radiant delight. The hair is wild and uncared for, as is the full beard. He is identified as a faun by the goat's horns sprouting from his forehead, and by the curling tail. There is something primitive and awesome in his vibrant energy and natural grace. He still diffuses a spirit of fresh life and untiring enthusiasm, and is one of the most welcome survivors from the once populous world of Greek sculptures which seemed to possess the life they once represented.

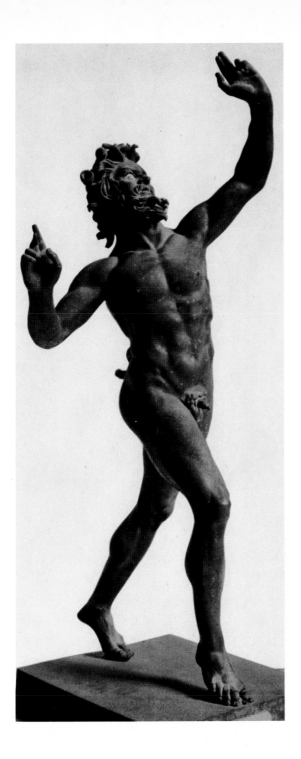

71

The unmitigated realism which marked one of the streams of artistic production in the Hellenistic age is graphically exemplified by this startling portrait. Its power in conveying a realization of inner misery and dismay is almost shocking. Here is an old man looking with empty despair at approaching death, shaken by the grim darkness ahead and saddened by his body's decline from its former vigor which had once emboldened him to face life's challenges with confident self-assurance. Now, lacking all hope and embittered by the torment of his inability to forestall inevitable death, which will so soon envelop him, the old pagan glowers at his doom with an intensity which reveals much spirit in him yet. It is doubtful that a more powerful study of this theme has ever been achieved in art.

The ancients too admired this piece, no doubt fascinated by its strength and brilliance, for some forty copies of it have survived, proving that it was extraordinarily popular in Roman times. By far the best of these numerous extant exemplars is this one, found at Herculaneum in the rich villa of the Pisones. Perhaps, indeed, it is the original from which the others were copied. If itself a copy of a lost original, it is most meticulously done by a first-class artist or is cast from a mold that transferred every detail of the archetype. The master who first created this portrait succeeded in making it an unambiguous revelation of an inner mood. The meaning is all in the realm of invisible psychological realities, but these are magisterially expressed by the special forms worked into the material. It is the combination of features which is so telling, but each detail too is stirringly effective—the gaunt staring eyes devoid of inspiration, the hollow haggard cheeks and scraggly beard, the drooping mouth and sunken contours of the neck, the tensely knit brows and distended nostrils expressing tension and fear, and the matted unkempt hair which betrays a loss of all interest in personal appearance. It is only dead bronze, but it seems to be a real man in torment.

Who is this man, so clearly an historic individual? The answer is persistently elusive. The older theory that it represents Seneca has been universally abandoned, since it is obviously a work of Hellenistic style, long before his time (he was tutor to Nero). Efforts to identify the subject as Hipponax, Archilochus, Philemon, Aristophanes, or some other poet have not proved convincing, and the laurel wreath which some copies show is not exclusively a poet's prerogative. Perhaps he is a philosopher, though most of the famous ones are identifiable in other portraits which bear no resemblance to this one. The latest study, a penetrating analysis by G. M. A. Richter (*Greek Portraits*, I, 1955), leaves the question unsettled but favors seeing in the man some Greek philosopher. Whoever he is, the person so vividly delineated here seems to stand, in the artist's eyes, for something more than himself. Here is a work of genius which in a concrete individual analyzes a universal and philosophical idea. This is a study in pagan Old Age itself.

BRONZE PORTRAIT OF AN OLD MAN

2/1 century B.C.
Naples,
National Museum

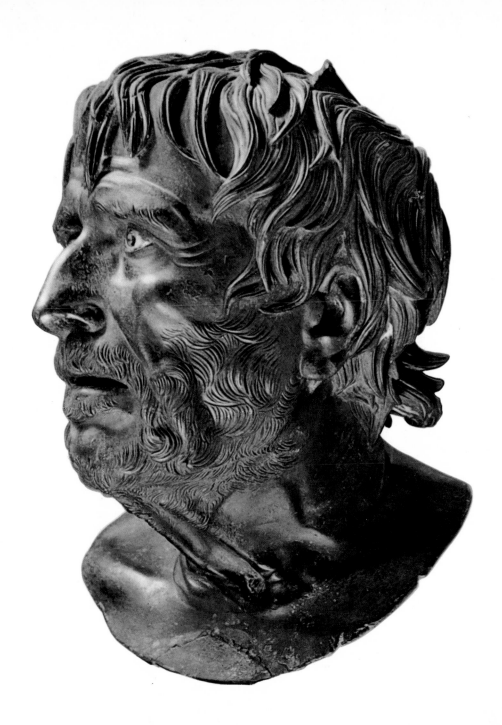

How far some Hellenistic art departed from the ideals of the high Classical Age of the fifth and fourth centuries is abundantly manifest in this harsh bronze. It is bluntly naturalistic and grim, making no effort at all to be noble, uplifting or beautiful. Rather, its aim is to be ruthlessly realistic, an unflinching statement of a situation in actual life which merits attention by its very toughness and inhumanity. There is much in common here with the mood of many artists and writers today, who boast at daringly presenting life as it is, not as it should or could be when illumined by an ennobling vision and a superior insight. It implies an attitude toward life and toward immaterial values which is cynical, hard, and without idealism. This facet of late Greek culture would have repelled and puzzled most earlier Greeks; no doubt our own disillusioned age can understand it more readily. It all shows the extraordinary range of the Greek spirit.

The boxer is a burly fellow, with a massively muscular physique that has been battered by his opponents. There are bruises and deep gashes on his shoulders, arms, thighs, and these were probably made more gruesome originally by coloring in purple and red. His nose has been broken and flattened, and he breathes with difficulty through his open mouth, which lacks some teeth. The cauliflower ears have been mangled by many blows and are oozing drops of blood. His head is small and unintelligent looking, and he scowls peevishly at being disturbed in his rest, as though struggling to get his jolted brain to react to some question or instruction. His thick neck and bulging back add to his brutish appearance, which is relieved only by the surprisingly careful arrangement of the hair and beard. Encasing his hands are the savage leather gloves with bands of lead at the knuckles which were known as 'killers' (caestus). Altogether grisly subject!

Such themes entered Greek art only after the profound transformation of Hellenic culture consequent on its mingling with foreign civilizations in the wake of Alexander's conquests abroad. This statue is signed by Apollonius son of Nestor, an Athenian sculptor active in the middle of the first century B.C. (he also did the 'Torso Belvedere' in the Vatican museum). Probably it is his free re-working of an earlier Hellenistic statue, perhaps of the Pergamene school, and he may have made it even more callously ugly than the original, to fit in with the jaded taste of the time. It was probably commissioned by some wealthy Roman to amuse him between gladiatorial shows.

BRONZE BOXER

c. 60 B.C.
Rome,
National Museum
(Terme)

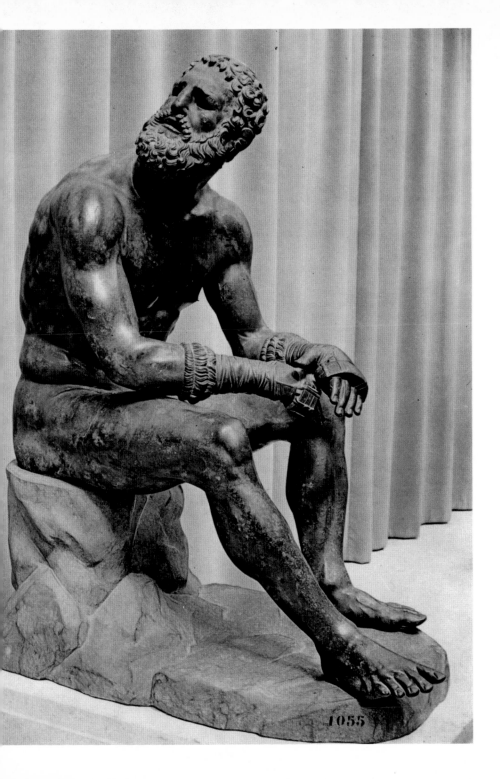

There is a poetic quality about this sculpture that challenges our attention. The tall conical neck of the horse curves sharply into the long head with its strikingly life-like features that seem vibrant with nervous energy and sensitivity. The mouth and nose are particularly fine, but the prominent veins, muscles, and large eyes also contribute to expressing the animal's lively spirit. The mane is imaginative and suggested, rather than realistic, and thus also adds to the general effect of combined fancy and objectivity – of nature observed but freely interpreted.

Coming from the site of the Eleusinian Mysteries, this work has appropriate symbolic implications. The horse was a common funeral theme with Greek nobles, especially the knights, and actual horses were sometimes sacrificed at the tomb or even buried with the deceased master. Here, the horse's *protomé* (neck and head) is represented as sprouting out of the ground, in allusion to the hope of renewed or continuing life beyond the grave, which was especially stressed in the religious rites at Eleusis. And the collar of acanthus leaves is perhaps in imitation of the *calathus* basket carried in processions of Demeter at Eleusis and elsewhere, besides the general associations of acanthus plants and cemeteries. (It is said that the originator of the Corinthian capital for architecture got the idea from observing an acanthus growing wild in a burial ground). It is likely, then, that this is a funeral monument, or at least designed to express a connection with the realm of the dead which was so much a part of Eleusis' meaning.

The horse, however, is only part of the statue. Next to it stood one of the Dioscuri, Castor or Pollux, whom the horse would serve to identify. Part of the hero's foot survives, attached to the same base. Several such statues have been found, in more complete preservation, for instance those in Cyrene and in the Louvre. But they have none of the *élan* and delicacy of this Greek example, which seems to be late Hellenistic in style, probably from the first century before Christ. No one could fail to see its special freshness and charm.

HORSE HEAD FROM STATUE BASE

c. 1st century B.C.
Eleusis,
Archaeological Museum

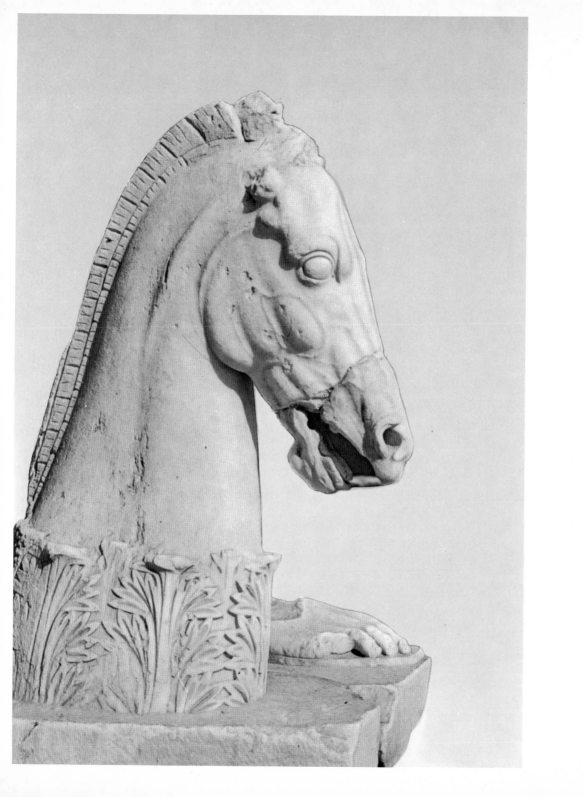

DOLPHINS
MOSAIC,
WITH
CUPID
RIDING

c. 110 B.C.
Delos,
House of Dolphins

The finest extant Greek mosaics are on the island of Delos, heart of the Cyclades. According to the ancient myth echoed in the 'Homeric' *Hymn to Apollo* and other literary accounts, it was here that Apollo and Artemis were born. The island became very early one of the chief religious centers of Greece, and the pilgrimages every five years to its great Sanctuary of Apollo were affairs of much pomp and importance. Socrates' execution was postponed, as the law required, until the expedition of 399 returned from Delos. In the third and second centuries before Christ, Delos was the leading commercial distribution point in the Aegean Sea. Many of its wealthy merchants' houses survive in part, in design and decoration much like the more familiar ones at Pompeii. The 'House of the Dolphins' (late second century B.C.) is a typical example.

The mosaic here shown is part of the floor of the peristyle court at the center of the house. Each of the four corners inside the colonnade has a pair of dolphins yoked with golden cords and ridden by a winged cupid with staff and streamers. One of the dolphins holds a ribboned crown in his long snout. Each pair is in gracefully intertwined motion, gleefully racing the others. The design neatly fills the triangular corner space.

Beneath the figures is a checkered band and parallel stripes, then an attractive wave pattern whose black and white contours are inverted counterparts. The meander below has wonderfully effective depth illusion and is a marvel of subtly varied color tones and shading. The whole is a charming example of Hellenistic skill and lightness of theme, a captivating detail in the refined decoration of this elegant and tasteful house.

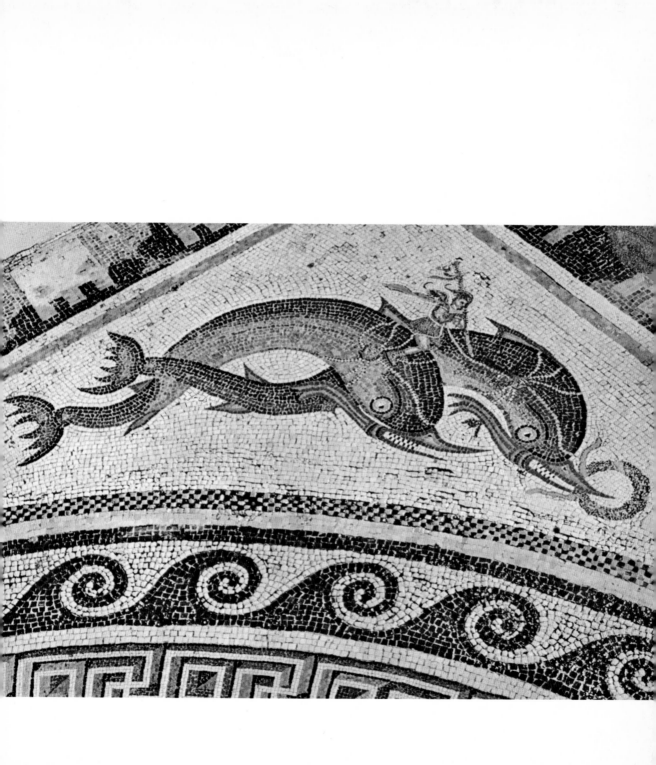

DIONYSUS
ON
PANTHER
MOSAIC

c. 100 B.C.
Delos,
House of Masks

When the French excavations on Delos uncovered the 'House of Masks' in 19, they revealed a splendid floor mosaic which is perhaps the finest that has surviv from the ancient world. It is strangely little known and rarely illustrated. Yet is clearly a masterpiece, ranking with any mosaic of even the finest later artis in that subtle and difficult medium.

The extraordinary vividness and vitality of the panther could hardly be matche The beast is all lithe tension, with a magnetic air of nervous energy and supe muscular refinement. The restless eager motion, fierce claws and swishing t. are climaxed by the taut craning of the neck and the savage snarl. Glaring ey reveal a fiery spirit and sense of power. So life-like is the whole animal that o feels an illusion of danger and an awe mixed with fear. Seldom has dead stor been brought to such vibrant life. Here the creative power of art, the triump of human mind over inert matter, attains a revelation that not merely compe admiration but carries us into an awareness of mystery.

In striking and intended contrast with the tense dynamism of the panther the calm nonchalance of the god. With divine serenity, Dionysus rides at ea conscious of complete control and immunity from harm. He is ornately dresse with rich flowing cloak, elaborate jacket, and floral crown. He holds his syn bolic thyrsus, a wand terminating in ivy leaves, which is a mark of his cult. T cymbal is likewise traditional, as worship of the wine-god was accompanied music and dance of an oriental flavor carried over from his foreign origins.

It is likely that this magnificent mosaic reflects the owner's interest in t theater, manifest in the series of mosaic masks in the border decoration of a other room of the house, for Dionysus was patron of the drama, and the gre theater at Athens was built in his honor.

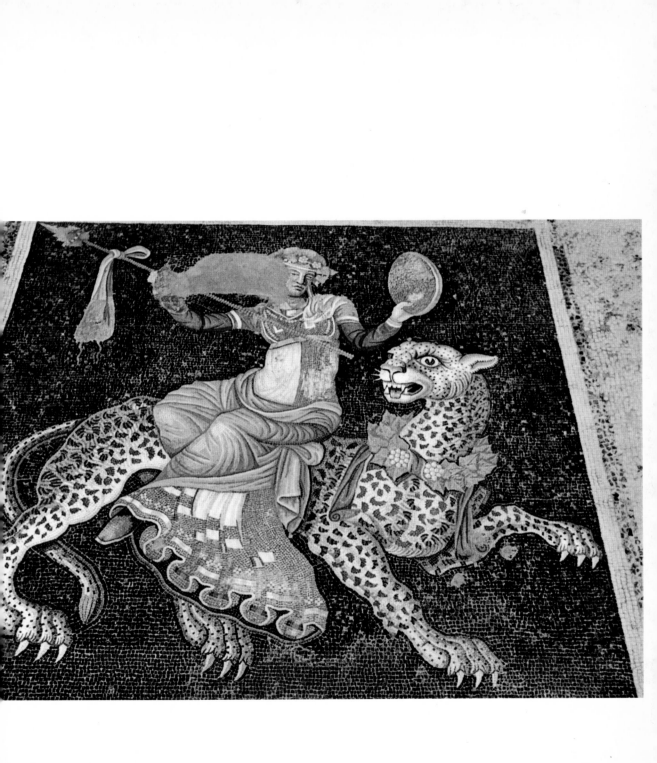

MENDICANT
MUSICIANS
MOSAIC
BY
DIOSCORIDES
OF
SAMOS

c. 100 B.C.
Naples,
National Museum

The so-called 'Villa of Cicero' at Pompeii, along the Street of Tombs near the famous 'Villa of the Mysteries' (Plate 91), preserved two fine mosaics which are signed by Dioscorides of Samos. One is a scene of three women huddled around a table, apparently an episode from a New Comedy play in which an old hag is being consulted about love-philtres. The other, here illustrated, shows wandering street musicians – either a direct study or as they are represented in a play. In any case, they wear masks, which gives them fixed expressions for which they must compensate by varying gestures and actions. They present a permanent smile of satisfaction which is meant to induce similar contentment among the spectators – and a more generous contribution. Though both are rather stout, the two men are dancing lightly as they play, one of them a tympanum like a tambourine, the other small cymbals. The woman flutist is less animated, only her fingers showing motion. The boy standing next to her may be part of the troupe, perhaps the one to take up the collection among the audience; or possibly only an urchin from the streets who has come to listen and watch out of curiosity. The latter seems more likely, from his intent gaze at the performers and his lack of a mask. His face is crude and dull, and he looks much older than his years. He provides effective contrast with the gay musicians, and a new element of human interest and of the harsh realities of everyday life.

There is a most competent use of light effects, part of the garments and figures strongly illuminated, the rest in varying degrees of shadow. The cymbalist made more prominent by the tympanum-player's shadow on the wall behind him. The general illusion of depth, and of separation from the background, is excellent, and the color tones of the bright clothes are most attractive. The mosaicist has used very small stones, to allow more subtle management of line and shading. He is clearly a superior artist in this difficult field, and proud of his work, as the signatures show. He did not originate the design, but has copied it from some fine Hellenistic painting of the third or second century, itself inspired by the popular comedies of Menander and his rivals. A poorer copy of this same scene has been found at Stabiae, going back to the same original. In the nearly total loss of authentic Greek painting, mosaics like this and the one in Plates 77 and 79 are especially welcome, not only for their own merits but as reasonably faithful images of the murals and easel work which we cannot otherwise see.

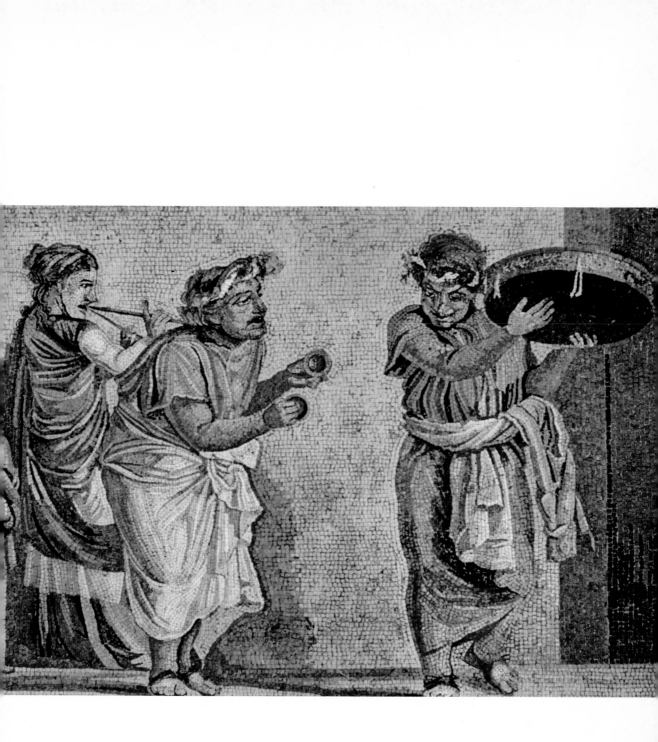

Besides the lively statuette seen in Plate 70, the 'House of the Faun' at Pomp
yielded this splendid large mosaic, sixteen feet across and half that high. The
are an estimated million and a half tiny stones in its composition, about t
size of grains of rice. The workmanship closely rivals that of the Dionysus a
Panther on Delos (Plate 75), but it is on a much larger scale.

The work has special importance because it is clearly a careful copy of
famous Hellenistic painting, and is in consequence our best direct witness to t
high level of Greek achievement in that line. Ancient sources refer to paintin
of Alexander's battles by Aristides of Thebes, Philoxenus of Eretria, and Hel
of Alexandria. On the basis of Pliny's description of Philoxenus' work (N.
35.110), it is most likely that his was the original which was translated into t
mosaic. His painting of the Battle of Issus was considered sensationally drama
and skillful; it employed, besides white, only four colors: red, brown, blac
yellow – which this mosaic faithfully follows. The battle, in 333 B.C., had be
an historic turning point, the beginning of Alexander's explosion into the v
Persian Empire which he then rapidly conquered. This was the real start of t
Hellenistic Age, and the artist has captured here its drama and excitement. I
shows Alexander in the forefront of the attack, and the Persian king (Darius I
in dismay at the rout of his troops. The bare background is without distracti
interest of its own, to keep attention on the historic action; it has only a de
tree, and a forest of spears. Bold foreshortening is used in picturing a horse
the center (not here illustrated), and everywhere a masterful economy of desig
which suggests much more than it actually depicts. The painting is a technic
triumph by any standards, and its rendition here in the much more diffic
medium of mosaic is as admirable for its daring as for its brilliant success. O
plate gives two close-up views of important details, to show different facets
the artist's skill.

Alexander is depicted with striking vividness. His impetuous courage a
fiery energy are conveyed by his resolute pressing of the attack in the mid
of great personal danger. But more dominant still is the impression of myste
and awe in his gaze, emphasized by the exaggeratedly large eyes. He is gripp
by a sense of destiny, as he looks beyond the present action into his extraordina
future, as the whole world begins to fall open to his domination. The use
high-lights to make his face glisten with the exertion and tension of battle is m
effective, and there is a wonderful vitality to his horse's head, especially in t
remarkable eye.

In the group of Persian nobles massed near the king's chariot we see the artf
compression of volume for which Philoxenus was famous, and his use of largel
hidden figures to multiply their number and to give three-dimensional effe
Each man and horse has individual treatment, and their turbulent emotions a
graphically evident. The chromatic tonality is deftly managed, and the who
picture is a marvel of realism and ethos.

ALEXANDER
AT
ISSUS
MOSAIC

2nd century B.C.
Naples,
National Museum

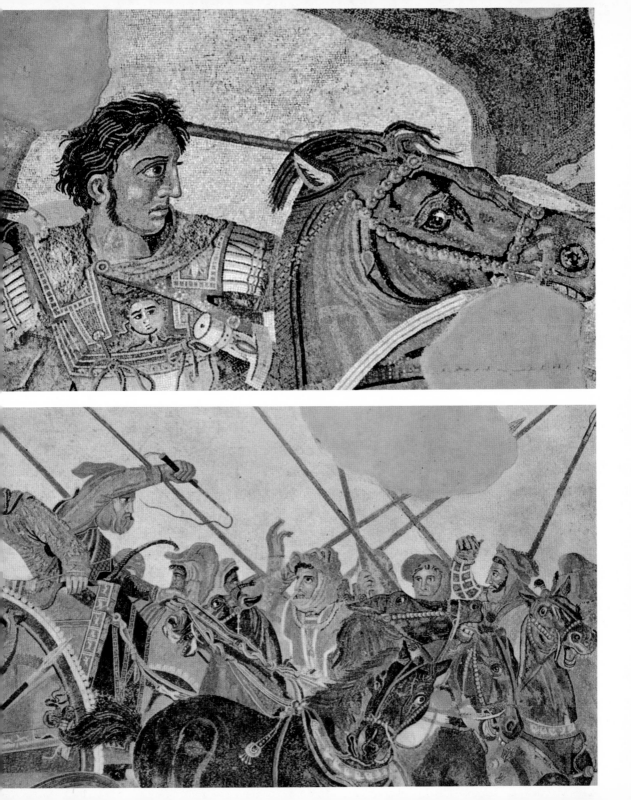

Several of the wall paintings at Pompeii are portraits of members of the hous
hold, but this is the only portrait in mosaic which has been found there. It
much more masterful than the paintings, though in a far harder medium fc
achieving details. By dexterous manipulation of the tiny stones of different colo
the artist has produced remarkably subtle gradations of lighting and strikir
naturalness of perspective. The three-dimensional quality is outstanding, th
being the hardest of all effects to attain with the necessarily irregular materia
in mosaic work. A further miracle of art is the successful capturing, in suc
materials, of the subject's intangible spiritual qualities. Her personality and livir
soul seem to shine out from the dead stones; and we feel that we are not merel
looking at her likeness but coming to know her personally.

The woman is no doubt the *domina*, the lady of the house, and it was app
rently her bedroom in which this mosaic was found, an inset in the floor. Wit
her large eyes, rather heavy nose, and dark hair, she is typically Campanian i
appearance, and it may be presumed that so superb an artist has succeeded i
representing her just as she was, with a slight touch of idealization. She wa
obviously cultured and refined, a lady of wealth and social eminence and tru
native beauty. She has enhanced her charm by tasteful use of cosmetics an
jewelry, but her chief attraction lies in her pensive eyes and sensitive mouth
The healthy glow on her cheeks, if artificial, is a tribute to ancient beautician
as well as to the mosaicist's skill!

The high level of achievement in this fine portrait points to a superlative artis
no doubt a Greek who traveled about on private commissions from wealth
Romans. Both the lady and we are fortunate for his skill and for his work
survival down the centuries.

The technique employed here, as also in the mosaics in Plates 75, 76, 77,
that called *opus vermiculatum*. This uses tiny pieces of stone of various irregula
shapes, to allow the utmost refinement of detail and delicate progressions c
color. These effects are naturally much less subtle in most mosaics, which ar
done in the *opus tessellatum* manner with larger cubes which are uniforml
rectangular. Sometimes colored glass was employed to provide supplementar
tones not available in the natural shades of the various kinds of marble and relate
stones. However, the main emphasis was not on bright colors, but on the adroi
arrangement of the fragments to produce an effect of naturalness, depth, and th
inner life of character and emotions, such as the present portrait so successfull
demonstrates.

MOSAIC PORTRAIT OF POMPEIAN LADY

c. 50 B.C.
Naples,
National Museum

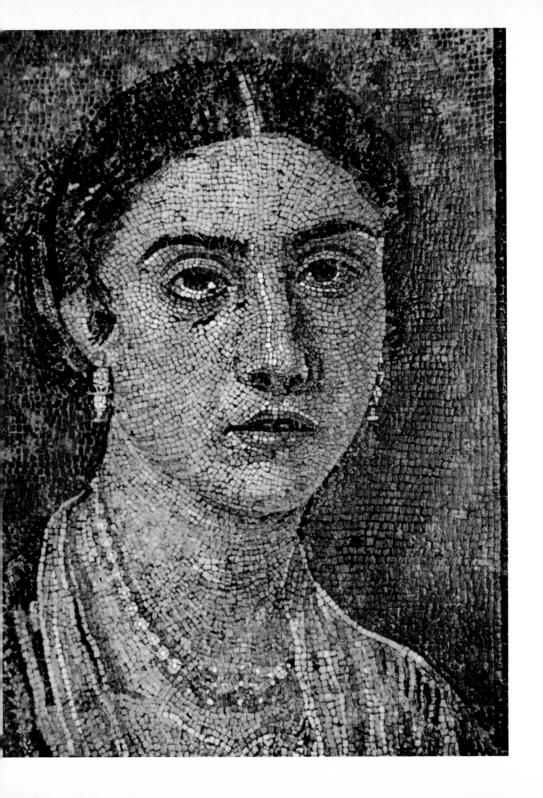

NEREIDS
MOSAIC
BY
ASPASIUS

c. 200 A.D.
Lambèse, Algeria,
Museum

This mosaic, in a small remote museum in North Africa, is little known and deserves more widespread attention. It is a remarkable example of late Greek art, produced around the beginning of the third century after Christ, when Greek cultural traditions had been largely overlaid by various foreign tastes and were losing their distinctiveness and vitality. There is evident in this mosaic a quality of lushness and fantasy that would not have been found in a work of the Classical or even the Hellenistic Age. Perhaps something of African exuberance can be seen here, struggling with the old Greek ideals of clarity and restraint. But the theme and general design are authentically Hellenic, however much the artist has accommodated himself to a provincial mood. He has signed it at the bottom, 'by Aspasius', in Greek letters. It was found at Lambaesis, essentially a military town and the chief base of the Third Legion, which, being charged with the defense of Roman Africa, had built the entire settlement in the second century A.D.

The scene, of which we show the right half, is a mythological conceit. Nereids, semi-divine daughters of 'The Old Man of the Sea', are enjoying the sun and air, riding with total aplomb on the backs of fantastic monsters from the depths. These have long serpentine bodies which end in the fore-parts of leopars, tigers, and fierce griffins or dragons. The fabled Loch Ness Monster could feel at home in their company! Yet for all their fearsome appearance, they seem gentle to the maidens and to the winged cupids who attend them. The sea-nymphs are very pretty under the canopy of their billowing veils. The colors employed are bright, and the green an unusual tone. Altogether, this is a striking production, a memorable way for Greek mosaics to end.

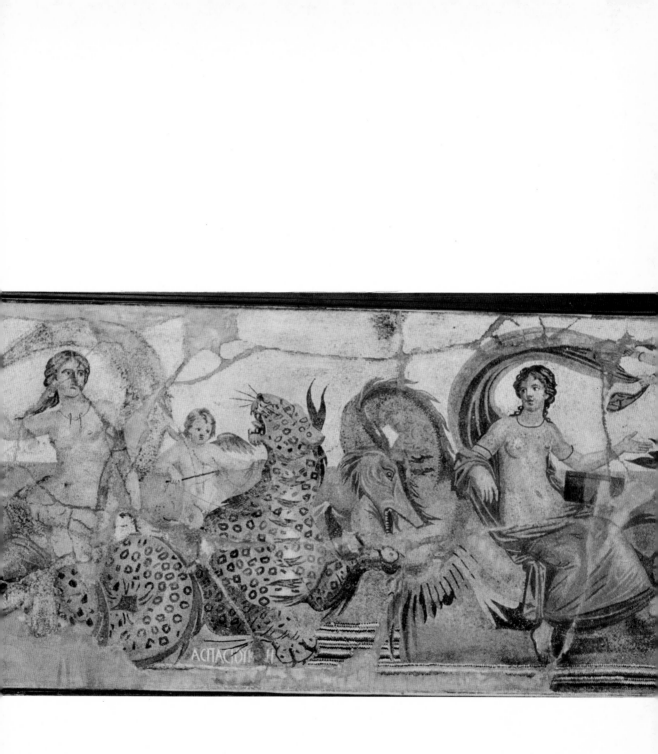

80

TYPES
OF
GLASS
VESSELS

6-1 century B.C.
Paris, Louvre

The production of glass for artistic purposes seems to have first developed Egypt, where colored glass beads and faience (a vitreous surface over clay quartz) occur as far back as 3000 B.C. The Cretans and Mycenaean Gree imported Egyptian glass objects and seemingly made some of their own f decorative uses. Colored glass inserts were sometimes employed in the Classic Age for architectural embellishment and even in sculpture occasionally – f instance, Phidias inlaid with glass some of the gold surface of his great statue Zeus at Olympia, as is indicated by the recent discovery of the molds fro which it was made.

The technique of glass-blowing on a tube was not invented until around tl first century B.C., probably in Syria. This allowed cheap manufacture of th transparent glass vessels, which were very common in Roman times. Until the glass jars were fairly rare and expensive, because made laboriously in molds by the sand-core method. Fine examples of the latter were produced in Gree during the Archaic and Classical periods, of which those in our plate are typica The hot viscous material was formed around a core of sand into the desire shape, and strips of other colored glass rolled into the pliant surface and draw over it in a decorative pattern, then the whole was allowed to cool. A gre variety of designs was thus feasible. The colors are usually a deep blue or cream white with bright yellow or red added, sometimes brown or green. In shape, tl glass vases are often much like the smaller forms of pottery – compare tho here illustrated with the clay aryballus, oenochoe, and alabastrum forms i Plates 10, 18, 35. This shows that they are Greek work. Glass imported fror Egypt or Phoenicia is usually in somewhat different shapes, and not of the sam color tones. The brown example in the foreground, and the blue-green bowl the rear, are instances of the thin-walled types produced by fused mold an blowing techniques. The chief use of these small Greek vases of glass was f perfumes and ointments. They are attractive combinations of utility and beaut

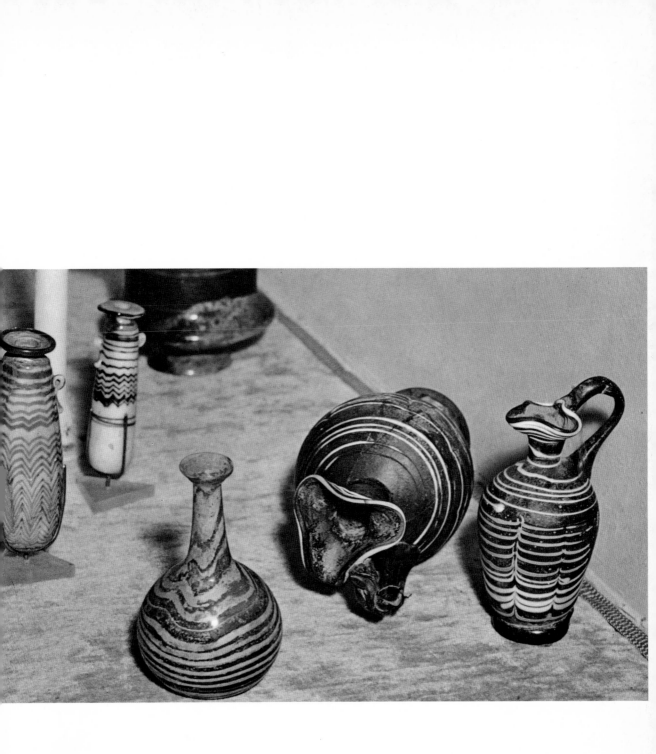

**'MILLEFIORI'
GLASS
BOWLS**

*1st century B.C. /
2nd century A.D.
Munich, Museum
Antiker Kleinkunst*

A development of the sand-core technique in making glass vases like those in the preceding plate led to the special type of bowl known as 'millefiori', Italian for 'thousand flowers'. This seems to have been an invention of Greek craftsmen at Alexandria in Egypt, the chief center of quality glass production in Hellenistic times. Rods of glass of different colors were formed into a pattern like flowers, stars, or marble veins, then fused into a solid cane. Fragments of these could then be inset into a mass of fluid glass (usually blue, red, or black) and the whole pressed into a mold and heated until all parts blended into a unit. The result would be a bowl of elegant ornateness such as those here shown. The pattern is often visible through the translucent substance of the entire vase, giving it a special fascination and mystery. In other cases, the effect was like mosaic work or the richly variegated texture of some rare marble. These vases were naturally very costly, but large numbers of them have been found. They were especially prized in Roman times and their production continued for centuries. Since techniques and styles changed little, it is hard to date them accurately, or to know which are Greek and which Roman in origin.

Very likely these sumptuous glass bowls were often sought as substitutes for the even more exotic and expensive *murrina vasa* of which we read in Pliny (*N.H.* 37.2) and other Roman authors. These were items of great luxury, made from a special substance like jade or agate which was known as *murra* and imported from Parthia. It was usually purple, white, or brilliant red, often opaque, sometimes irridescent, and had a delicate scent. Vessels made from it brought extravagant prices and were often objects of wealthy show and social prestige (cf. Juvenal 6.156). If these inlaid glass bowls were somewhat less fabulous than that, they were still items of rare elegance and beauty.

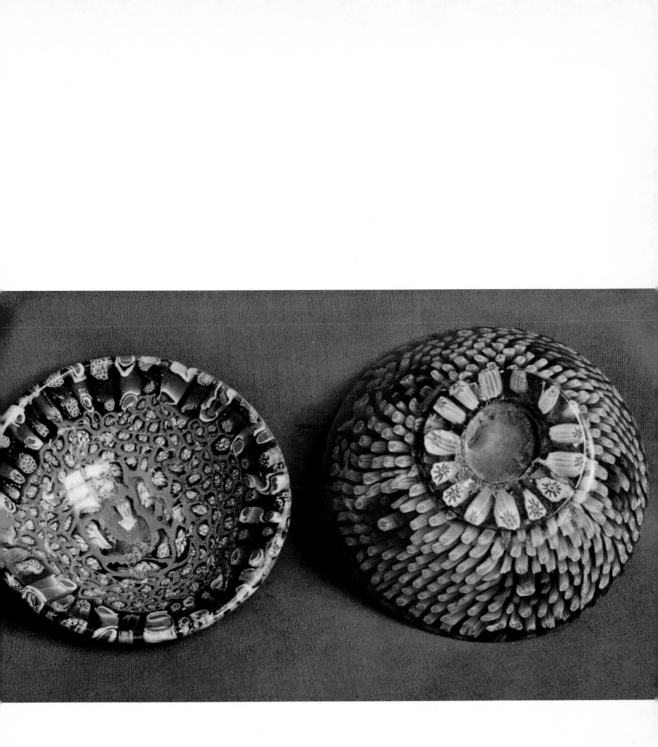

THE
'FARNESE
PLATE'
CAMEO

3/2 century B.C.
Naples,
National Museum

For many centuries, gems and precious stones had been carved in *intaglio* (reverse relief), since their primary purpose was use as seal-stones (cf. Plate 49). In early Hellenistic times a new approach was developed at Alexandria, by which the carving was in relief and the aim directly ornamental. This is the cameo technique, principally employed on stones or sea-shells which have layers of different color, or on glass made in that manner (Plate 83). It became very popular among the wealthy in Roman times, especially with the Imperial families, who had their portraits or historic exploits carved in cameo medallions. The finest of all Greek cameos that we have is this one in Naples, which dates to the early period of the art. It is clear, on stylistic grounds, that it was produced at Alexandria in Ptolemaic times, a century or so after Alexander's conquest of Egypt. It is also the largest of Greek cameos, eight inches across and nearly three inches deep, in the shape of a large dish with convex rim. A single piece of sardonyx, it is intrinsically precious for its size and beautiful grain. Being also worked with the highest skill, it is altogether the most valued cameo known. It was once owned by Pope Paul II, from whom Lorenzo dei Medici inherited it in 1471. It passed from him to the noble Farnese family and along with most of their great collection of art was transferred in the eighteenth century to the Naples museum.

The design is executed by cutting away portions of the stone down to its thick layer of gray, in which the figures are carved in relief. The background is then cut away to a lower stratum of chestnut brown which contrasts with and emphasizes the figures. The scene is clearly symbolic of the beneficent forces of Nature. At the left, Father Nile is seated next to a tree, holding a large cornucopia overflowing with the fruits of the soil which he annually enriches by his floods. At his feet reclines a female figure, who is probably Isis, the chief Egyptian divinity, but perhaps Ceres or the Nile's wife or daughter. She is leaning on a sphinx whose veiled head faces to the right, the body carved in the rich brown of a higher layer than that used for the other figures. Above, at the center, stands a youth holding agricultural implements, seemingly Horus the kindly young god popular with the Greeks who knew Egyptian mythology. He is presented very much in the guise of Alexander, and perhaps symbolizes Alexandria and the fusion of Greek and Egyptian cultures. Two male divinities fly over his head, one blowing a trumpet. They are thought to personify the Etesian Winds whose blowing on the Nile slows its stream and facilitates sailing on its waters. Two nymphs are shown at the right, one drinking from a cup, the other holding a long horn: probably the Horae, the seasons of inundation and of harvest. Accommodation to Greek divinities and their traditional representation is evident. The back of the plate has a remarkable Gorgon head in relief, with flowing hair of great intricacy. The whole work is a marvel of fine carving and mature richness of style.

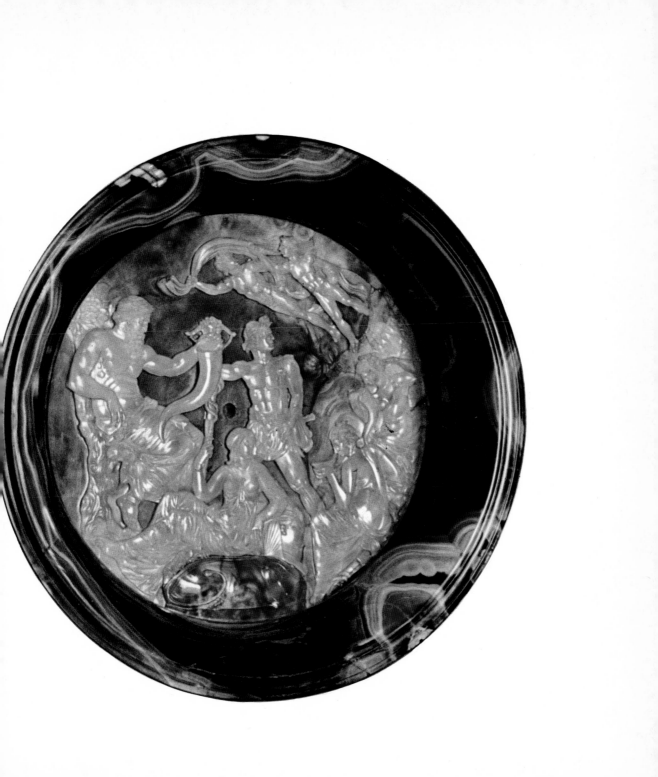

This is the finest known example of the cameo-type glass vase, a process seem
ingly originated at Alexandria and here viewed in its highest perfection. Th
body of the vase was formed from a deep blue glass, then a layer of soft whi
glass was superimposed. This outer surface was then carved away in places, as
the making of a cameo, leaving the design standing out in white against th
dark background of the primary layer. The figures are treated like sculptur
cut to different depths in various parts for three-dimensional realism. Th
carving is exquisitely fine and the design shows the true Greek sense of clari
and control. It has a soft, gentle quality which gives it an air of refined elegan
and something of the mystery of the legendary age on which it draws for them
In other ways, it is like a painting, and the partial translucence of the materi
creates its own special effect

The decorative theme is not specific enough to be certainly identified no
Various scholars have suggested that it represents the myths of the love betwe
Peleus and Thetis (parents of Achilles), Zeus and Leda (whence Helen 'of Troy
Pluto and Proserpina, Orpheus and Eurydice, or some other symbolic legen
According to the fullest recent analysis by Erika Simon, one side (illustrated her
shows Apollo gazing at the beautiful Atia, who is reclining under a fig tre
with Venus Genetrix looking on and promoting their love. On the other sid
Apollo is leaving his shrine to take Atia's hand as she sits under a laurel tree wi
a mystic serpent in her lap and Eros fluttering above to increase Apollo's lov
while some Roman deity or hero, perhaps Romulus, watches the historic meetin
This Atia was the mother of Octavian, known as Augustus after his rise
supreme power in Rome. Thus the splendid vase skilfully promotes the story
Augustus' divine lineage and sets him in parallel to famous heroes of legend li
Achilles and Romulus, as was done in other Roman art (such as coins representi
Augustus as Apollo) and in literature of the time like Vergil's poems. On th
basis and on other scores of style, the vase is now thought to have been produc
shortly after Octavian's triumph at Actium in 31 B.C. over Antony and Cle
patra—very likely in Rome itself by artists trained in the high technique of came
carving developed at Alexandria since the fourth century B.C.

The vase was found in 1644 inside a sarcophagus thought to be that of th
Emperor Alexander Severus, a few miles outside Rome. It was kept in the Ba
berini palace until bought by Sir William Hamilton in 1770 for the Duchess
Portland; her husband later loaned it to the British Museum, where since 18
it has enjoyed world-wide fame and has illuminated yet another facet of th
Greeks' artistic inventiveness. It became a prime model of Wedgwood Wa
since Josiah Wedgwood first imitated it in 1790, fathering a noble line of elega
household ornaments.

THE 'PORTLAND VASE'

c. 30-25 B.C.
London,
British Museum

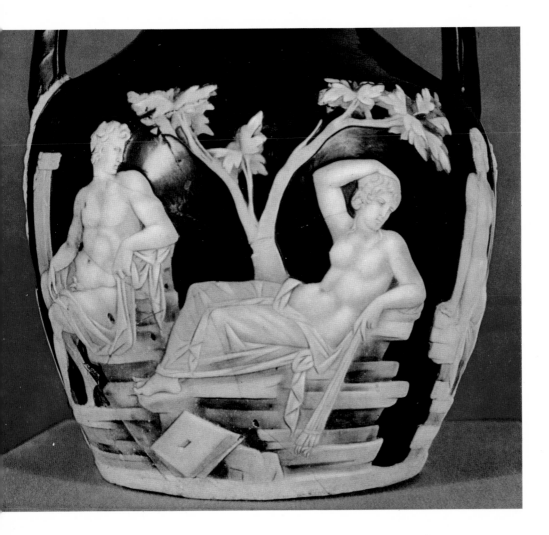

TERRACOTTA FIGURINES

A. Seated Girl

3rd century B.C.
Copenhagen,
Ny Carlsberg
Glyptotek

B. Standing Lady

3rd century B.C.
Cambridge,
Fitzwilliam Museum

A charming aspect of Greek art is the little world of daily life represented b terracotta figurines. Great numbers of them survive and together they consti tute a broad sampling of the manifold activities and situations of the mor cultivated common people. From them one gains insight into the tastes an interests and manner of dress which prevailed, and into what kind of people th Greeks really were.

The best of these statuettes in moulded clay are from the fourth and thir centuries before Christ, in the late classical age. It was especially at Tanagra, small town near Thebes to the north of Athens, that they were produce though several other centers were also active: Smyrna, Paestum, Tarentum, an particularly Myrina in Asia Minor. Those from Tanagra, such as the ones her illustrated, have a special delicacy and grace. Their simple direct naturalne makes them very appealing. Their dignity and refinement and reposeful cal show sensitivity of appreciation for the finer human values. They create a atmosphere of quiet beauty and civilized understanding of natural goodness.

The two shown here are typical for gentle charm and ease. Details are few but admirably bring out the important facets of face and dress which the arti has selected for conveying his vision of harmonious loveliness, unpretentious b very real. A classic serenity and humanism give nobility and significance, wit no striving for grandeur. These figurines are for simple enjoyment, not inspira tion. They are delightful to have around. Soft gay colors enlivened them onc as bright traces on some of them show.

Their purpose at this period seems to have been primarily as art objects in th home, though earlier ones were mostly votive offerings for sanctuaries and tomb It is our good fortune that many have survived. The one in Cambridge has be put together from two statues (the head added to another fragment), b hundreds are remarkably intact.

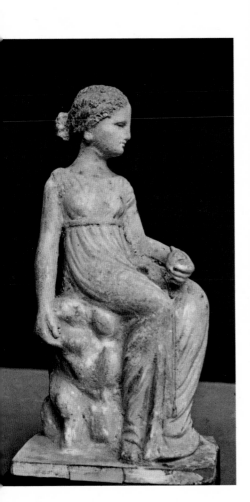
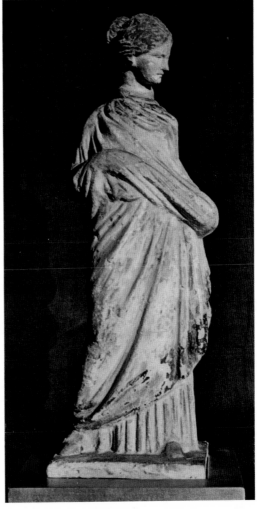

TERRACOTTA PORTRAIT OF A ROMAN MAN

c. 35 B.C.
Boston,
Museum of
Fine Arts

This is perhaps the most lifelike portrait that has come down from the classic world. Its extraordinary realism holds our attention and gives a strong feeling being in the presence of a living man. Not merely photographic preciseness detail, but an impression too of the inner spirit and personal character is stri ingly conveyed. There is an insistent force of vigorous personality driving o from the figure and impinging on our awareness. Here is a man of who notice must be taken!

The technique employed to obtain such living reality of portraiture seems depend on a cast made from the life. It is known that the Greeks had develop such a method in the fourth century B.C., and its perfection is ascribed to th brother of the great sculptor Lysippus. The Romans often made masks of wa from living or recently deceased persons, to keep in the home as a memoria Some fine portraitist of the late Republican era drew on these skills to produ this remarkable likeness. Probably he took a wax or clay impression of the fa only, either doing half of the face at a time or providing vents for breathing un der the mould. Then the ears, hair, back of the head would be formed by han to supplement the face cast, and the finer details of skin roughness, wrinkle crow's feet at the edge of the eyes worked into the pliant clay. Since no joinin are discernible, it is possible that the whole was produced free-hand, with a ca only serving to keep the subject's features available for prolonged guidan while the busy man went back to his occupations. Who he was is not know But he obviously was a man of strong character and dynamism, mellowed b experience and education. He gives us a very favorable impression of Rom dignity and purpose.

The bust was found near Cumae, to the west of Naples. Few other exampl of this type of portraiture in clay are extant. This is really a great loss. Bo history and art would welcome more like this one.

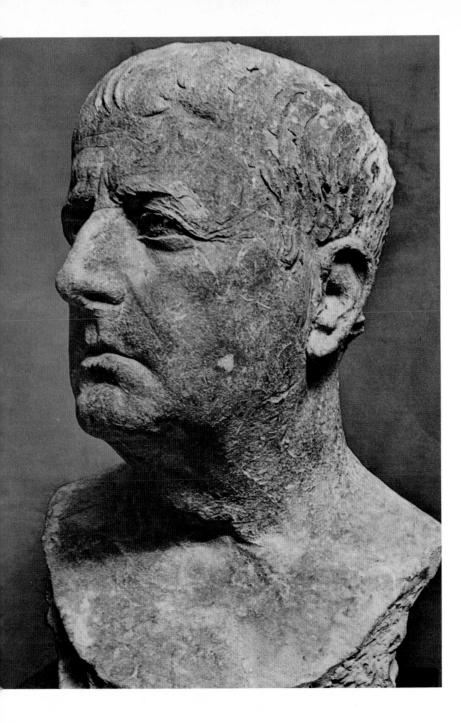

A series of large urns and vases of unusual shapes and peculiar decorative tec nique has been found in Greek tombs at Centúripe in Sicily, in the mounta area between Acireale and Enna. They were likely cinerary urns for the grav but may have been also used in homes for other purposes until needed for t dead. They have molded relief ornamentation of various kinds – leaves, vi shoots, human or animal heads, and friezes like those in temples. Usually there an elaborate lid, with its own decoration. They seem to date to the third centu B.C., and to be a specialty of that area in Sicily. Several fine examples are in t Syracuse museum, others elsewhere. The one illustrated, in New York, is amo the best preserved in fabric and color and a good representative of the gener style.

What is most notable about these Centúripe vases is their manner of paintin which is in tempera as in murals, not the usual glaze. In other ways too th resemble wall paintings, and are therefore of special interest as at least indire evidence of Greek painting in homes, which has not survived in its own rig Most commonly, the background is bright pink, with several human figur in gracefully arranged groups. They are usually women, and their dress affor the artist much scope for varied color tones and for delicate draftsmanship. T figures are in natural poses, often in three-quarter views, with good contr of perspective. Lighting is well managed, and the shadows contribute to realistic effect of volume and depth. Special care is given the faces, which in t present example are round and full but quite pretty.

These vases are not great art, but they are colorful and attractive, and th reveal the common Greek enjoyment of beauty and sound taste.

PAINTED VASE FROM CENTURIPE

3rd century B.C.
New York,
Metropolitan
Museum of Art

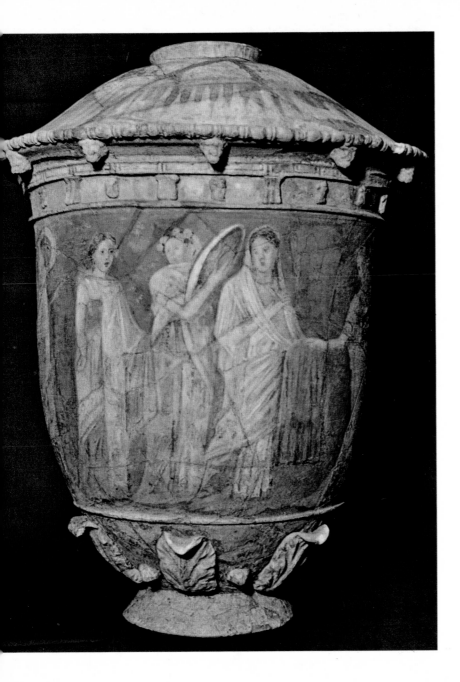

Euripides' *Medea* is a powerful tragedy which has made the modern wor
familiar with much of the cruel story of that barbarian princess, who kill
King Pelias for the sake of her lover Jason, then, when he later deserted her f
another more civilized princess at Corinth, slew the girl and the local king ar
even her own children by Jason to spite him and destroy his hopes. It is a probir
study of fierce emotions and of thwarted love, and is one of the great dramatist
most moving plays. Among other ancient illustrations of the story was a famo
painting by Timomachus of Byzantium, the last of the creative Greek painter
who in the days of Julius Caesar produced a brilliant panel of Medea and h
children which was much copied in sculpture and gems as well as paintings.
mediocre imitation at Pompeii shows that the children were playing unsu
pectingly at an altar – where they were soon to be sacrificed by their mother
fury – while Medea stood near a window watching them and brooding over h
murderous scheme. Fortunately at Herculaneum a much better copy of t
Medea figure itself has survived, which is obviously a very competent wor
and may be presumed to convey much of the quality of Timomachus' origina
The detail in our plate shows how excellent it was.

There is deep psychological expressiveness in the face and whole figure.
is a study of tension and turbulent emotions. She looks to the right, at the chi
dren, with tormented fixity, yet her body is wrenched to the left as thoug
to flee. The unusual twisted roll of her garment symbolizes an interior distres
and the nervous compression of her linked hands betrays her tumult of spir
She is still a mother and a woman, remembering the sweetness of love, despit
the raging hatred against her unfaithful mate – of whom the children unfor
tunately remind her and whom she can most hurt by their death. The swor
is in readiness, and she will use it. But she is human enough to hesitate over th
awful deed. Her eyes glow with a barbaric intensity, and her parted lips and tens
neck mirror her distraught state. All is contrast, agitation, strength. It is a paintin
of high merit. The original must have been even more striking and subtle. W
too are cast by it into mixed feelings: glad to enjoy its many facets of interes
pained at its proof of the great paintings we have lost.

MEDEA,
AFTER
TIMOMACHUS
OF
BYZANTIUM

1st century B.C.
Naples,
National Museum

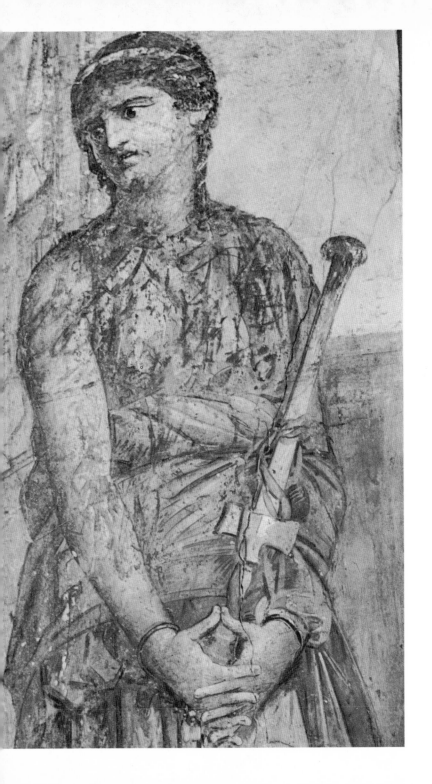

DETAILS FROM WALL PAINTING

A. Girl Pouring Perfume

1st century B.C.
Rome,
National Museum
(Terme)

B. Crouching Woman

1st century A.D.
Naples,
National Museum

The inner walls of Greek homes were ordinarily not decorated with painted scenes until late Hellenistic times. An exception was the house of Alcibiades at Athens, whose love of extravagant show led to his hiring the famous painter Agatharchus to decorate his rooms. Otherwise, it was in the palaces of kings that such art was mostly found, until Roman times when it became common in the splendid mansions of the rich merchants and government officials. Usually the paintings were copies – often quite free – of renowned works of Classical or Hellenistic artists, done by professional decorators who were usually Greeks or (especially after the Augustan era) Roman painters schooled in Greek traditions. Authorities still argue whether the technique was true fresco, painted in the damp plaster, or tempera on the dry wall. Recent chemical analysis seems to indicate that these murals of the Roman era were done by a special tempera process, using watered lime in a soapy solution as the adhesive agent. We illustrate here two examples of the art, one from Rome the other from Pompeii, both close-up details from larger works.

The girl pouring perfume from a round vase into a long one is part of the wall decoration of a luxurious Roman house along the Tiber, known as 'The Farnesina' because found on the property of Cardinal Farnese in 1879. The series of paintings there is in the neo-Classical manner in vogue at the end of the first century B.C. and through the reign of Augustus. The signature 'Seleucus' near one of the scenes would imply that it, and probably all, are by a Greek artist from Syria. The style is eclectic, a tasteful blend of Classical and Hellenistic modes. The present figure could easily be imagined on a Greek white-ground lecythus vase (cf. the somewhat similar type in Plate 35). It has exquisite grace and delicacy and is a very satisfying composition of lines and soft colors. The girl is charmingly natural, as she concentrates on not spilling any of the expensive liquid, her eyes intent on the work, her feet tensely raised on their toes. The drawing is pure Greek in style, of the late fifth or fourth century manner. The plain background enhances its simple beauty.

Very similar in quality is the woman crouching to look for something in her sewing kit or cosmetics box. The face has the traditional 'Greek profile', with a single line for forehead and nose. The eyes are particularly expressive, and the tightly closed lips effectively convey the woman's absorption in her search. Her cap and dress are neatly arranged, and the mild color tones fit in readily with her gentleness and poise. The bare arm and shoulder are daintily feminine, and the whole picture is quietly attractive. A special touch of naturalness is the position of the foot on which the lady supports herself so unpretentiously.

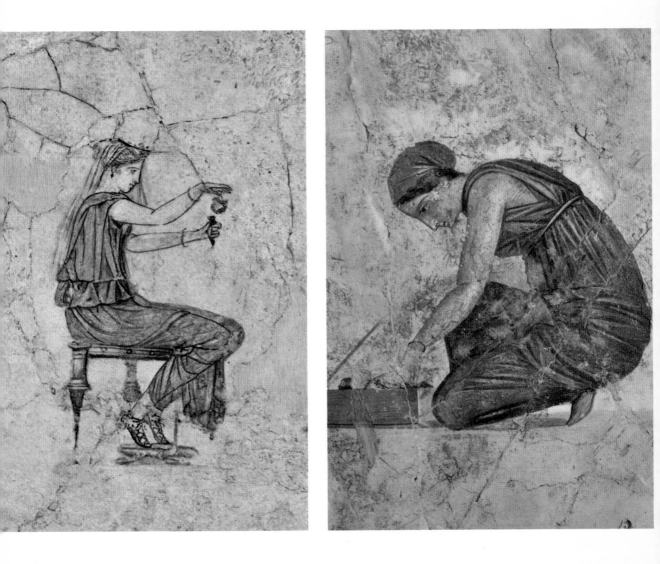

Landscape painting originated in Greece for stage scenery, where it **was** used in fairly simple forms during Classical times. In the Hellenistic Age it was not surprisingly made into a distinct field of art, especially after the pioneering work of Demetrius of Alexandria in the second century B.C., some of whose painting was done at Rome. It became popular in Italy, with its many natural scenes of great beauty to develop people's interest in the subject. The most remarkable example of painted landscape which has come down to us from the Graeco-Roman world was discovered in 1863 in the excavations of the Roman country villa known in ancient times as the *Veientanum* and *Ad Gallinas*. It was near the site of Veii, the important Etruscan town nine miles north of Rome which caused the early Romans so much danger until conquered and destroyed in 396 B.C. The villa belonged to Livia, the wife of Augustus, and was sumptuously appointed. The splendid marble statue of Augustus in armor, now in the Vatican Museum, was found there, and a room with this remarkable mural all around its circumference, nearly forty feet long. This has been skillfully transported to the Terme Museum, for better preservation and availability. The designation 'from Primaporta' refers to the modern hamlet at the villa site, with an old brick arch for gateway which commemorates Constantine's decisive victory nearby over the forces of Maxentius, in the battle of the Milvian Bridge, 312 A.D.

The unknown artist was probably a Greek from Alexandria, but possibly the Roman painter Ludius of the Augustan era, who is reported to have specialized in landscapes – though there are here none of the buildings which he was famous for setting among the scenery. At any rate, the painting is in the direct Greek tradition, probably with an Italian quality of extra lushness and exuberance, to please local tastes. It is wholly different in spirit from the usual mythological and fanciful landscapes of the time (such as the famous scenes of the *Odyssey* from a Roman house on the Esquiline, now in the Vatican Library), but the recent excavations at Pompeii have produced orchard scenes rather similar in manner.

There is excellent perspective in this study of an elaborate garden, and notable accuracy of detail. The low stone fence, with its grille motif, sits back a short space from the wooden trellis in the foreground and at regular intervals bends back to form a niche for a pine tree. Beyond it lies a forest of other species of tree: quinces, pomegranates, laurels, exotic palms and tall cypresses. Wild rose bushes and daisies add their colors to that of the bright fruit and the varied green of the trees. Birds of several kinds bring further touches of color, and give the scene more life and additional interest. It is clear from this uniquely extensive remnant of Graeco-Roman landscape painting that the art had mastered all its problems and could produce works of monumental quality and practically any scale.

GARDEN MURAL FROM PRIMAPORTA

1st century A.D.
Rome,
National Museum
(Terme)

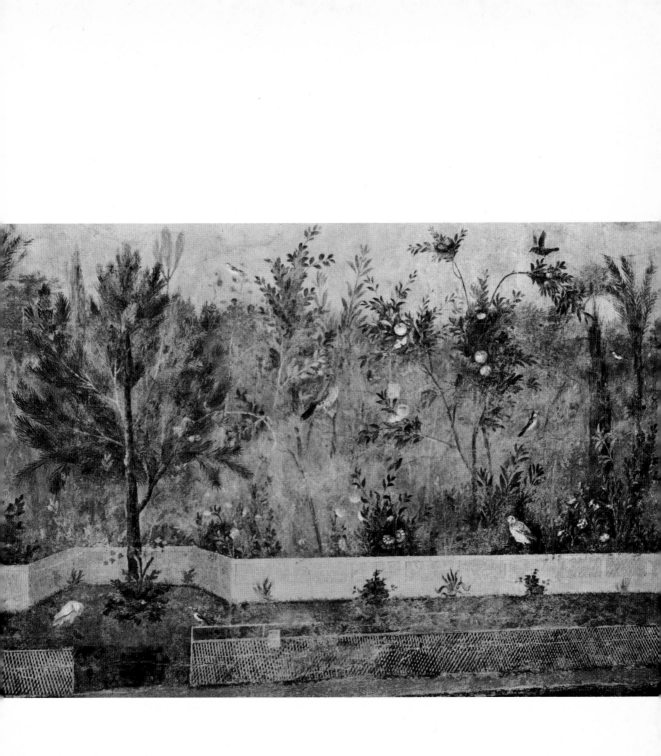

Two unusual features of this painting are that it is in monochrome, and is don[e]
on a slab of Parian marble. Several such pieces were found, as this was, [at]
Herculaneum, apparently meant to be insets in the wall of a room. The smoot[h]
snowy surface of the marble, with its glittering mica flakes, forms a clean back[-]
ground for the figures, which are thereby emphasized, yet gives an element [of]
added distinction to the work. The drawing is uncommonly good, its extreme[ly]
fine lines producing a notable clarity, but above all a delicate gradation of ligh[t]
and shadow effects that is very realistic. This is especially true of the forepar[t]
of the Centaur, where the three-dimensional quality and surface lighting ar[e]
masterfully managed. The front legs stand out, too, from the figure beyon[d]
with excellent illusion of motion. Other anatomical problems are satisfyingl[y]
handled, and the youth's body, like the Centaur's torso, is plausibly heroic i[n]
physique, as the theme requires. Of special merit is the emotional quality of th[e]
three faces, which clearly convey their subjects' respective determination, dismay
and distress.

Some think that the theme is Hercules rescuing Deianeira from the centa[ur]
Nessus; others that the topic is that frequently chosen one in Classical art, th[e]
turmoil caused by the Centaurs at the wedding feast of Pirithous and Hippod[a]mia (cf. its treatment on the Olympia pediment, Plate 40). The actors in th[e]
present scene are probably the Centaur king Eurytion, the bride Hippodam[ia]
whom he is seeking to carry off, and the Lapith king Pirithous, her new spous[e]
and brave defender. The hero has a firm grip on the monster's head and with h[is]
knee braced against the Centaur's haunch has further muscular purchase fo[r]
driving home the sword which is poised in his right hand. The composition [is]
neatly unified by the balanced position of the three figures, which are all i[n]
contact yet held separate, the center of perspective, as of the converging oppose[d]
forces, being the Centaur's prominent head and sturdy trunk.

In general style, the painting much resembles a metope of some fifth centur[y]
temple. In fact, many metopes have Centaurs, in this or other episodes, as thei[r]
sculptural theme, including several of the Parthenon. It is thought, howeve[r]
that the artist is more likely copying a painting of the late fifth century, ver[y]
possibly one by the great Zeuxis who often worked in monochrome. A com[-]
panion piece to our present painting, the brown picture on marble of five girl[s]
playing the knucklebone game, is signed by Alexander of Athens, who seem[s]
to have been active at the end of the first century B.C. and first part of the er[a]
after Christ. The style is somewhat different from that of this Centaur scen[e]
because it is an imitation of another fifth century panel painter. But the techniqu[e]
and skill are similar, and very likely Alexander produced the Centaur pictur[e]
also, in his rare medium of brown stain on marble. It is another instance of Gree[k]
inventiveness and constant artistic experimentation.

PAINTING
ON
MARBLE

*1st century B.C. /
1st century A.D.
Naples,
National Museum*

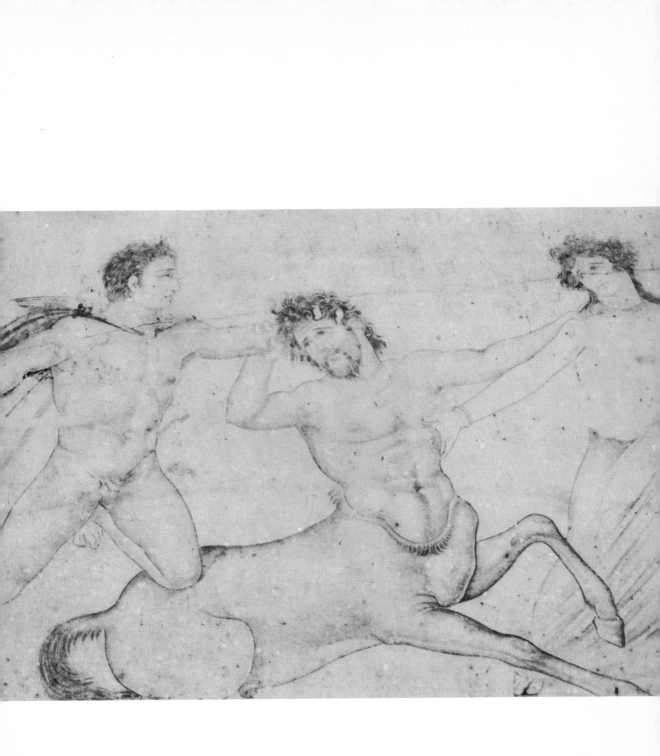

MURAL
FROM
VILLA
OF THE
MYSTERIES
AT
POMPEII

*c. 50 B.C.
Pompeii,
Villa of
the Mysteries*

Just outside Pompeii to the north, toward Vesuvius and Herculaneum, was a large country house of some wealthy Roman family which, since its excavation in 1929-1930, has become world-famous for its unique series of painted scenes of an ancient religious rite. These probably represent stages in the initiation of women into the Dionysiac Mysteries, which were a sort of pageant of the story of Dionysus' marriage to Ariadne after she was abandoned on Naxos by Theseus (cf. Plate 32). This was a mystic ritual symbolizing the union of human and divine forces, and an apt preparation for marriage and the miracle of new life. The cult was fairly widespread among educated women in the first century before and after Christ, especially in Campania, apparently, with its centuries-old connection with Greek culture. It seems that the lady of this elaborate villa was an initiate, for it was probably she who commissioned some great artist of late Republican times to decorate a large room of the house with these episodes from the Mysteries. The painting runs around three sides of the room, and contains nearly thirty figures in several distinct but inter-related scenes, which represent stages in the initiation ceremony.

The paintings are a work of genius, and though clearly drawing on Hellenistic and Classical antecedents, seem to be an original creation in their actual form. The artist was most likely a Greek, of Campanian origin or imported from abroad—which the wealthy owners of this expensive estate could obviously afford. He has given the theme a powerful organization, and treated it with personal touches revealing a strong individual style. His figures are no academic abstractions or copies of other paintings, but real people based on local types. He has full mastery of perspective and use of space.

In the scene here illustrated, two girl-satyrs (identified by animal ears) wait out the ceremonies seated on a rock, one with a pan-pipe, the other feeding a deer. Next to them a woman being initiated registers surprise and fright at the revelation of awesome mysteries near the opposite corner (she is looking across the space between). She is drawn back in dread, her hand raised to ward off what repels her, her veil billowing above her head. The expression in her face is vivid dismay. The drapery of her garments is worthy of high Classical sculpture. All is drawn with vigorous facility.

Although Maiuri and others explain the other group as partaking of the sacred *kykeon* potion, it is clear that the young satyr is not drinking or the others helping him drink. Nor does it likely illustrate *lekanomanteia*—seeing future events symbolized on the surface of a liquid in a special prophetic bowl. Probably it is a bit of magic deception. The fat Silenus has told the boy to see his true self in the mystic bowl. As he peers in, his eyes start with amazement, for what he sees is a weird mask which the other satyr (with a mischievous grin) holds at just the right position to be in focus for the parabolic mirror which the silver bowl's interior forms!

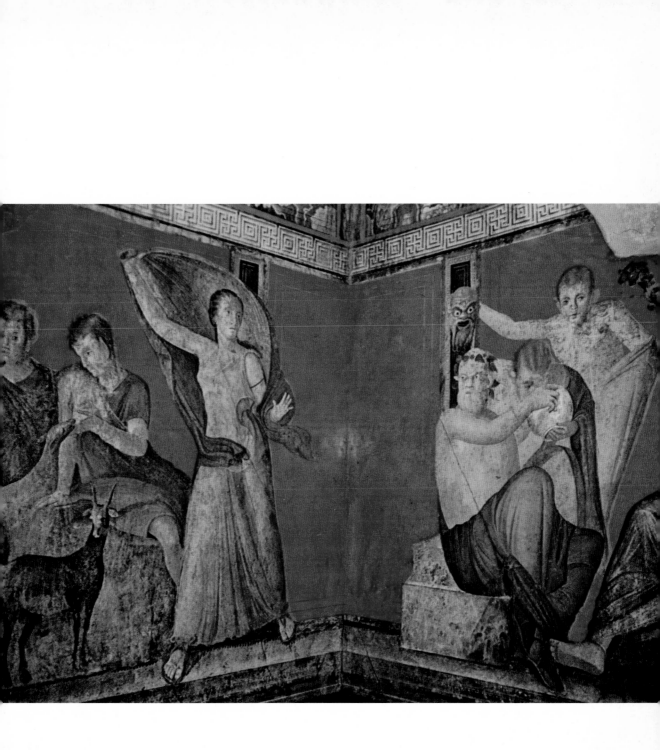

An instance of the Greek ability to assimilate alien ideas while stamping the[m] with the special Hellenic quality is the development of the mummy portrait [in] the Graeco-Roman settlements in Egypt. The extant examples, of which the[re] are over four hundred, come mostly from the Fayum, a fertile region on t[he] west side of the Nile some fifty miles south of Cairo and the Pyramids. T[he] Greeks settled in that area extensively under the Ptolemies in Hellenistic time[s] and many Romans later mingled with them. Egyptian customs were wide[ly] adopted, including the mummifying of the dead. In the early centuries of t[he] Christian era, it was a practice in these Graeco-Roman communities to have [an] artist make a portrait of oneself during life, which was usually on a wood pan[el] though sometimes on linen. This likeness would be displayed in the home, a[nd] on the person's death it would be trimmed to fit into the mummy wrappin[g] as a covering over the head – replacing the traditional Egyptian mask for th[is] function, which was rarely a real portrait of the deceased.

The painters who practised this specialty were ordinarily mere artisans, n[ot] first-rank artists – whose services would be too expensive for most families. T[he] portraits are therefore for the most part mediocre and crude. But a few, such [as] those in this plate and the following and four or five others not here illustrate[d] are far superior in merit. They show real competence on both the technical a[nd] the psychological level. The subject's individuality is clearly conveyed, and w[e] have a sense of close contact with the inner spirit. Clearly, the portraitist in the[se] few instances reveals original ability of a high order and the authentic Gre[ek] gift of grasping the essentials and expressing them with clarity and force. It is [a] tribute to the tenacity of Greek artistic ideals that the true Hellenic quality c[an] thus survive in so alien a cultural context.

This study of a young boy is perhaps the finest of all these Fayum portrait[s.] It is painted on wood, in seven color tones: black, brown, gray, pink, yello[w,] and touches of red and mauve. The method is the 'encaustic' technique, t[he] Greek equivalent of oil painting (which is a late medieval invention). The colo[rs] were mixed with wax as a binding agent, and applied by a hot spatula or bru[sh] in strong strokes. This produces a glowing luminosity and an impression [of] substance in the flesh and garments, and allows delicate modulation of the mixe[d] colors. As the paint stands out noticeably from the background, there is a speci[al] vitality in the play of light and reflections, and the effect differs as the view[er] changes angle of observation. The expressive face of this boy, with his lar[ge,] pensive eyes and refined features, is one of our best bridges to a direct unde[r-] standing of the kind of people who made up the late Greek world and i[ts] mingling of many races and traditions.

PORTRAIT
OF BOY
ON
MUMMY
CASE
FROM
FAYUM

*2nd century A.D.
New York,
Metropolitan
Museum of Art*

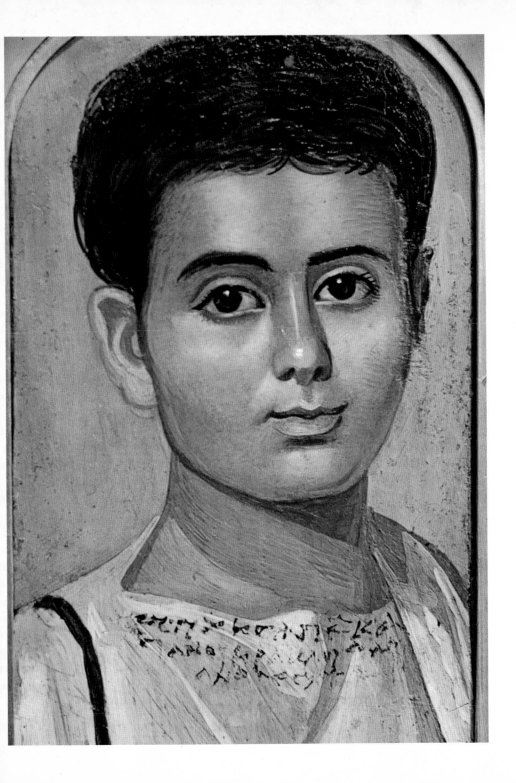

**PORTRAIT
OF GIRL
ON
MUMMY
CASE
FROM
FAYUM**

*2/3 century A.D.
Frankfurt,
Liebieghaus*

Though not equal in quality to the preceding portrait, this picture of a young girl from one of the Greek or Roman families living in central Egypt in the early Christian era is still an interesting study and artistically much more competent than most of these mummy portraits. The artist has given his subject a soulful expression which makes her seem very real. She is obviously an intelligent girl, with some education and refinement; and likely from one of the more prosperous merchant families, who could afford a superior portraitist for this daughter whom they esteemed. The large eyes are typical of this species of art, and are a convention for emphasizing the sense of life within, so that even in death the subject seems to live on. Perhaps, though, they are not much exaggerated, for it could well be a characteristic of the mixed stock in such settlements in Egypt. In any case, the eyes certainly hold our attention and stress the spiritual element in the portrait.

It is a lovely face, in its simplicity and goodness, and we can feel the girl's natural charm. Her black eye-lashes and prominent brows give her a brooding reflective aspect, but the open and kindly gaze of the eyes tempers the solemnity and makes us sure that we like her. The unusual lavender lipstick might make her seem very modern, but in fact it only shows how old are most human fashions... A crown of laurel leaves graces her black curls, perhaps as a token of her parents' affectionate regard for their 'little princess', perhaps as a token of some literary or musical accomplishment.

If we compare this portrait with the marble head of a Roman girl in Plate 95, we notice at once a great difference in their social level. Much of the charm of this painting is that we known this girl is just an ordinary young daughter of a typical better-class family. There is no air of pretentiousness, no special benefit from the elegant nurture and grooming which only the nobility and the very rich enjoy. This girl's appeal is rooted in her own merits. She wins our affection instantly.

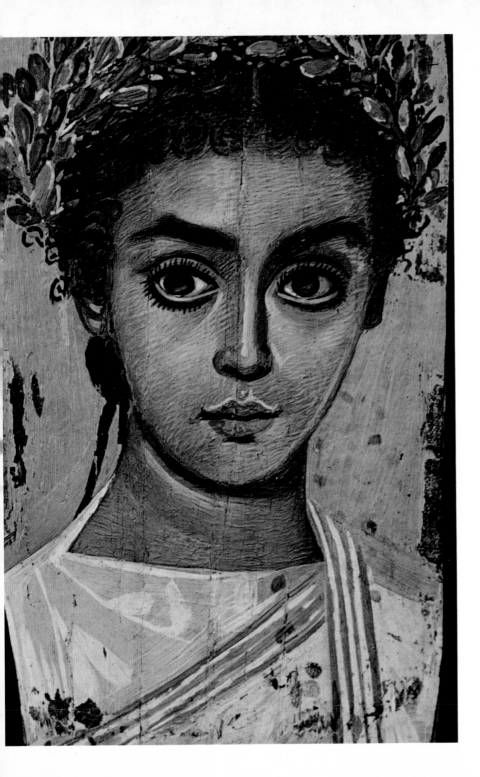

Greek artists were active in portraiture of Roman notables from the end of the Republic well into the Imperial era. Many of their names are known, and superior portraits of the Roman period are often signed by Greek sculptors. Some of the later works however are apparently by Roman artists trained in the Greek tradition.

This head of Pompey the Great, now in the remarkable collection of ancient portraiture in Copenhagen, is excellent proof of the high level which the art had reached. Beyond complete technical mastery there is evident here a psychological comprehension of notable depth. The man himself lives on in this intriguing study of his character.

Gnaeus Pompeius (106–48 B.C.) was son of a consul and early gained prominence as a military leader of genius. In the fierce and tumultuous series of civil wars which racked Italy and the colonies during most of the century before Christ, young Pompey effectively supported Sulla against the armies of Marius in Sicily and Africa. After Sulla's death in 78, he won notable victories in Spain and obtained the consulate together with Crassus. His lightning campaign in 67 against the dangerous pirates infesting the Mediterranean was sensationally successful, as was also his conquest soon after of Mithridates in Asia Minor, thus ending a long struggle against a ruthless and wily foe of Rome. Pompey enlarged and re-organized Roman provinces in the East and founded or restored to importance many cities there. He returned to Italy in 62 with a devoted army and great fame. The political maelstrom at Rome was too complicated for him, however, and after much jockeying for power with which to uphold the traditional governmental system and ideals of the Republic he was decisively defeated by Caesar at Pharsalus in 48, and slain on his arrival in Egypt where he sought refuge.

Pompey's greatness lay in extraordinary ability to manage military forces and strategy and to win deep loyalty from his men. He sought to restore dignity and order to a government rotted through by faction, selfishness, and corruption. He had married Caesar's daughter Julia in 59 and after her death Cornelia, daughter of Metellus Scipio, his colleague in high civic office. Though these were marriages of expediency for political advantage, both women came to admire and love him deeply. On his death, Cicero wrote to Atticus that in Pompey he had known a man upright, chaste, and serious-minded such as few others.

The ancient artist has caught in this striking portrait much of Pompey's quality. It is a valuable aid to our understanding of the man, and a fine example of a very difficult and subtle form of sculpture. We see captured here his good-natured but somewhat baffled dignity, his intelligence, cunning, and vanity, his mixture of seeming softness and quick reaction to events. The horizontal wrinkles and hair curling over the forehead are modelled on portraits of Alexander, whom Pompey emulated.

This Copenhagen copy was probably made c. 50 A.D. in the reign of Claudius, from an original a hundred years earlier by a Greek portraitist in the Athenian tradition, who no doubt worked from the life with Pompey's cooperation.

PORTRAIT OF POMPEY THE GREAT

c. 55 B.C.
Copenhagen,
Ny Carlsberg
Glyptotek

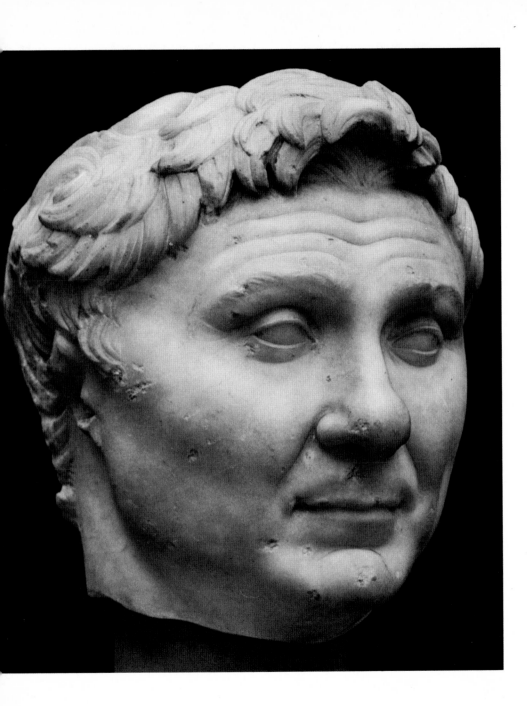

PORTRAIT
OF
ROMAN
GIRL

2nd century A.D.
Rome,
National Museum
(Terme)

Vergil said of Greek portraitists that they could make a stone likeness seem to liv
vivos ducent de marmore vultus (Aen. 6.848)
An example is this charming study of a young girl from a Roman household. S
is perhaps a princess in the Imperial family; or in any case, from a home wealth
enough to afford a first-rate sculptor's time and talents. He was probably
Greek artist living in Rome, as many did after the first century B.C. His pr
sentation of this little girl is worthy of the best Greek traditions in portraiture.
combines careful accuracy of detail with just enough idealization to lift it in
the level of artistic interpretation, freeing it from the limitations of mere realis
and individuality and stamping it with the quality of a new creation. Thoug
produced toward the end of the long span of Greek art, it is still fully in th
authentic spirit. This is not an indication of the decline that had begun, b
rather a last flower of the strong vital drive toward beauty and idealism whi
had been for centuries the fertile life-principle of Greek art in all its phases.

This is a delightful study of the special charm of children – a topic which t
Classical artists had never developed. The girl's pretty face is sweet and tende
yet hints at her lively, carefree spirit. She shows a native dignity and goodne
an innocence unspoiled by abuse of liberty or by the base standards of the adu
pagan world around her, which is still outside her experience or understandin
She looks clear-eyed into the future, with the simple directness of children. H
lovely face is attractively framed by the pattern of her hair. The long locks,
their neat, formal arrangement and contrasting curves, lend animation to h
features, while the swept-back strands and chic knot at the back make her see
all the more a little lady.

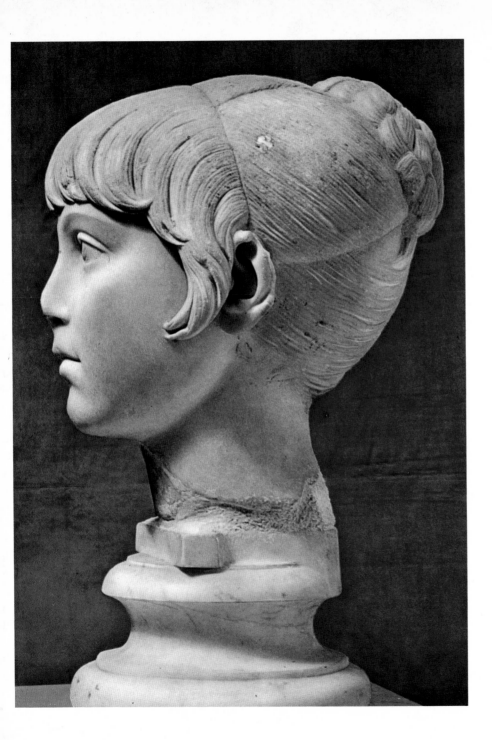

SMILING FAUN

2nd century A.D.
Athens,
Stoa of Attalos
Museum

This pleasant fellow was found in an abandoned well in the Agora at Athens. He seems glad to be out! Actually, the cheerful appearance is his regular mark, for he is a carefree rural divinity, a faun or young satyr, full of animal spirits and rejoicing in his closeness to nature. He is mostly human, but has the pointed ears and goat's tail of his partly brute nature. Greek imagination in thinking up such mythological creatures was serious as well as playful, for there is a profound idea or symbolism underlying such fancies. We read of these half-human, half-animal beings from Homer to Theocritus and in later Roman echoes. They are popular subjects of art also, as are their more unruly counterparts, the Centaurs (Plates 40, 90, 91). No more pleasant sculptural representation of them has survived than this Roman era copy of a Hellenistic statue, which once stood somewhere in the civic center of Athens.

The faun is shown standing at ease next to a goat on his haunches. The boy holds him by the horns. In his right hand is a pan-pipe, and a rough skin cloak is thrown around his upper body. The whole composition has a delightful directness and fresh liveliness. The most striking detail is the plain boyish face, with its engaging smile. He makes us enjoy being with him. The art here is not sublime; but it is real, and it succeeds in transporting us into an imaginary world which affords us pleasure. That is a Greek ideal as old as Homer.

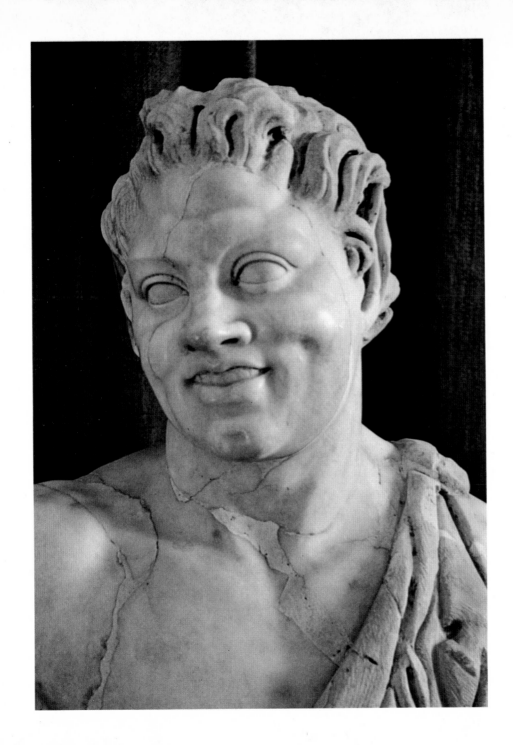